Christmas in America

Christmas in America

A PHOTOGRAPHIC CELEBRATION OF THE HOLIDAY SEASON

Skyhorse Publishing

Skyhorse Publishing books may be purchased in bulk at special discounts for sales promotion, corporate gifts, fund-raising, or educational purposes. Special editions can also be created to specifications. For details, contact the Special Sales Department, Skyhorse Publishing, 307 West 36th Street, 11th Floor, New York, NY 10018 or info@skyhorsepublishing.com.

Skyhorse® and Skyhorse Publishing® are registered trademarks of Skyhorse Publishing, Inc.®, a Delaware corporation.

www.skyhorsepublishing.com

10 9 8 7 6 5 4 3 2 1

Library of Congress Cataloging-in-Publication Data is available on file.

ISBN: 978-1-61608-096-9

Printed in China

Introduction

Stars are shining brightly. Beneath a blanket of celestial diamonds, the sun enjoys its longest slumber as the winter solstice slowly embraces America. A wondrous tableau begins to emerge, from aromatic kitchen counters to frozen woodland dells. Magic is on the stove. Christmas is in the air.

Listen. Across the village green, there's the muffled crunch of snow beneath eager boots heading home. Inside, crackling fireplaces release fragrant curls of smoke. Beyond the valley, sleigh bells jangle through snow-capped forest. Down the lane, carolers sway to the syncopated cadence of heartfelt ballads. Out in pine-scented fields, hoarse rhythms echo as handsaws meet wood and forest growth is transformed into living room altar.

Meanwhile in the city, boulevards are jammed by pedestrians burdened with armfuls of ribboned presents. Hailing taxis, they scurry off with the pent-up anxiety only incomplete shopping lists can create. Santas ring bells and grace department store doorways where wide-eyed children weave a slushy path toward massive window displays. Chestnuts roast in the pans of thickly-bundled street vendors and across the bustling avenue, theaters spotlight sugar-plum fairies waltzing to audiences filled with the yuletide spirit.

Pull aside the theater's curtain for a moment and look backstage behind all the dizzying pageantry. Just how did animated nutcrackers, levitating, red-nosed reindeer and jolly, bearded men who happily stuff themselves into chimneys come to represent the glistening magic of the holiday season? Perhaps unrecognized is that the very core of magic's linguistic roots evolved from the Magi, a trio of ecstatic gift-bearing travelers determined to celebrate what was certainly the most noted birthday party in history.

Beckoned by starlight, these Three Wise Kings traveled the frankincense routes of Arabia to rendezvous at a faraway manger near Bethlehem, in Palestine. Here, local shepherds had also been summoned by the gleaming astronomical display. Ironically, those stars, beaming their brilliance so many years forward into our own existence, remain the sole witnesses to an episode more than two millennia ago in a distant land.

Christmas was first observed as a holiday three hundred years after the fact, purposefully displacing the pagan Saturnalia jubilations of the winter solstice. Little heed was paid to historical accuracy as the original nativity occurred no later than September, when those notable star-struck shepherds would have spent a night with their flock in the fields.

Centuries later, and some 4,132 miles south of the North Pole, a monk named St. Nicholas was born around A.D. 280 near modern day Myra, Turkey. Eventually ordained bishop, he acquired a reputation as a miracle-worker and matured into a patron saint for children, sailors and pawn-brokers (his three sacks of gold used to ransom a female trio from a life of enslavement spawned the profession's symbolic trilogy of gold balls). It then took more than a millennium for the early nineteenth century New York storyteller Washington Irving—creator of Rip Van Winkle—to embellish the resume of the saintly Turkish bishop. He was transformed into an elfin, roly-poly figure who smoked a clay pipe and recognized an entirely different use for chimneys. Thirteen years later, and a bit further downtown, a well-known poem (whose authorship is still under contention) about the night before Christmas was first published. In it, Santa discovers the sleigh, Manhattan's wintry rapid transit of choice at the time, pulled by eight tiny reindeer. During the Great Depression, Rudolph and his glowing proboscis joined the arctic herd when a struggling copywriter for a Chicago department store created a children's giveaway made famous when cowboy singer Gene Autry sang the adapted tale.

Rudolph's nose, though, cannot hold a candle to the glorious illuminations of the fabled Christmas tree. Its triangular shape is said to represent the Holy Trinity. But there were no Christmas trees on those biblical lands two thousand years ago. They were first decorated, then illuminated by candlelight, in Martin Luther's sixteenth century Germany. Vegetation's symbolic roots are deep each season. Druids revered the healing powers of the parasitic mistletoe, then believed a curative for female infertility, now believed to be a sign for an open-air holiday kissing booth. The pointed red leaves of the *Euphorbia pulcherrima*, a plant whose milky sap was used by the Aztecs as aspirin, were noticed by an American diplomat who thought them to be symbolic of the star of Bethlehem. Joel Poinsett, also an avid botanist, brought them back from Mexico and they subsequently became the rage in American flower markets and by 1836 were known as poinsettias.

The spiritual essence of Noel was introduced by the French, who accented the holiday with "les bonnes nouvelles" or "the good news." That news was harmonically spread through carols which had their melodic roots embedded in Victorian England. In the Scandinavian darkness, where winters were longer, Yule logs lit the Swedish night as an acknowledgement of the haunting Norse gods and as an embodiment of ancient bonfires. A host of traditions and beliefs spanning continents and the ages continue to be woven into the fabric of Christmas.

Christmas in America is an event like no other. Its emotional boundaries seem to stretch from the moment carved pumpkins are abandoned and lights are strung,

through clandestine visits from Santa, and well into the following year when the Feast of the Epiphany celebrates the Magi's largesse. On this Twelfth Day of Christmas, the famous carol helpfully suggests, "twelve drummers drumming" might just be the most perfect gift to one's true love.

During this season of joyful renewal, some find its physical expression in the sporting delights that take advantage of our wintry countryside. Prancing horses tow open sleighs through corridors of gentle woodland. Mushing dogsled teams dash across frigid kettle ponds with the barking urgency of a moving freight train. Deep in a canyon's gorge, straining ice climbers penetrate the yawning throat of frozen waterfalls whose nine-story icicles provide gleaming tinsel for the riverbank. Out on the glassy expanses of chilled lakefront, sails billow on handsome ice yachts as shaved ice slaps rosy cheeks and roaring gusts could sweep the tears from your eyes. Victorian chair skaters seem to slide out of the quaint lithographs of Currier and Ives.

For one brief season each year, goodwill, tidings of generosity, and hopeful rejuvenation spread across the land. Almost anything seems possible, but just like the fresh dusting of a snowstorm that brushes the landscape, all these images will melt into another year of sobering reality and weighty routine. Christmas trees are discarded. Light displays are disassembled, ice skates go into the closet, forgiveness and charity might even become a tad less fashionable. That is until next year when, once again, the waning pastel daylight surrenders itself to a ceiling full of dazzling stars.

PETER GUTTMAN

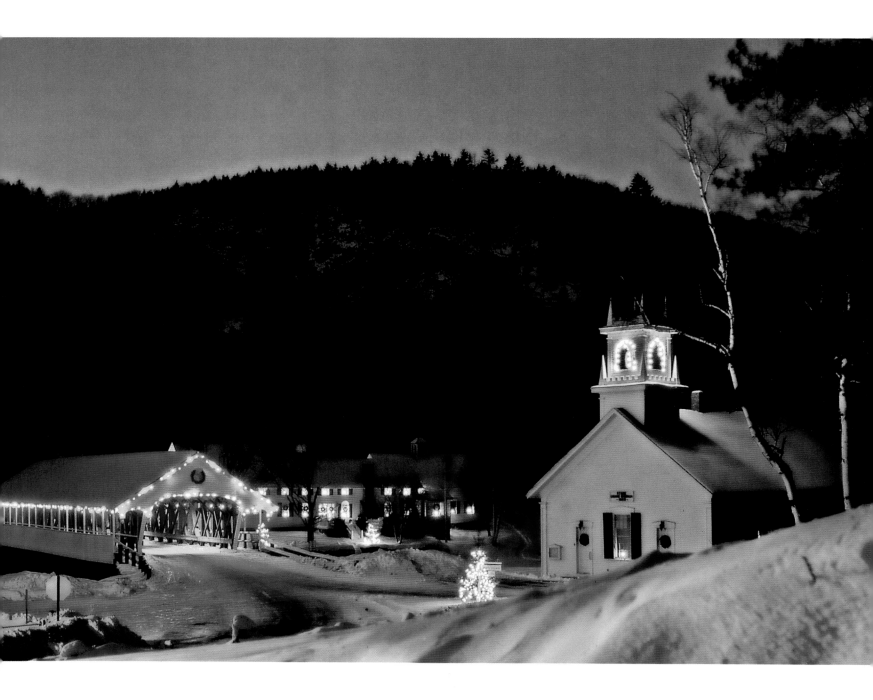

Christmas in the East

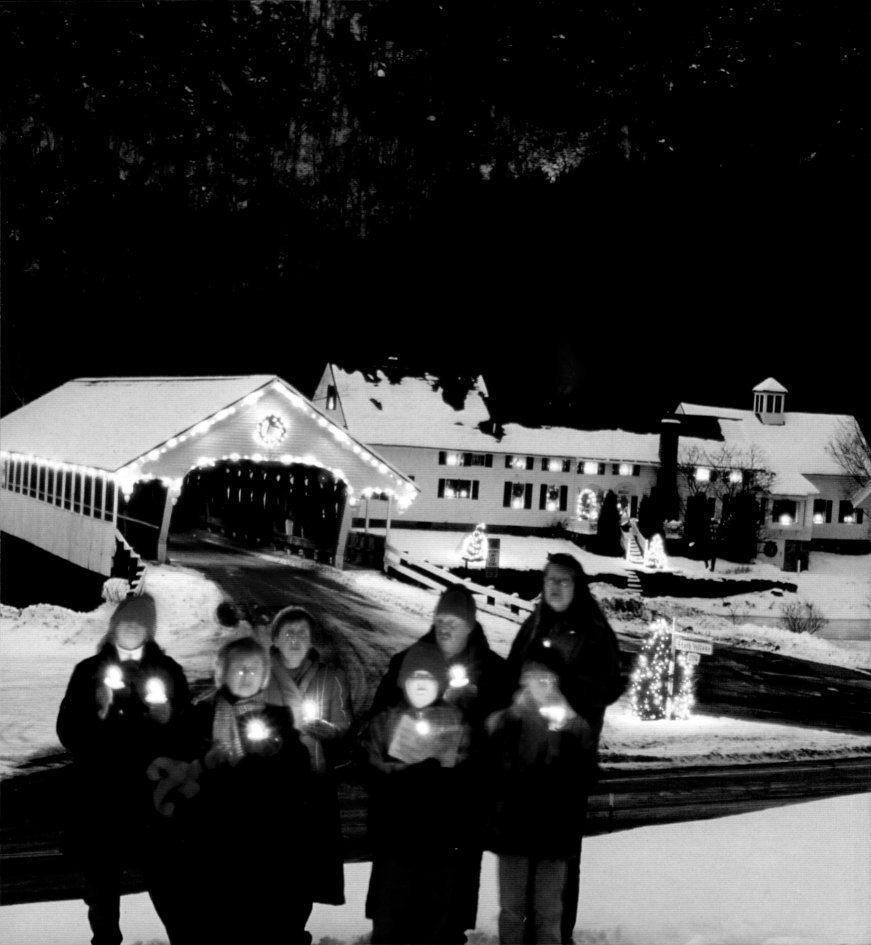

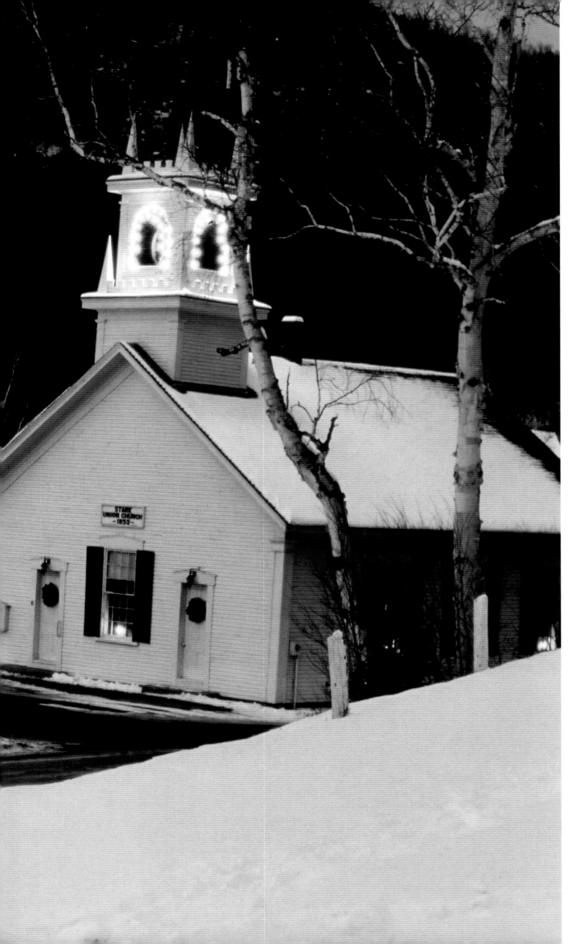

In the storybook mountain village of Stark, caroling voices aim toward the heavens as does smoke wafting from the village inn's chimney. The wreath-decorated Stark Union Church is illuminated in anticipation of Christmas mass, when the town's tiny population easily fits within this charming 1853 structure.

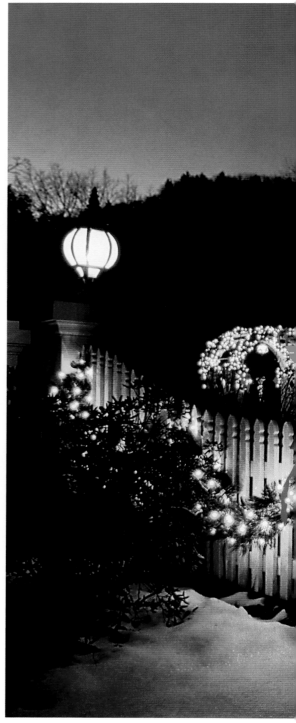

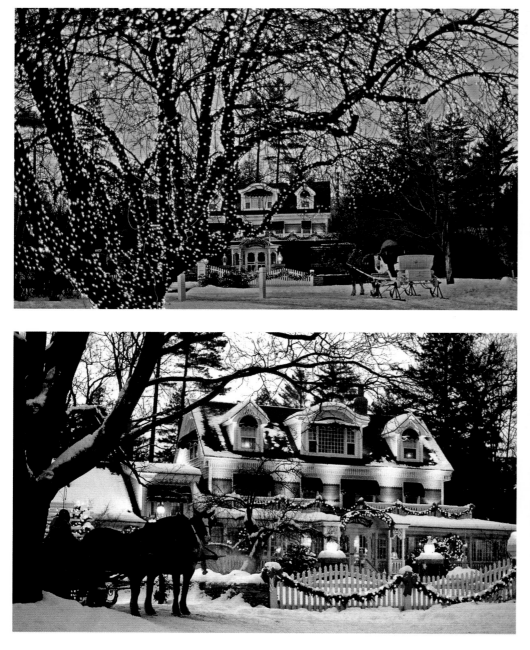

Bedazzled in lights and ribbons, the gingerbread Nestlenook Farm awaits its next delivery by horse-drawn sleigh. The two-hundred-year-old inn oversees more than sixty-five acres of rural winter wonderland in the heart of the White Mountains.

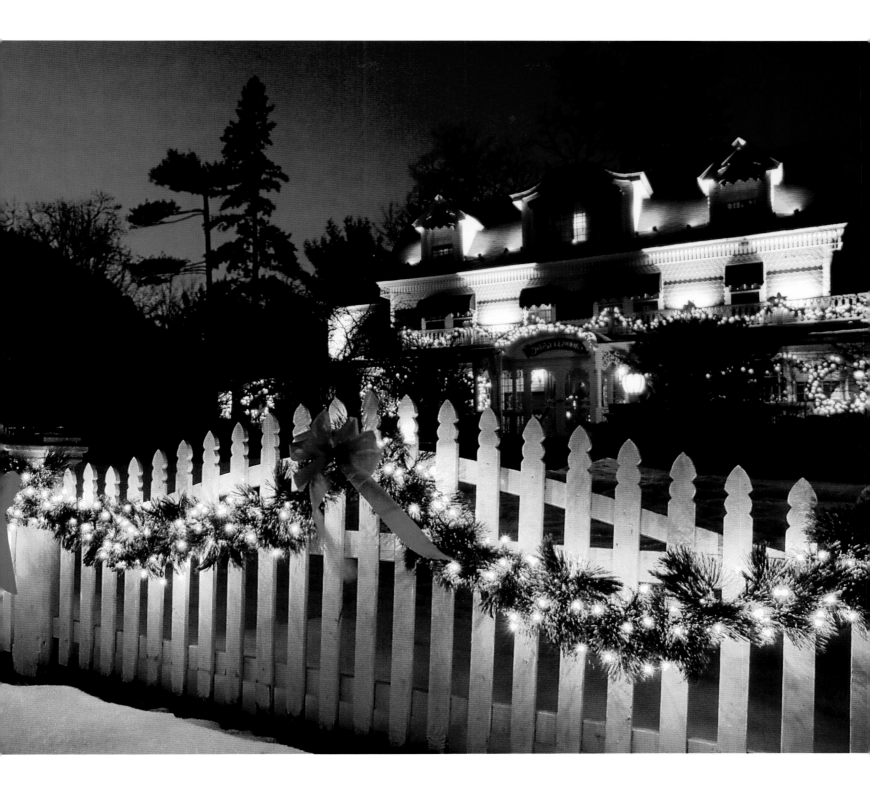

Near New Hampshire's very own little town of Bethlehem, a horse-drawn wagon plows through the Rocks Estate, a Gilded-Era Christmas tree farm stippled with undulating rows of heavily sugar-coated balsams.

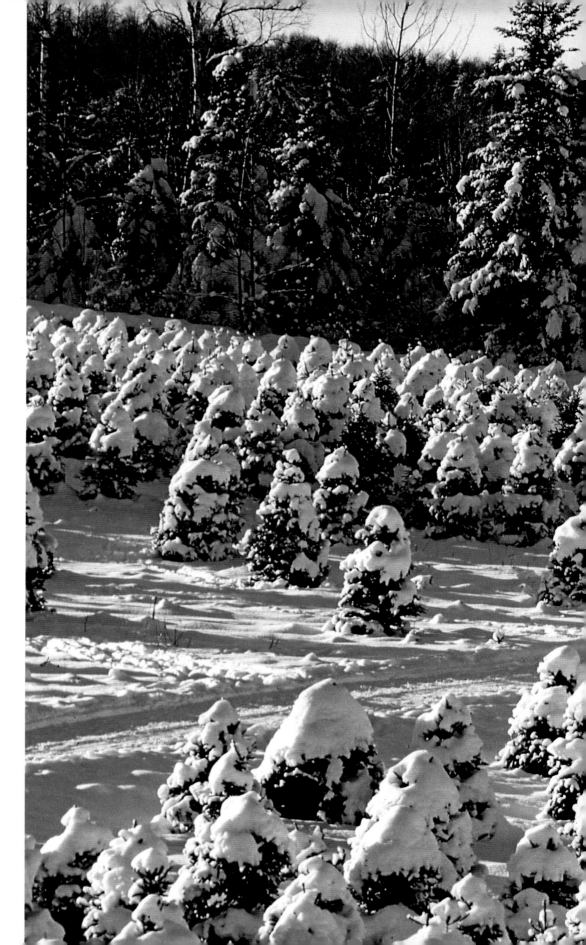

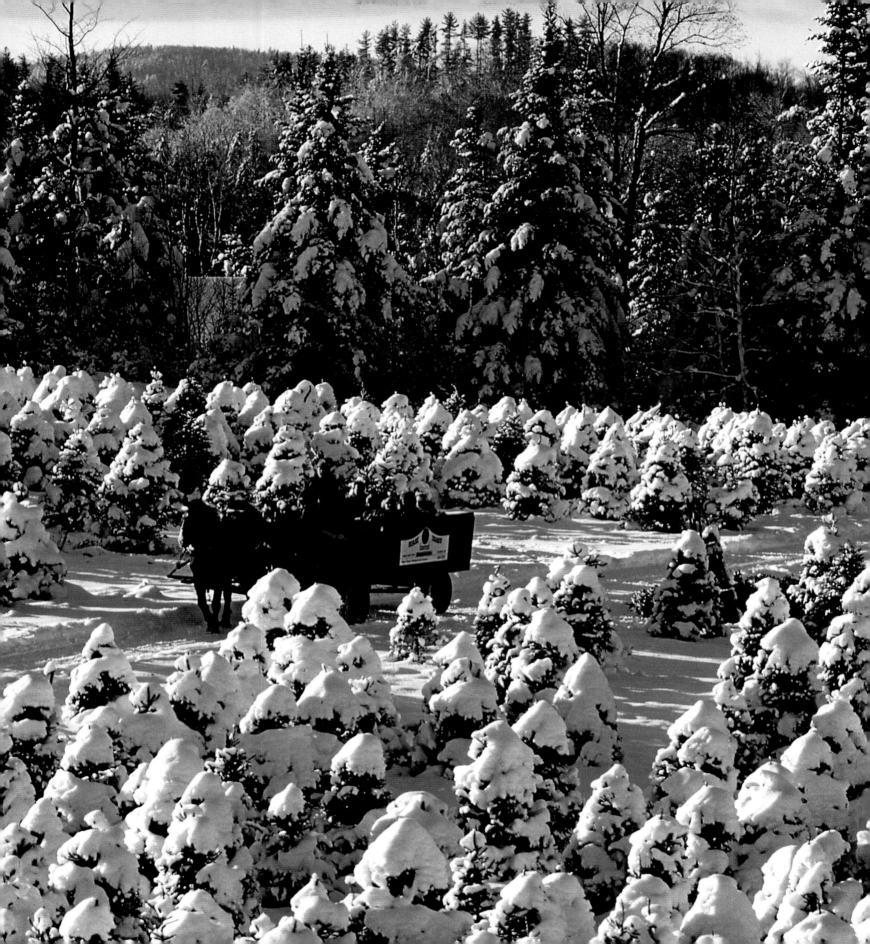

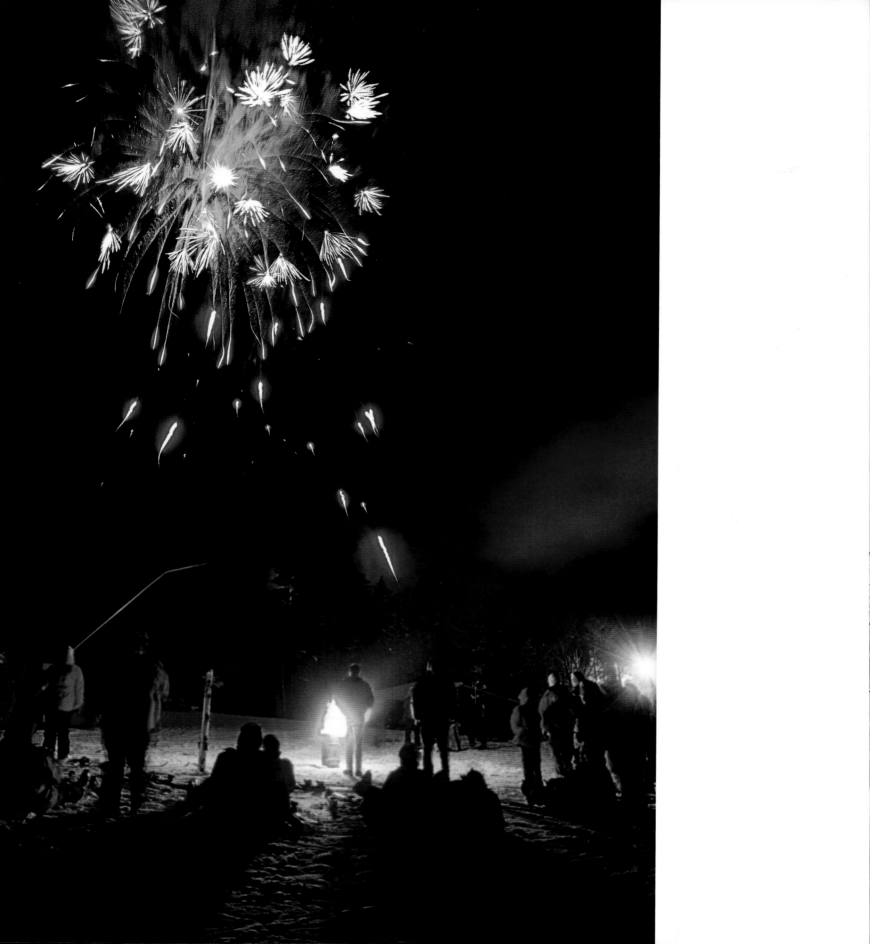

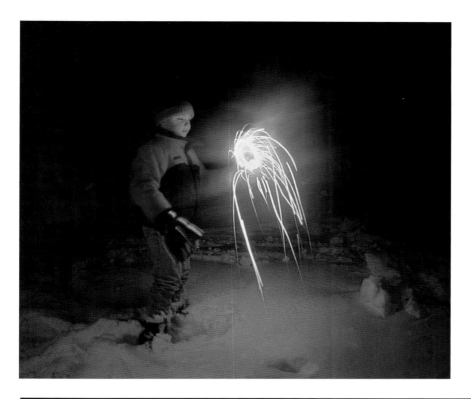

Bundled up against the near zero temperatures and never too far from the roaring fire, a boy (left) unveils his sparklers to celebrate New Year's Eve in the fields near Franconia, New Hampshire.

On New Year's Eve, Christmas trees are illuminated not by bulbs, but by the sparking embers about to engulf the conifers (below). Thought to foster good luck, the Burning of the Greens in North Conway, New Hampshire, is meant as a termination of both the calendar year and the religious holiday season.

(Opposite) A blazing bonfire offers little competition for fireworks monopolizing the sky over the Bretton Woods ski resort. Mesmerized skiers are temporarily distracted from temperatures that plunge toward 20 degrees below zero.

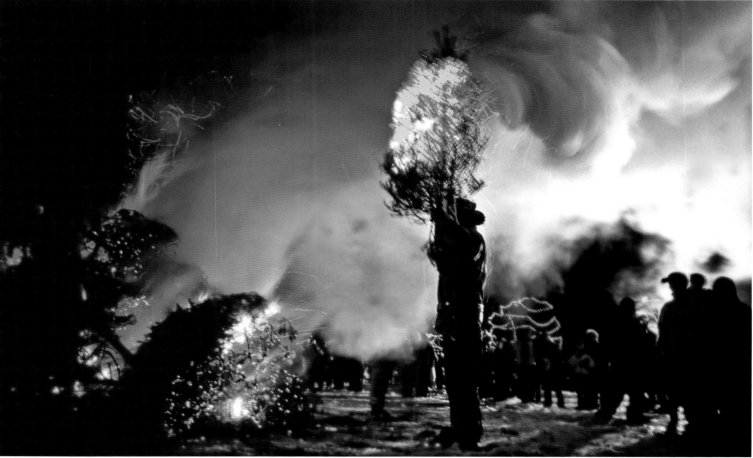

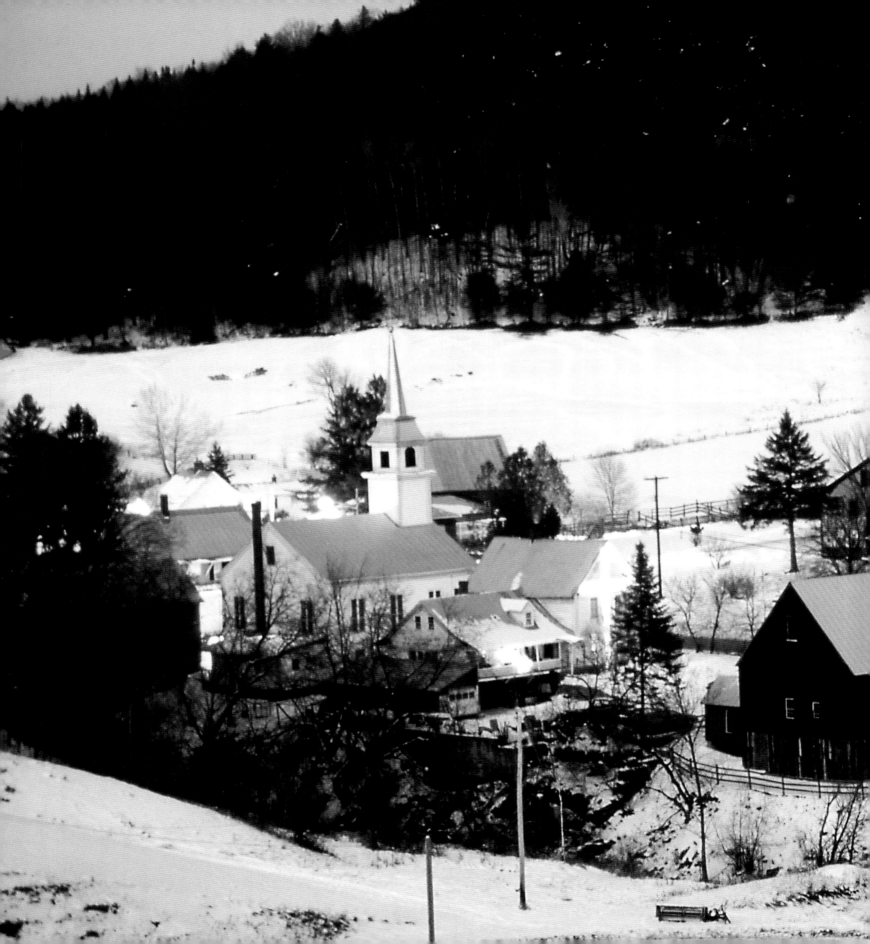

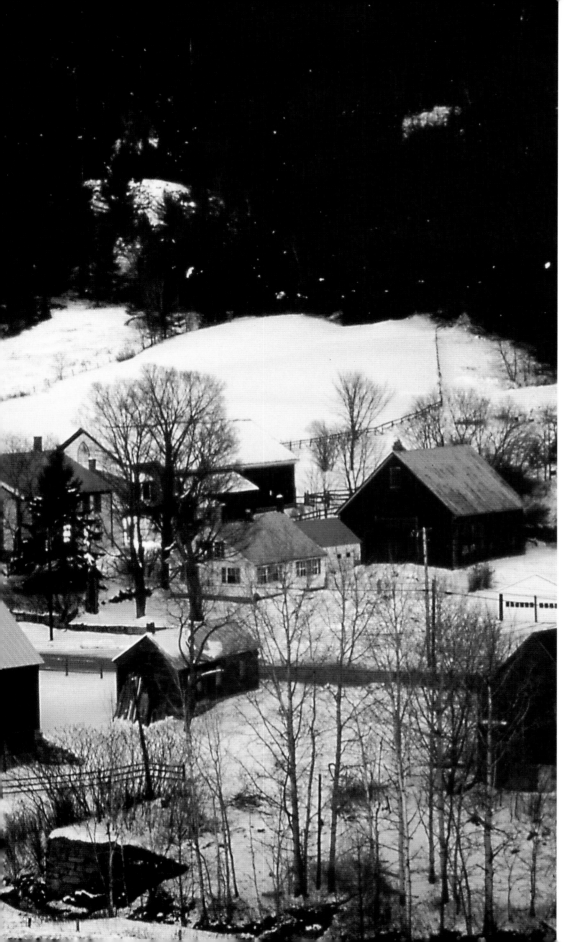

Near the edge of Vermont's North-east Kingdom, the classic hill town of East Corinth prepares for a long winter night. Its center sits quietly amongst dormant sheep pasture and, like all perfect New England villages, spreads from the shadow of its local skyscraper, the white-washed Congregational Church.

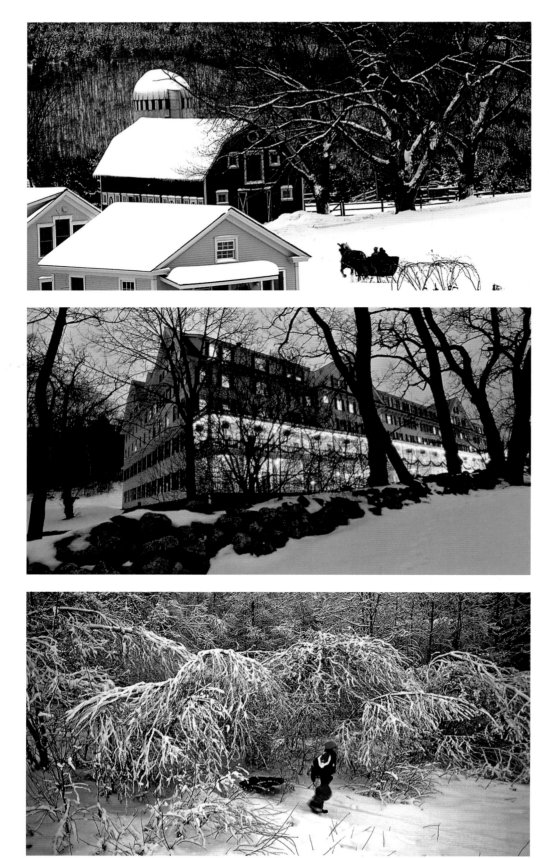

Beside Vermont's Wildflower Inn, open barn doors seem to beckon a hard working horse just returning from a day pulling travelers by sleigh along mountain ridges. Father and daughter (opposite) share a quiet moment on blades as dusk descends on East Burke, Vermont, behind the Wildflower Inn. The sky provides the last moments of natural light for the year as party preparations inside are underway to greet a brand new calendar.

In the heart of the White Mountains, the Eagle Mountain House (middle) and its blazing 280-foot-long wooden mezzanine has welcomed chilled skiers into Victorian charm since 1879.

One more run is in the offing as sled and owner are repositioning for yet another exhilarating descent through the North Woods of northern New Hampshire's winter wonderland (bottom).

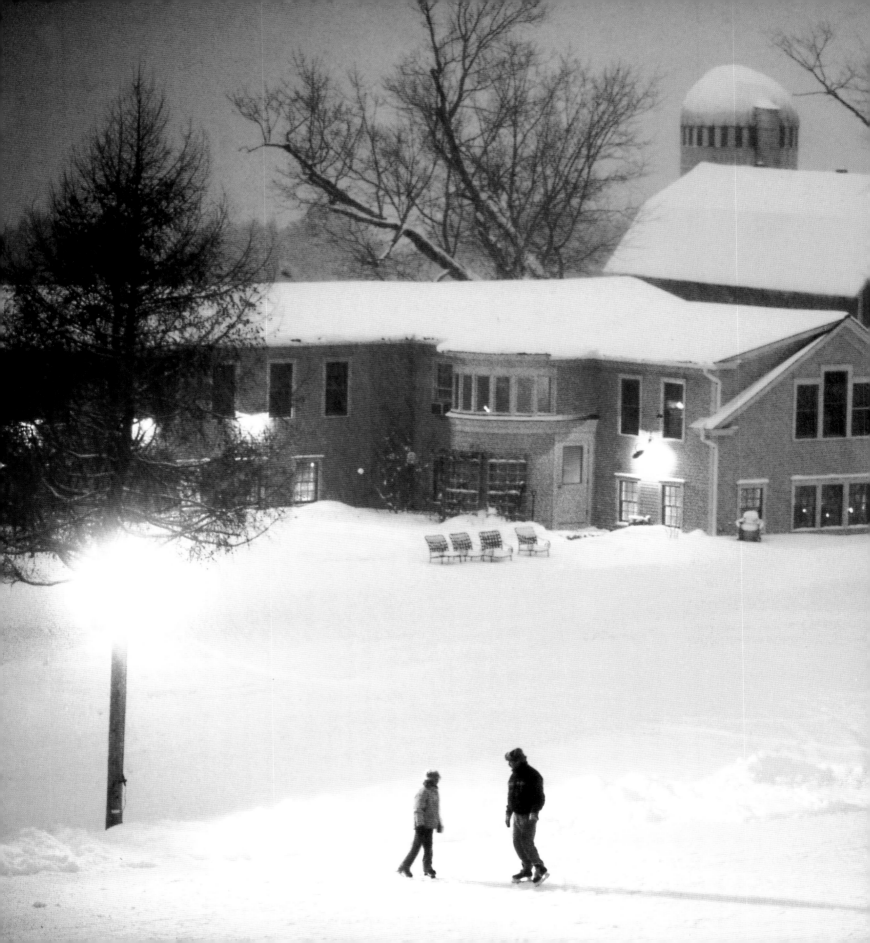

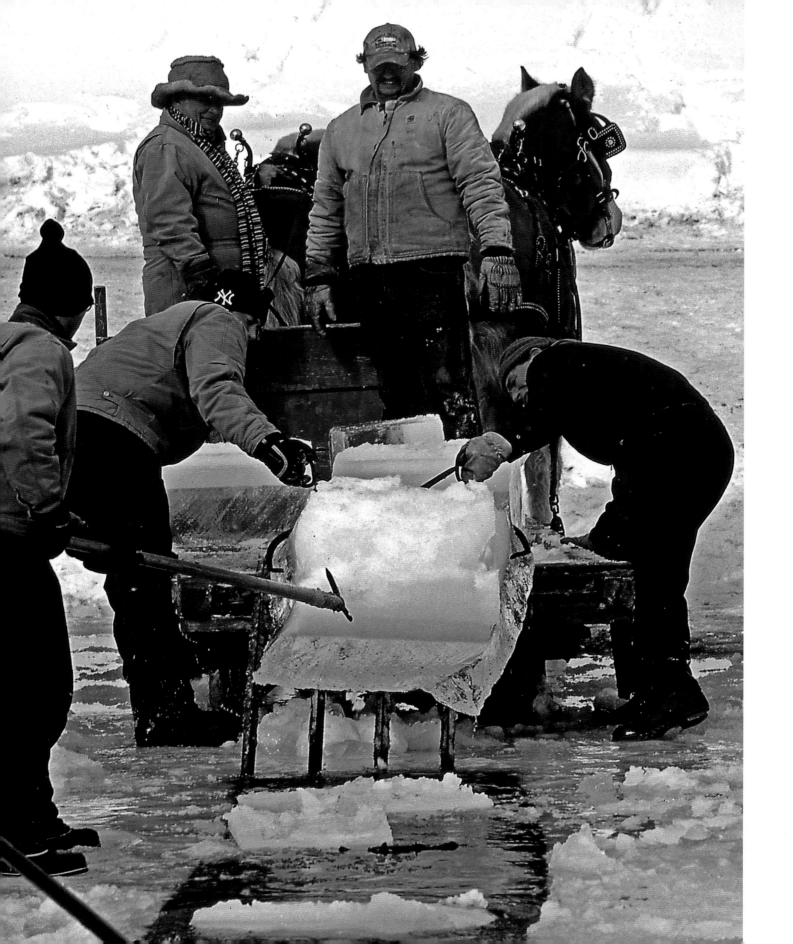

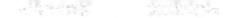

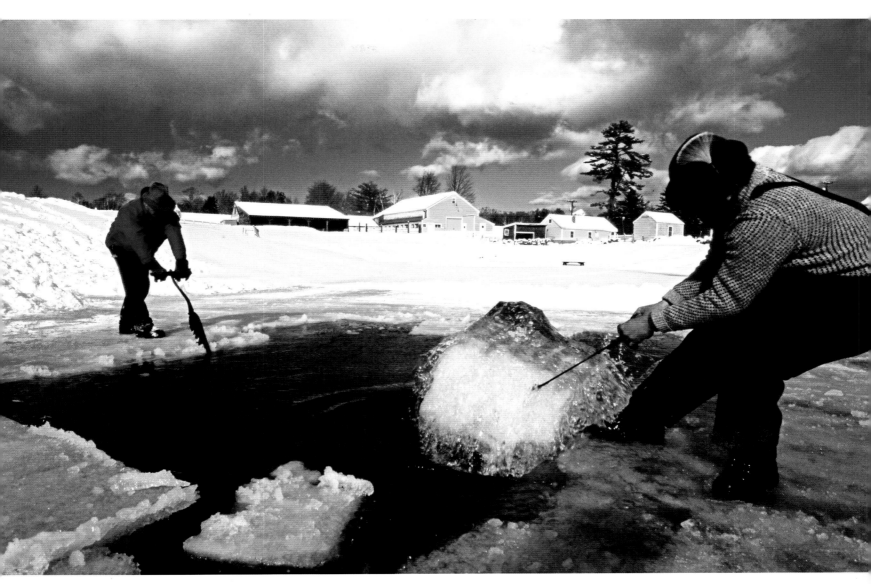

In a tradition unchanged for well over a century, the ice covering the lake at Millers Mills, New York, is dissected by saws and pike poles, then tong-loaded onto horse-drawn pickups for its journey to the village ice house. Insulated with sawdust, the frozen blocks will reemerge in early summer, to serve as a crucial ingredient for strawberry ice cream served at the church social (opposite).

Backs strain as saws grind and chunks are hoisted during an ice harvesting at the mill pond in Tamworth, New Hampshire. Like a fly in amber, the distant flaxen farmstead remains a perfectly preserved specimen, a vibrant witness to the rich rural heritage of the region.

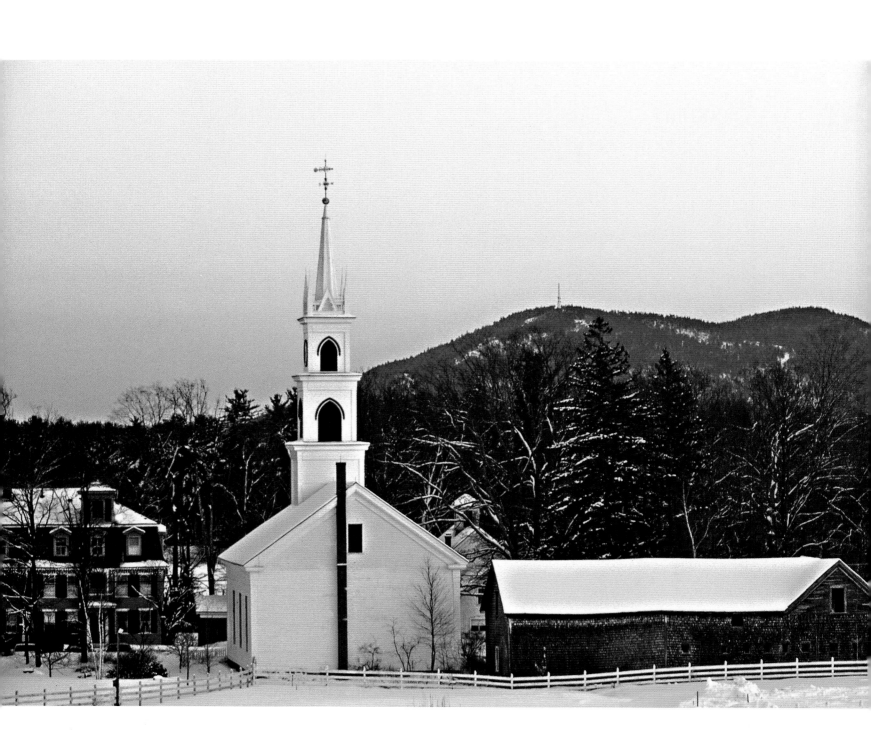

Beneath a pastel atmosphere, in the shadows of Mount Chocorua, the skyline of downtown Tamworth is dominated by a weathervaned belfry in a village of two shops and a classic inn.

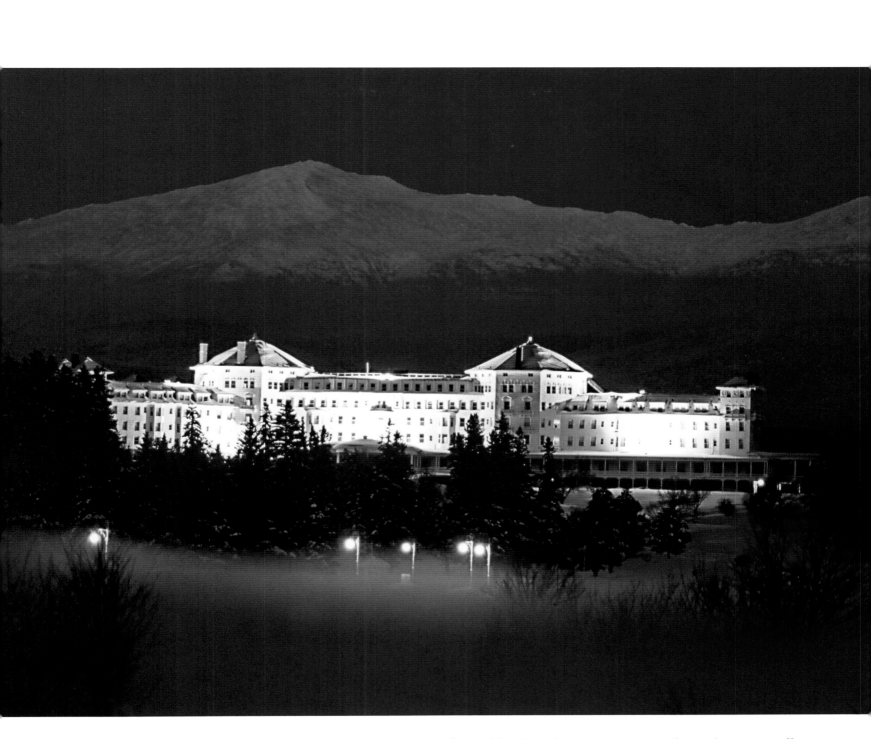

An imposing mirage of grand hotel architecture seems to hover between valley
fog and the usually hidden peak of Mount Washington, where the world's
highest recorded wind speeds have occurred.

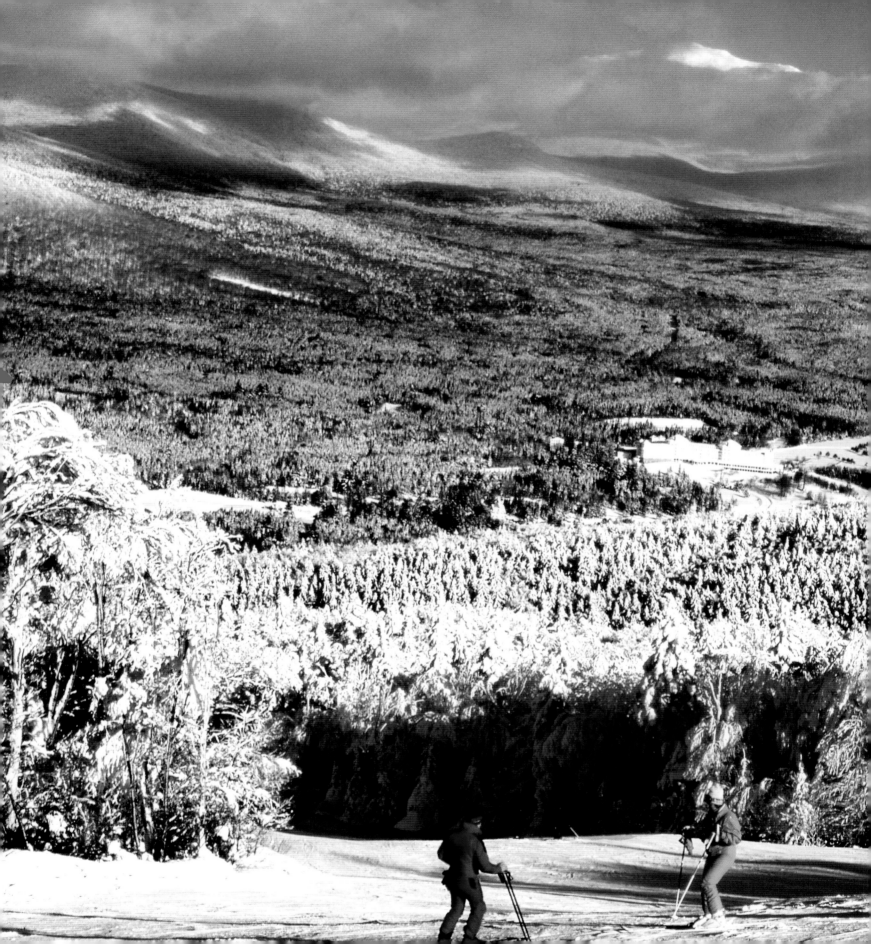

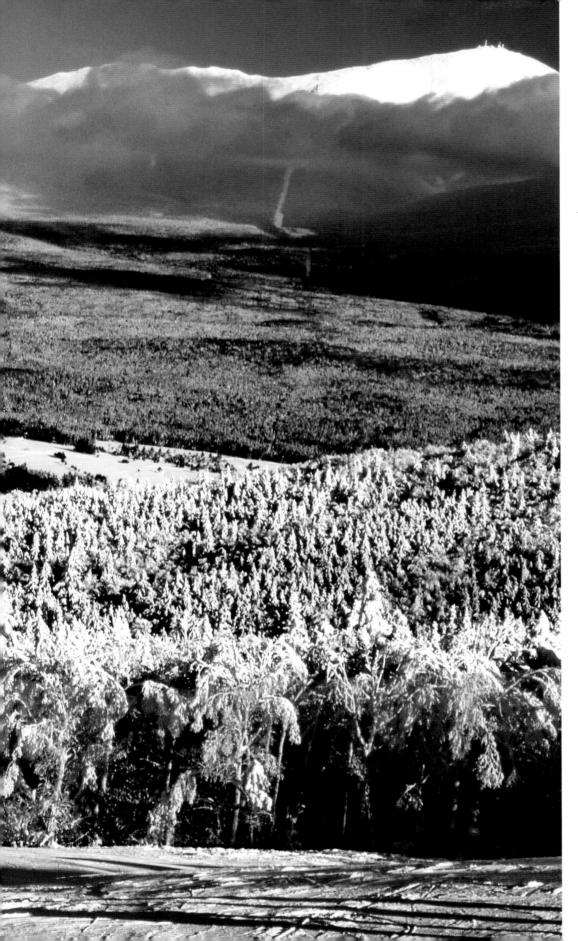

Skiers drink in the astonishing frosted scenery of the Mount Washington Valley, where even sprawling grand hotels are swallowed up in the vastness of the Presidential Range.

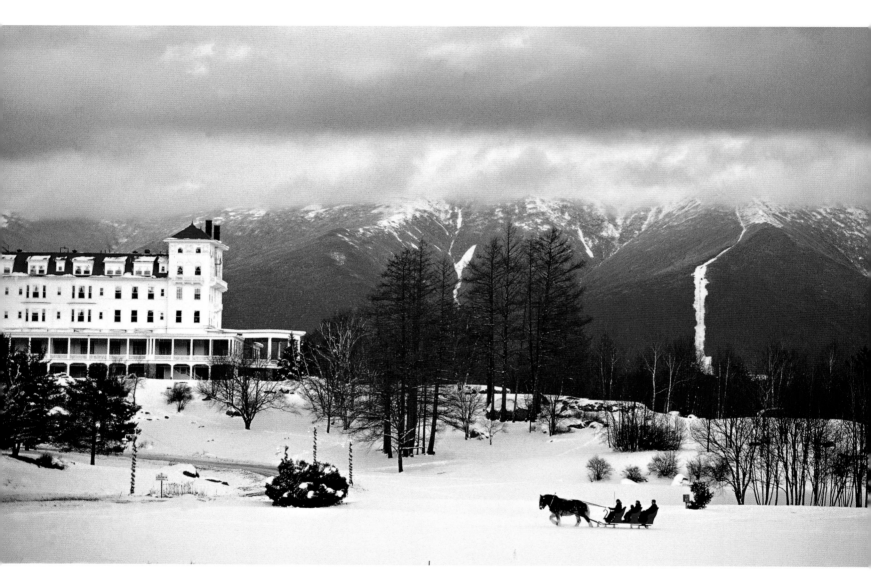

Returning to the commanding Mount Washington Hotel, a Clydesdale-pulled sleigh prepares to drop its passengers into the elegant sanctum that has hosted three presidents since its doors first opened in 1902.

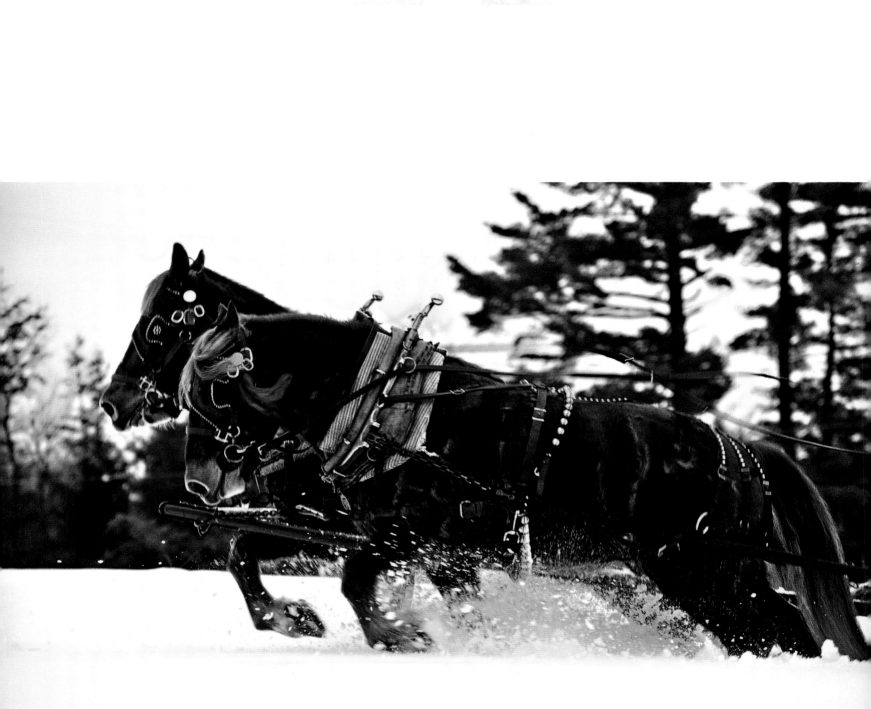

Bulldozing through the drifts, the hooves of the rare Suffolk Punch shower snow across the ivory meadows of central Vermont.

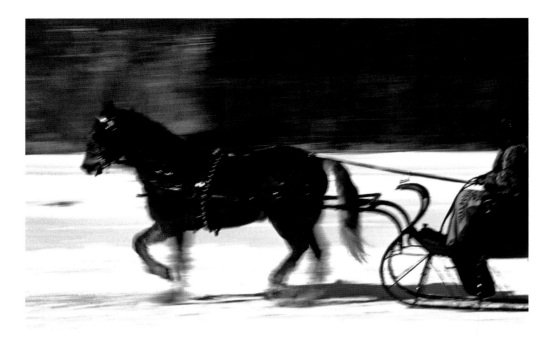

With not a moment to lose, a one-horse open sleigh zooms across a Currier and Ives landscape during a competitive sleigh rally (left). A gentle snowfall softens the chill as mare and driver take a break in the open fields near New Hampshire's Franconia Inn (below).

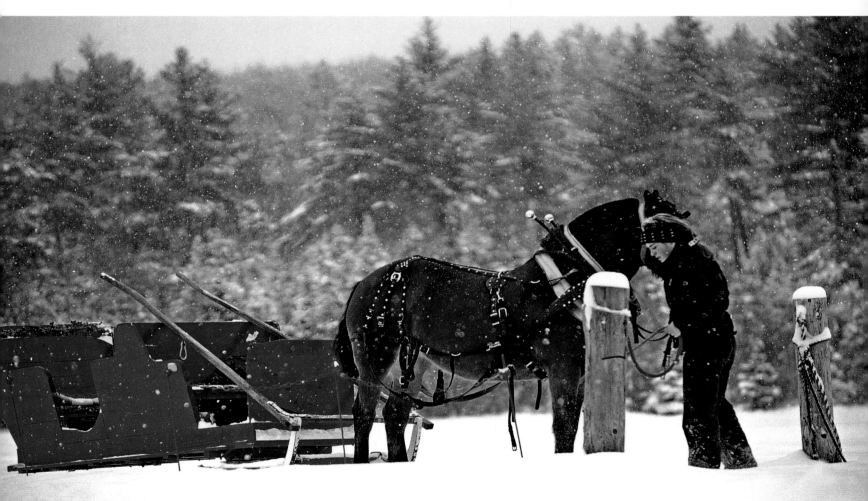

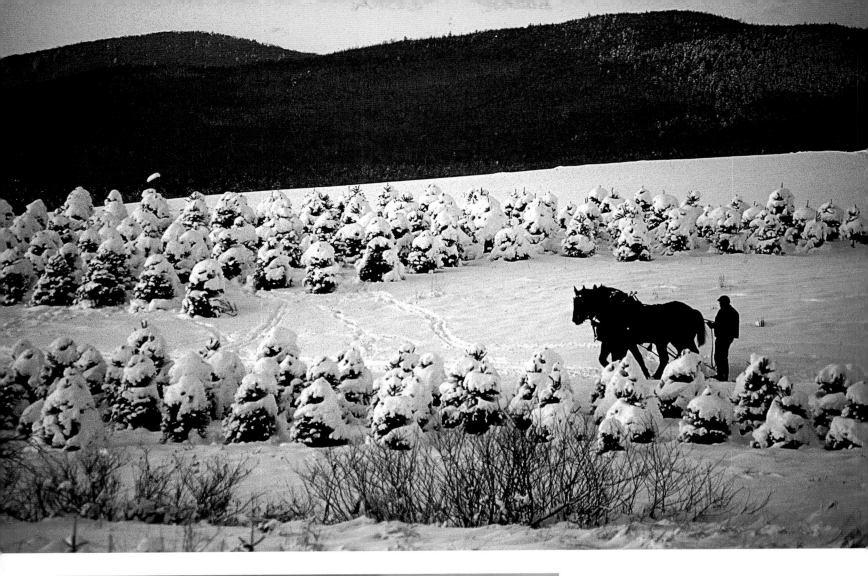

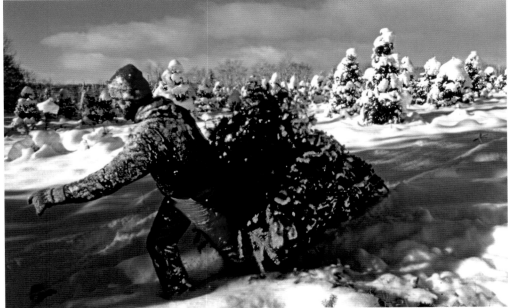

After a day in the fields hauling trees, a weary trio returns to the stables as the sky loosens its last grip on rosy daylight. In the early part of the last century, horses served as the primary station wagon for the transport of Christmas trees (left). With the confident stride of a hunter having bagged his prey, a snow-dusted woodsman hauls the perfect evergreen away, leaving behind a healthy inventory of rejects. The Rocks Estate in northern New Hampshire serves area families with a seasonal field of dreams (above).

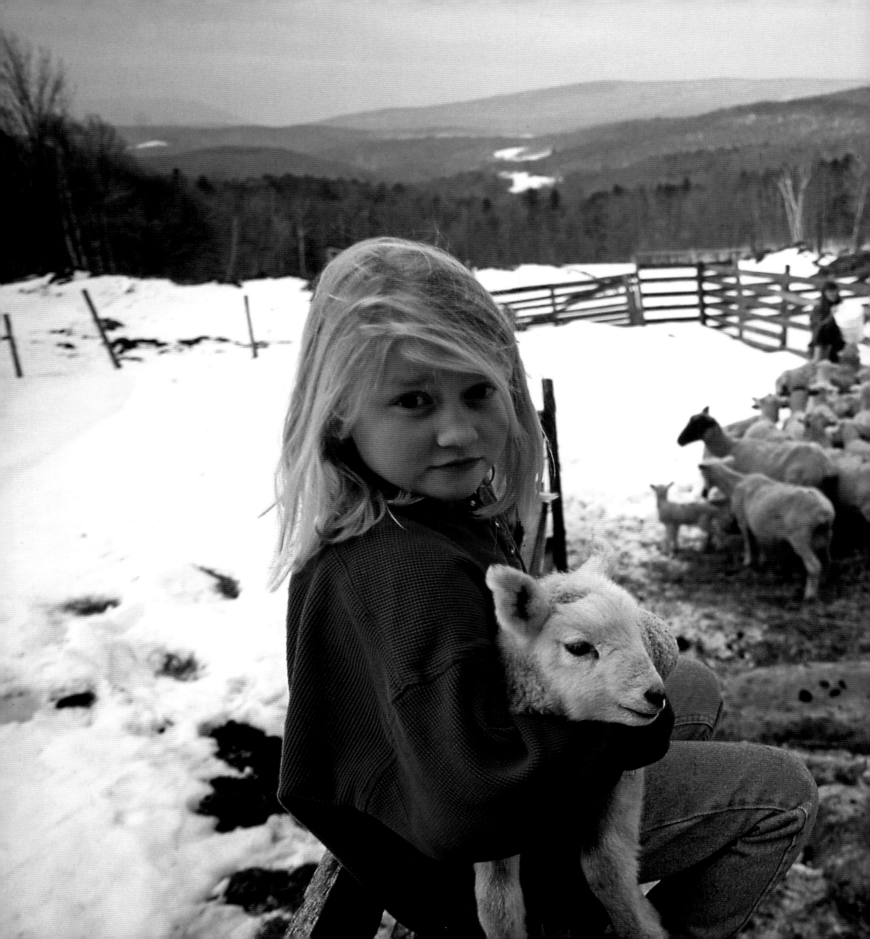

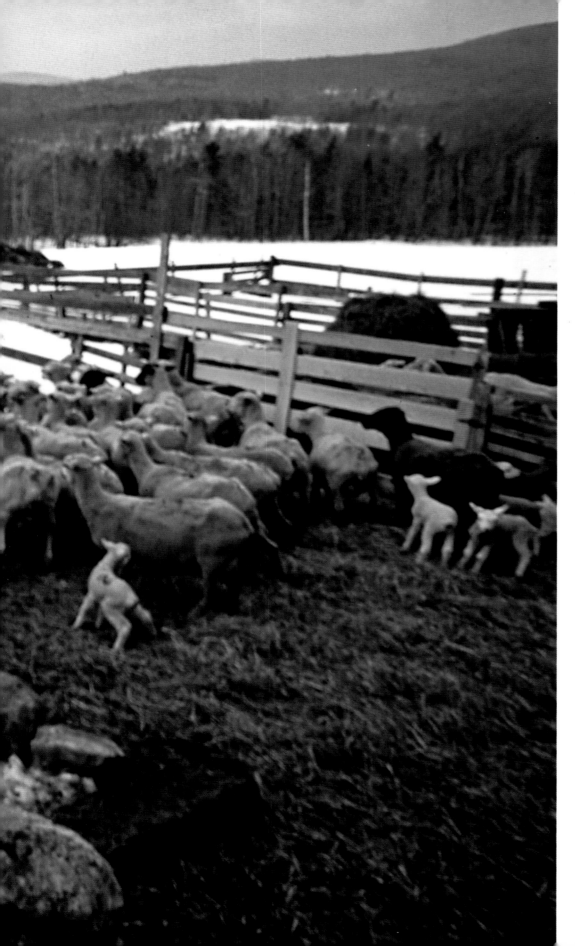

Arm in arm, the innocent youth of two different species seem to enjoy the break for feeding time amongst the lambs that reside at this farm in the Green Mountains near Ludlow, Vermont. The lambing season may begin around Christmas as ewes make their first drop-off.

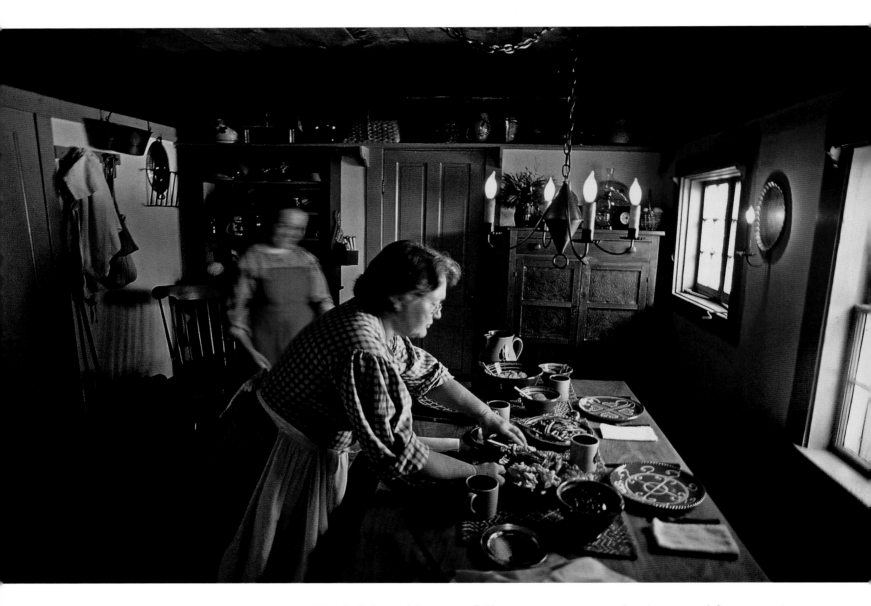

The holiday table is carefully set amongst a smoky time travel fragrance in the teeny Farm at Frost Corner near Wolfeboro, New Hampshire. Turkey is roasted by the hearth in a rural eighteenth century farmhouse where a parade of colonial recipes accumulate before a final serving of Marlboro pie.

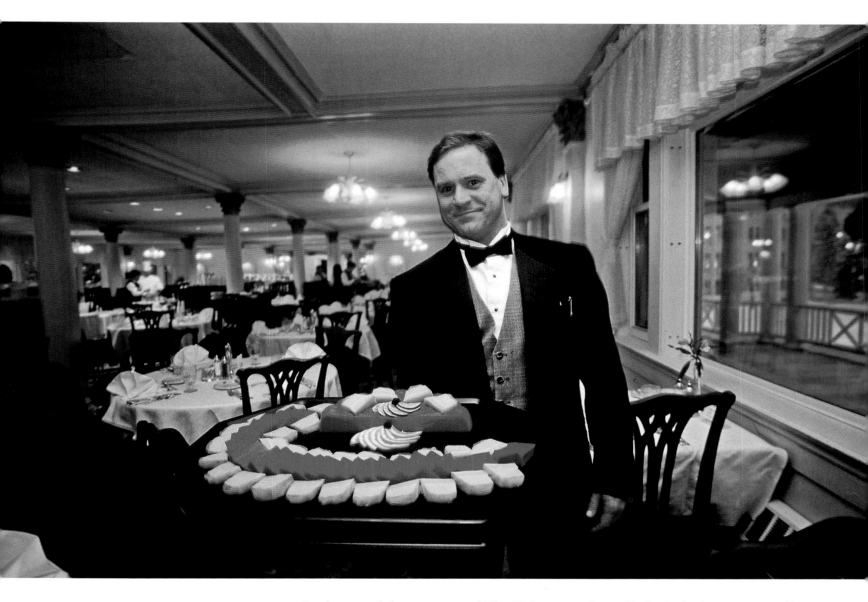

In the grand dining room of The Balsams, a formally-bedecked waiter proudly displays an elegant dessert tray beautifully patterned with cotton candy colors. The resort lies beneath a dramatic mountain cleft a mere snowball's throw from the Canadian border.

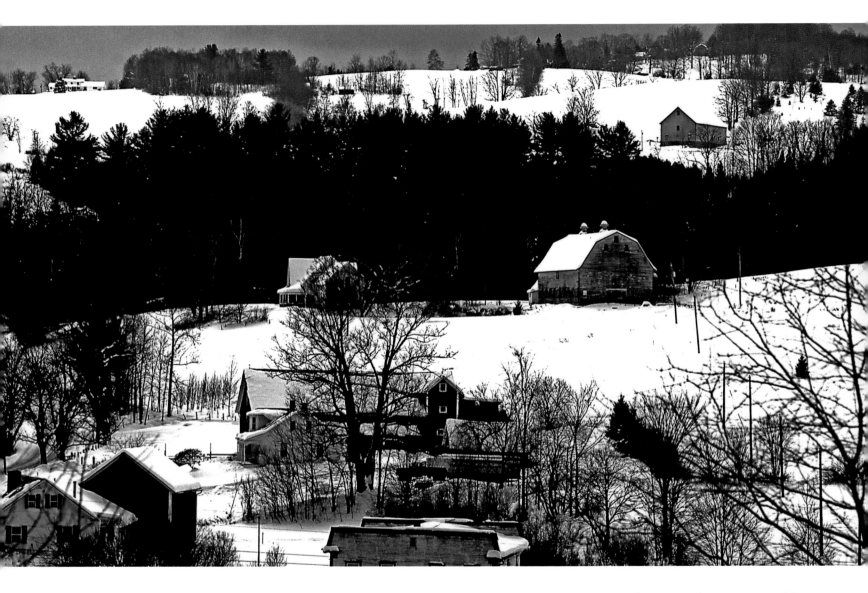

Soon after winds retire the last deciduous leaves, the monochromatic world of winter descends on a Vermont hill town. The tranquil village of Peacham displays its many farmsteads amongst the cascading folds of rural hillside.

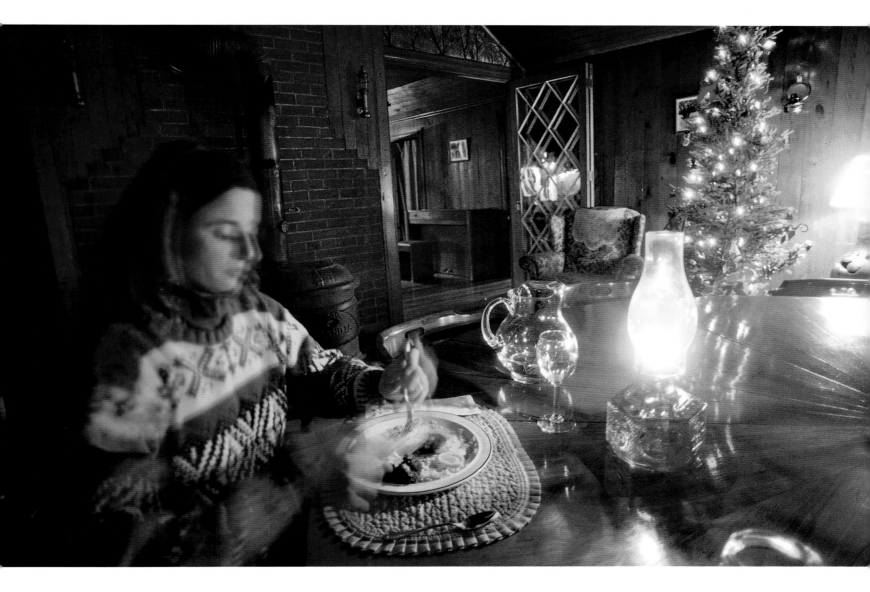

The glow of kerosene lanterns lights dinner on an antique cherry wood table at the handcrafted Telemark Inn near Bethel, Maine. Built at the turn of the last century, the inn serves as a cozy base for llama trekking through the surrounding pine-covered wilderness.

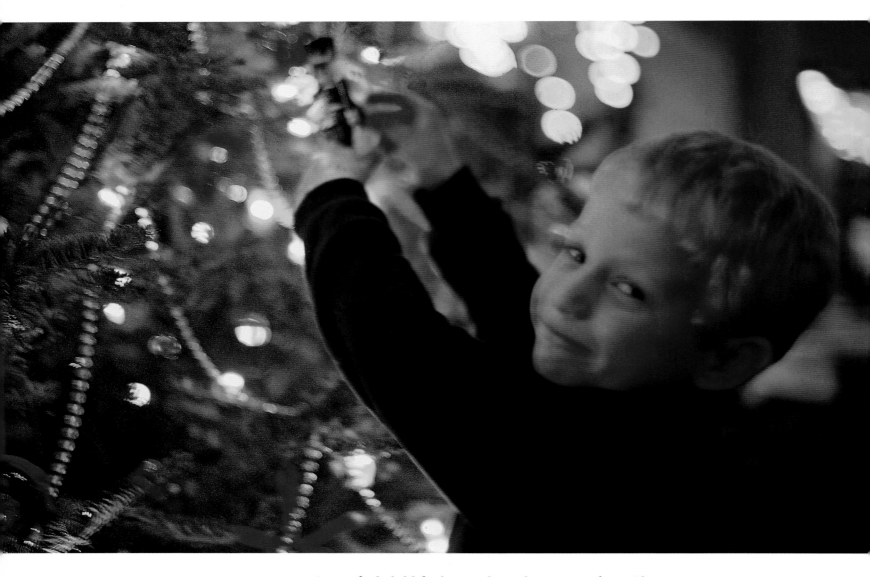

A satisfied child finds just the right position for a Christmas tree ornament. These arboreal amulets were first introduced into America by German immigrants in the mid nineteenth century, but only exploded in popularity a half century later when introduced by F.W. Woolworth of five and dime fame.

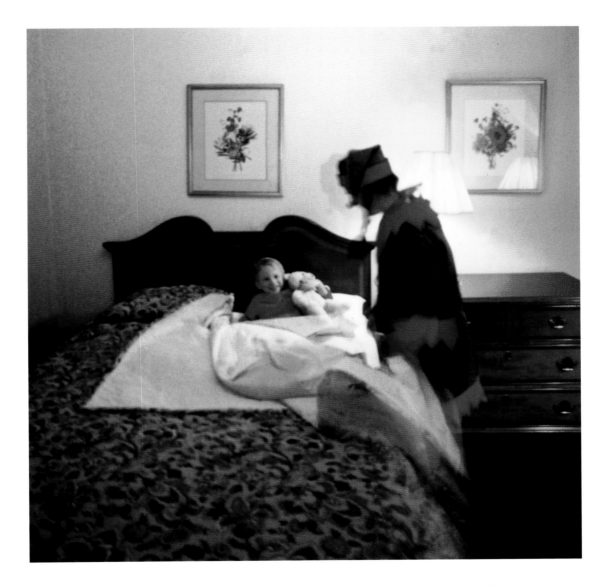

Clutching his teddy bear, this young boy receives additional assistance for a night of sweet dreams with a personal send off by one of Santa's elves. The grand Mount Washington Hotel provides children this holiday Elf Tuck-in and bedtime story service to help facilitate a smoother visit by clandestine Santas.

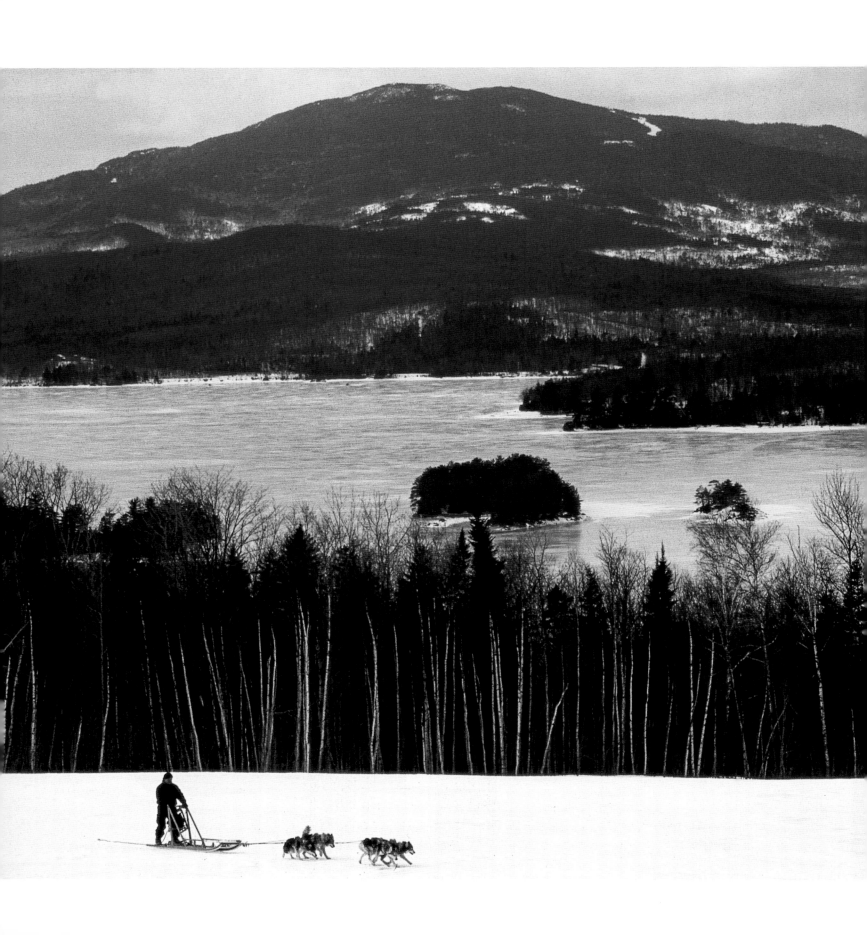

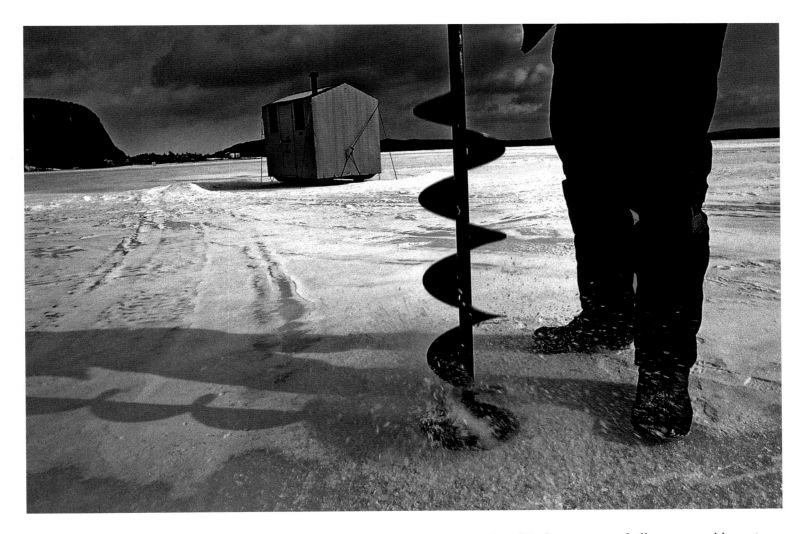

A new neighbor arrives on Moosehead Lake as auger drill meets stubborn ice and foretells the location of an additional ice shanty. In the shadows of Mount Kineo, heated fishing huts require at least four inches of ice to safely support a big dose of patience and its owner, who may sit for hours jigging for fish (above).

On Moosehead Lake, islets are accessible by foot as nosediving temperatures solidify their surroundings and provide the frigid backdrop for a lone musher attempting to control his dogsled team (opposite).

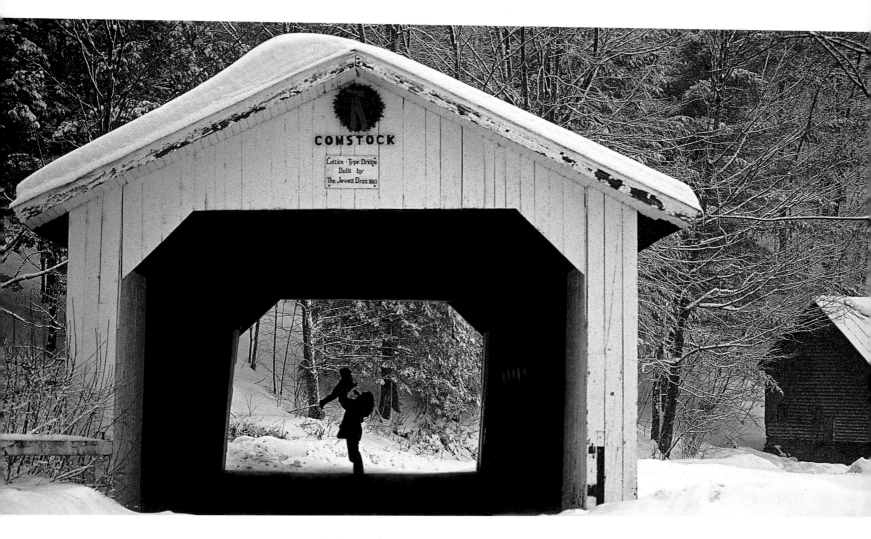

Sheltered from falling snow, a mom and child enjoy a moment of warmth beneath the lattice woodwork of a covered bridge near Montgomery, Vermont. "Kissing bridges" were built by thrifty Yankees to save money on foundation replacement and to serve as blinders for horses too skittish to cross the river.

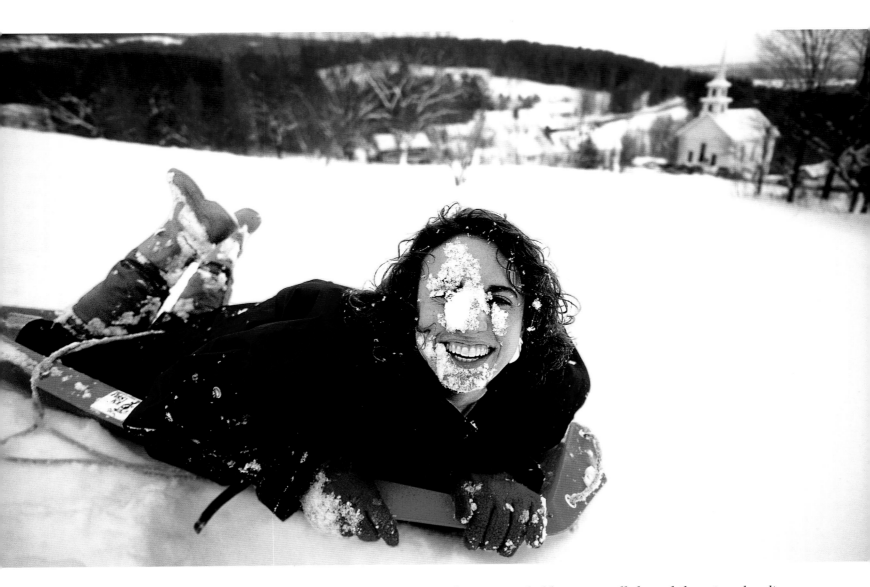

Happily sampling the frosting, a sledder tastes all the exhilaration the slippery descent provides. Caught en route between the Rabbit Hill Inn and the skyline of Lower Waterford, this plastic rapid transit system of northern Vermont works with an astonishing efficiency on snowbound days.

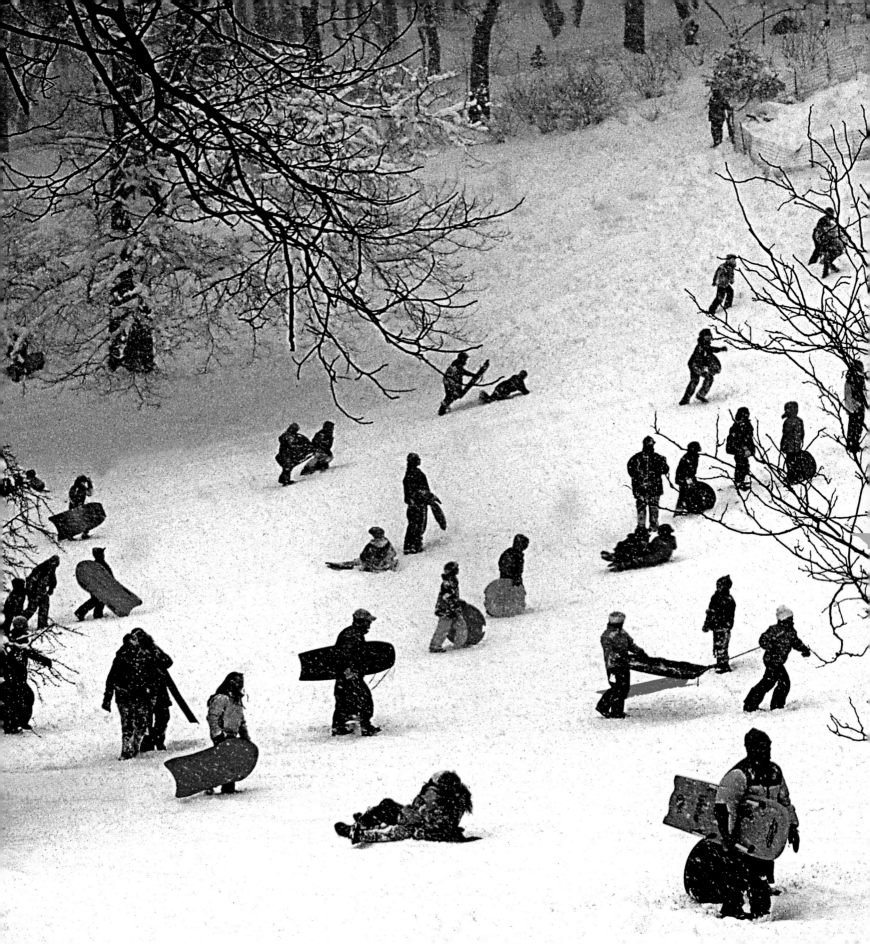

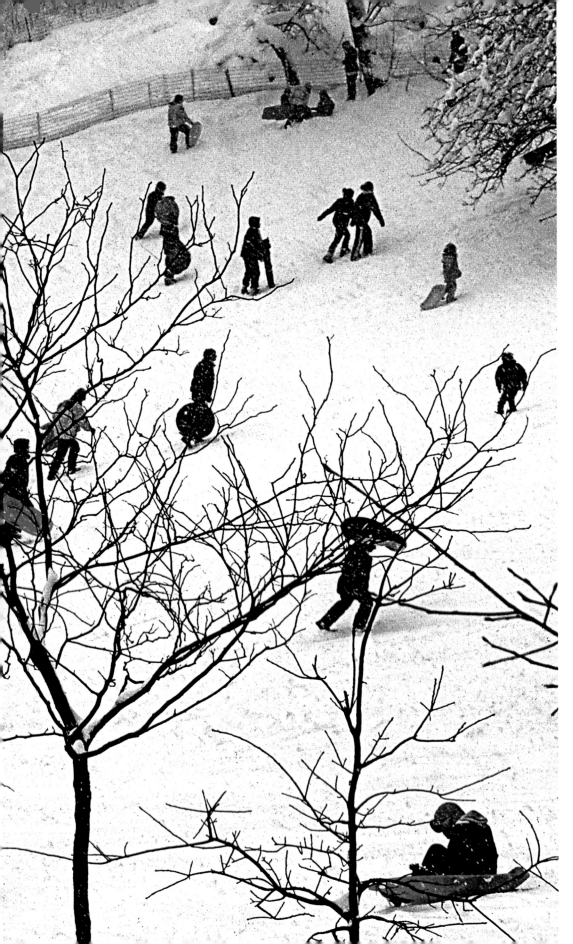

A roaring blizzard makes miniature Grandma Moses figures out of children enthralled with record-breaking accumulations on a Riverside Park slope in Manhattan.

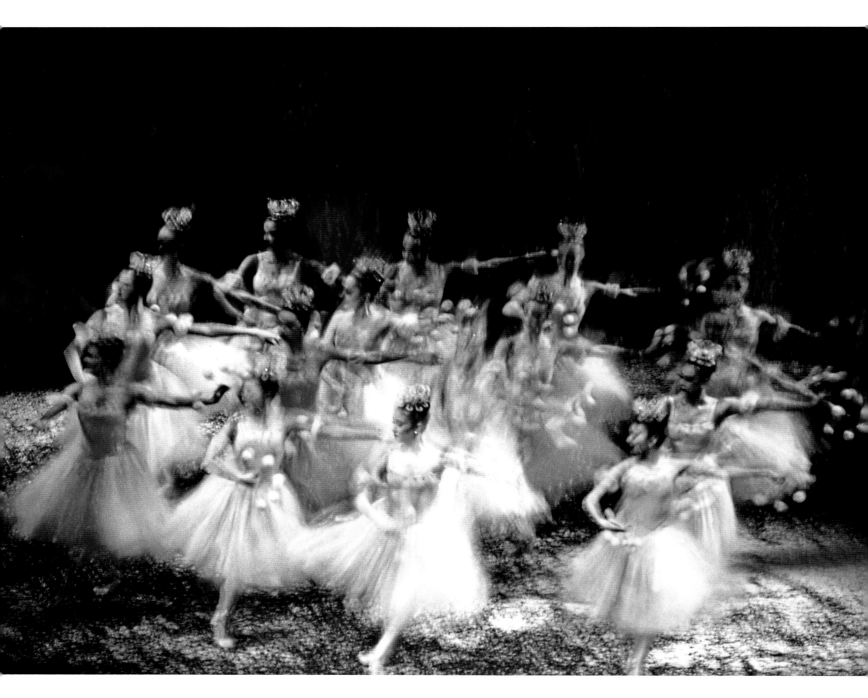

Like chalked figures from a Degas sketch, the Sugar Plum Fairies prance to a Tchaikovsky lullaby amongst a backstage snowstorm. The acclaimed Lincoln Center production of the Nutcracker Suite is a theatrical highlight for holiday visitors.

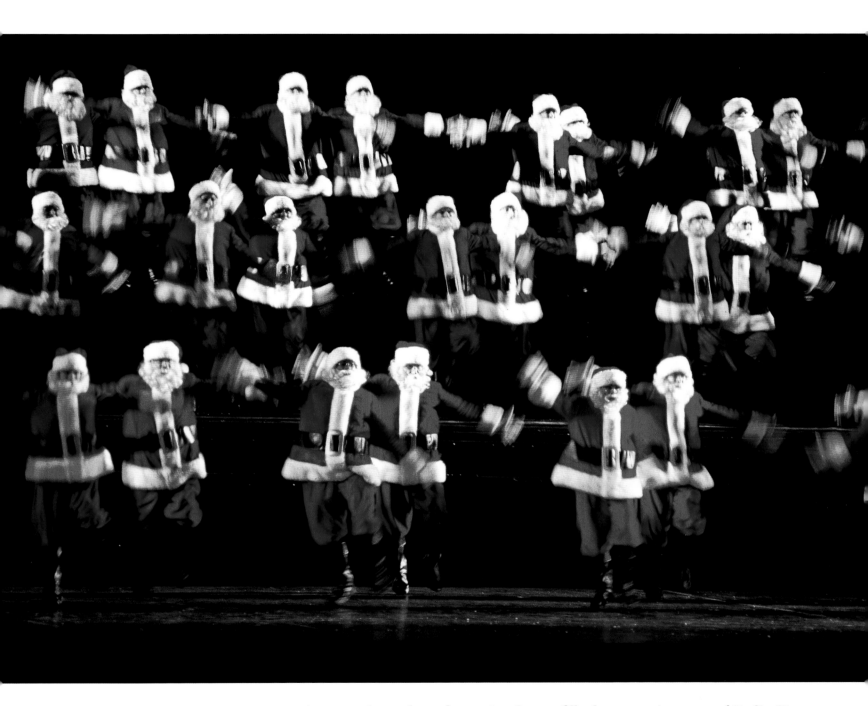

A joyous chorus line of prancing Santas fills the expansive stage of Radio City Music Hall during their annual extravaganza.

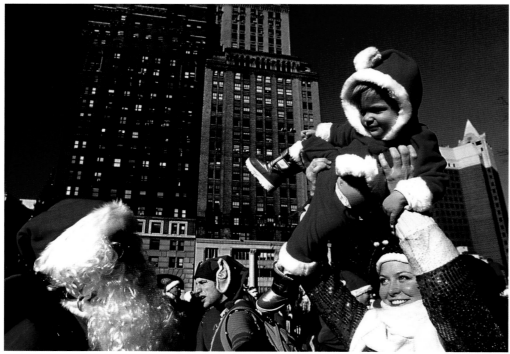

Lifting the spirits of a skeptical city, Santas assemble in downtown Brooklyn for an annual red-capped revelry that proceeds across the boroughs during an all-day fling. The Santacon event stuns unsuspecting bystanders into a premature holiday spirit and explodes in the heart of Central Park.

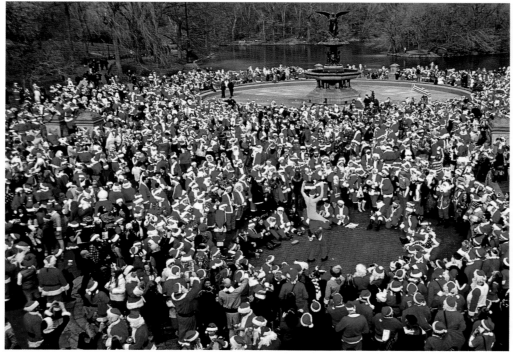

Coming to town not through the chimneys, but rather through the cobwebbed cables of the Brooklyn Bridge, an army of Santas will make their annual Santacon spree an occasion to remember.

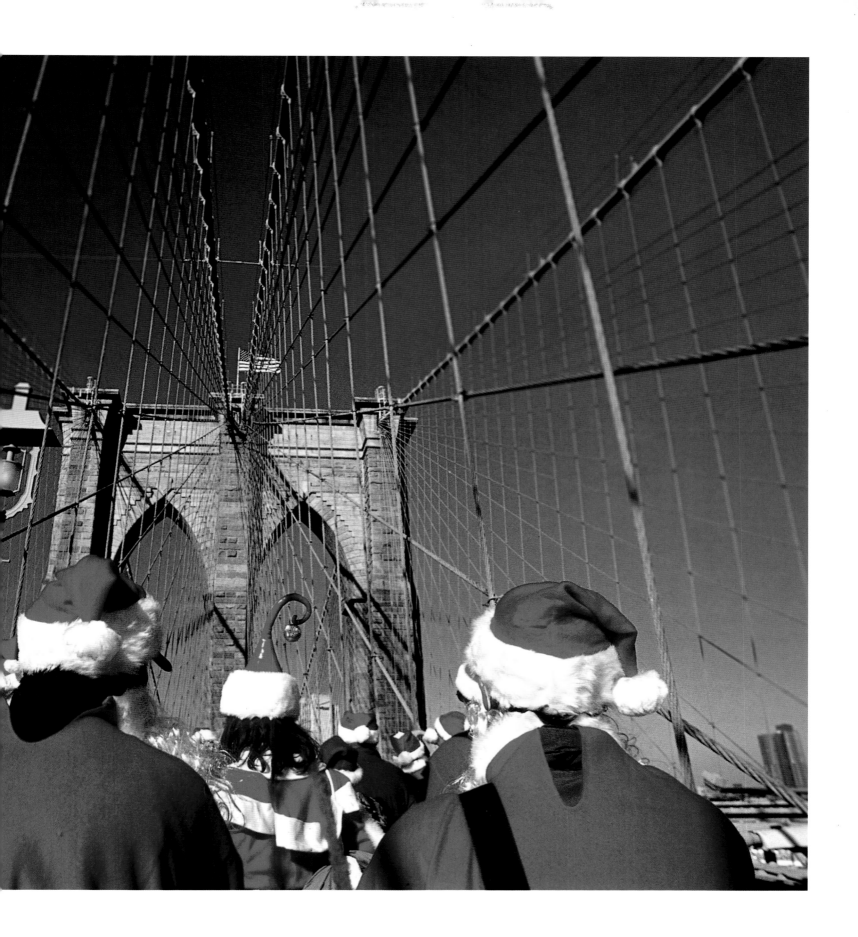

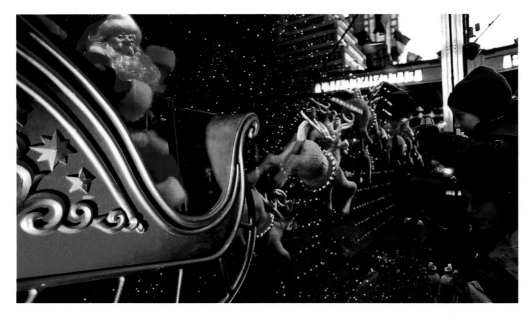

Santa acknowledges an appreciative crowd counting the reindeer flying through Bloomingdale's Christmas windows. Children and parents alike are enthralled by the glassed pageantry that create compelling sidewalk theater throughout midtown Manhattan.

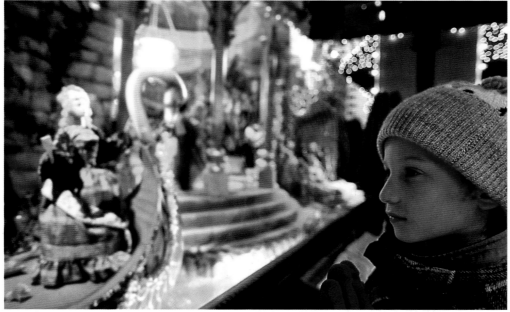

Like a ship in a bottle, the intricate Christmas fantasies staged in department store windows provide a mesmerizing subject of study for children of all ages.

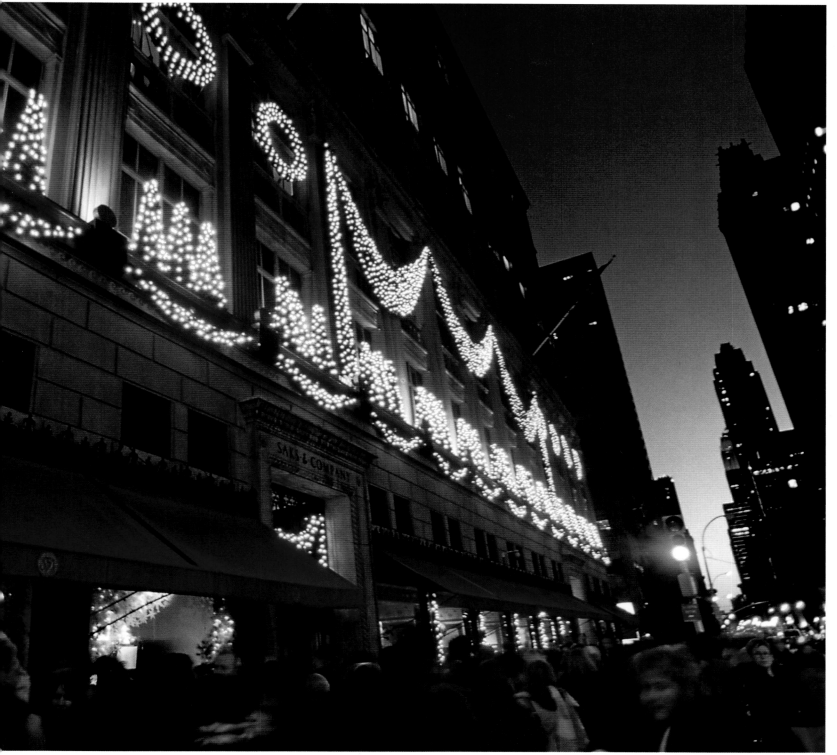

Beneath a dazzling splash of golden lights and lavender skies, frenzied shoppers scurry down Fifth Avenue for last-minute items, hoping that Saks will fill the final gaps on their shopping wish list.

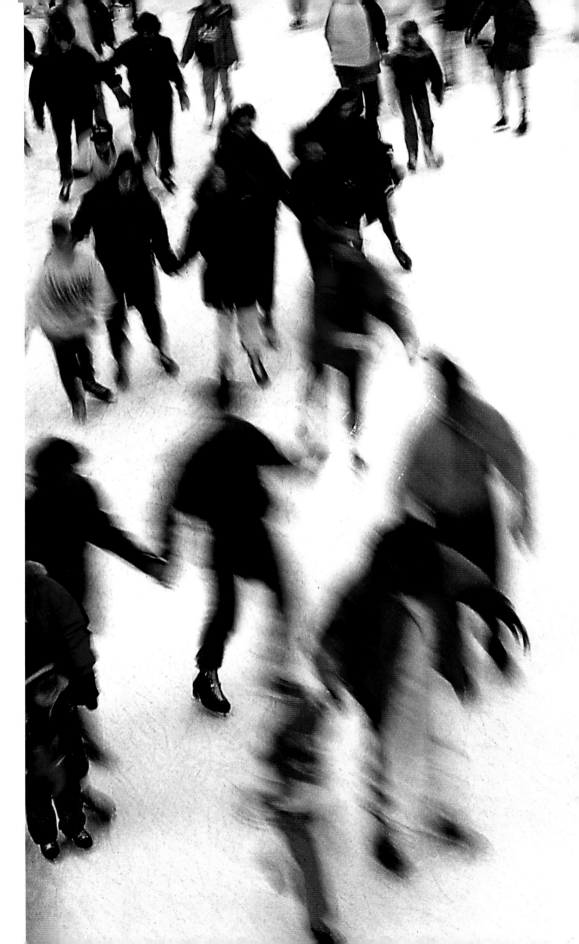

Rockefeller Center's famed ice rink, wedged within the skyscraper canyons of midtown Manhattan, swirls with a graceful carousel of humanity. Bladed visitors keep time to holiday music as they take a break from the hectic shopping season.

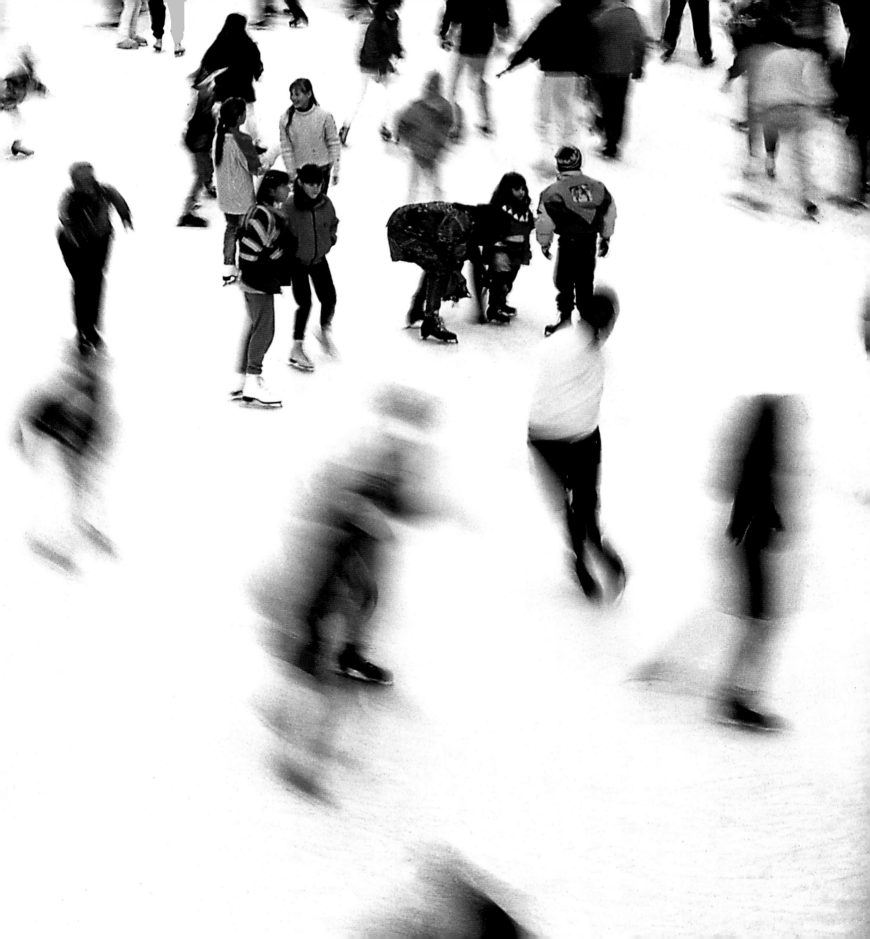

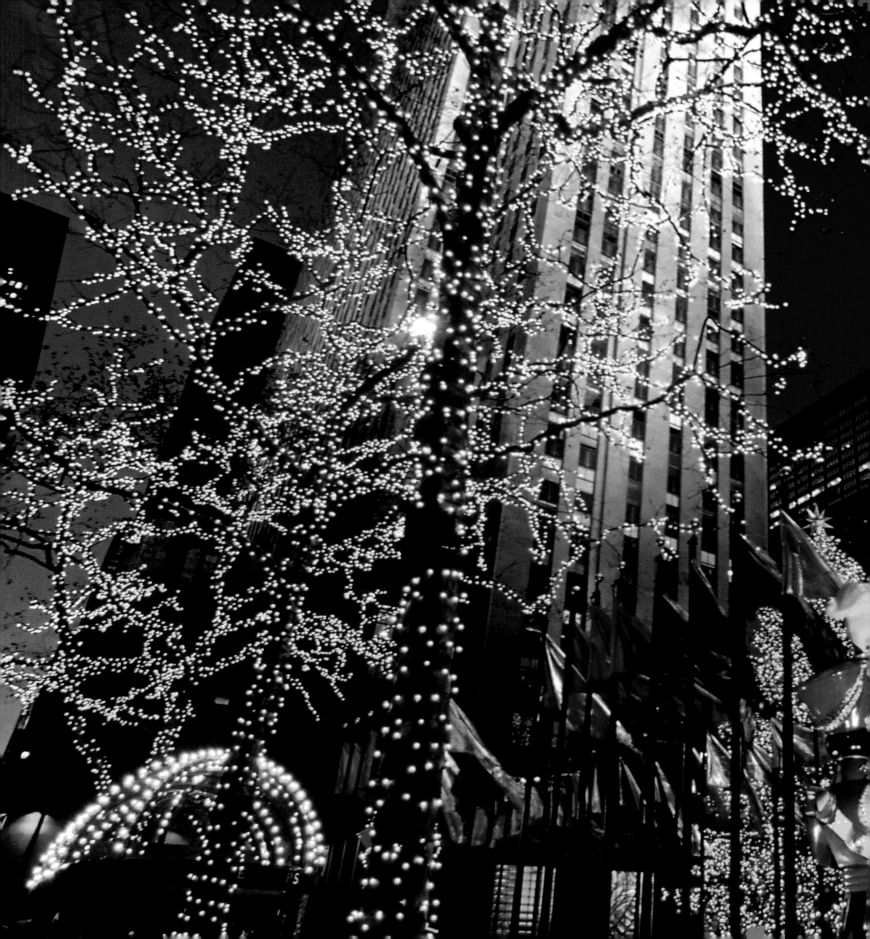

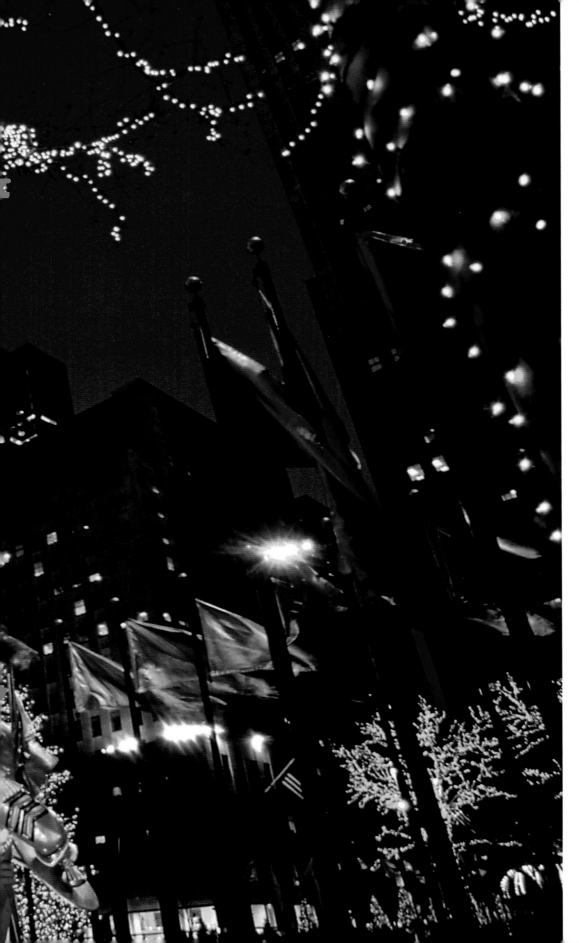

Shiny flags flutter to the rhythm of bugles blowing at the Rockefeller Center rink where a tree's 25,000 multicolored 7.5 watt bulbs illuminate skaters down below.

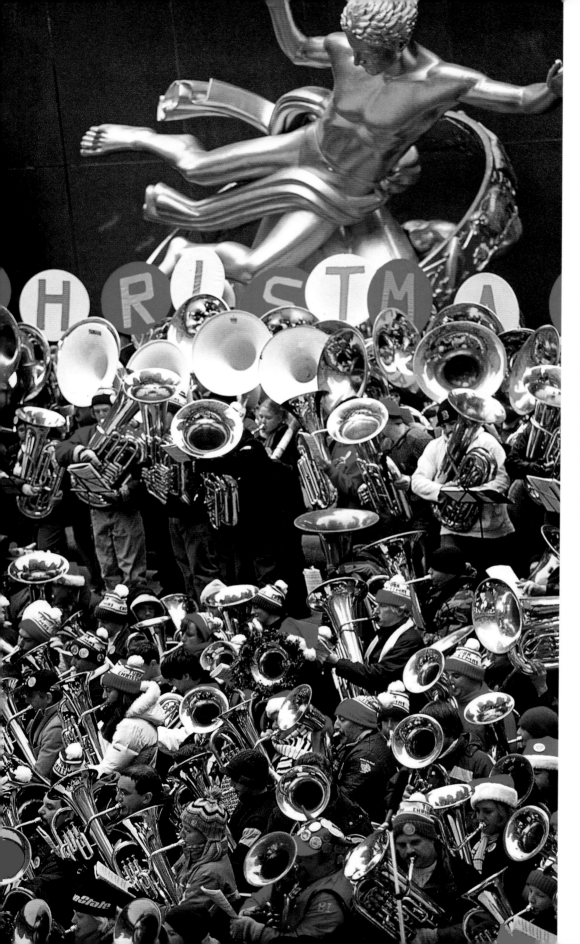

The gilded statue of Prometheus seems jarred by the baritone cacophony emanating from a sea of tubas and euphoniums performing a specially orchestrated repertoire of Christmas tunes (left). Their Rockefeller Center venue provided the first Tuba Christmas concert that began a tradition in 1974. The Center's Christmas tree, a Norwegian spruce, towers over cheering spectators moments before its 25,000 multicolored 7.5 watt bulbs spring into action and announce New York's official commencement of the holiday season. Five miles of electrical wiring are required to bring the celebrated tree to life (right).

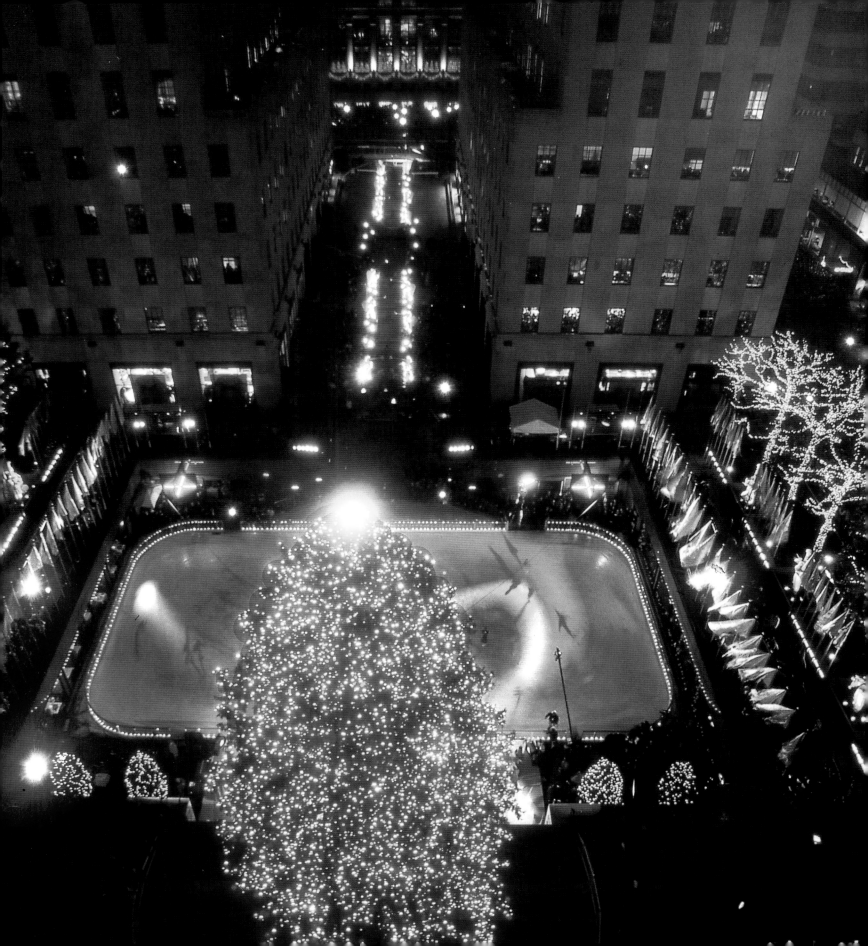

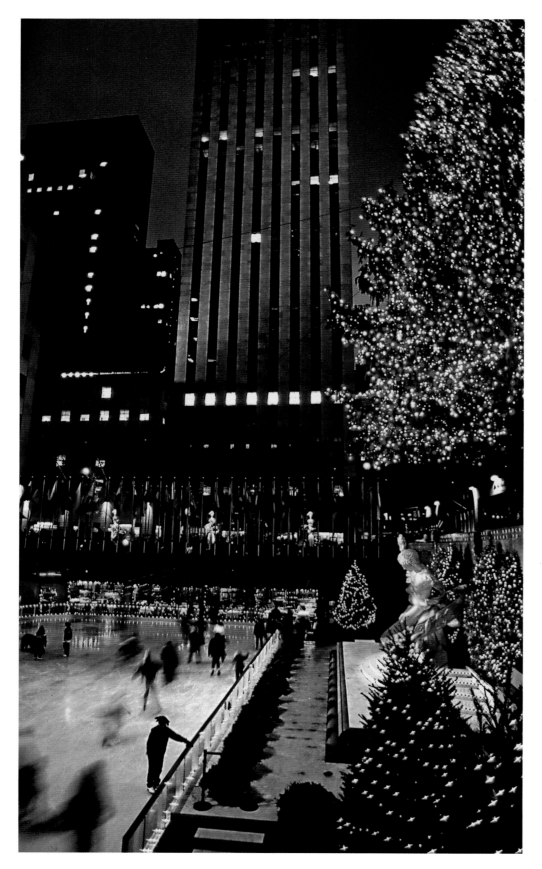

Rockefeller Center's famed Christmas tree provides an intermission for fatigued shoppers and towers over a diverse spectrum of skills exhibited on ice skates below.

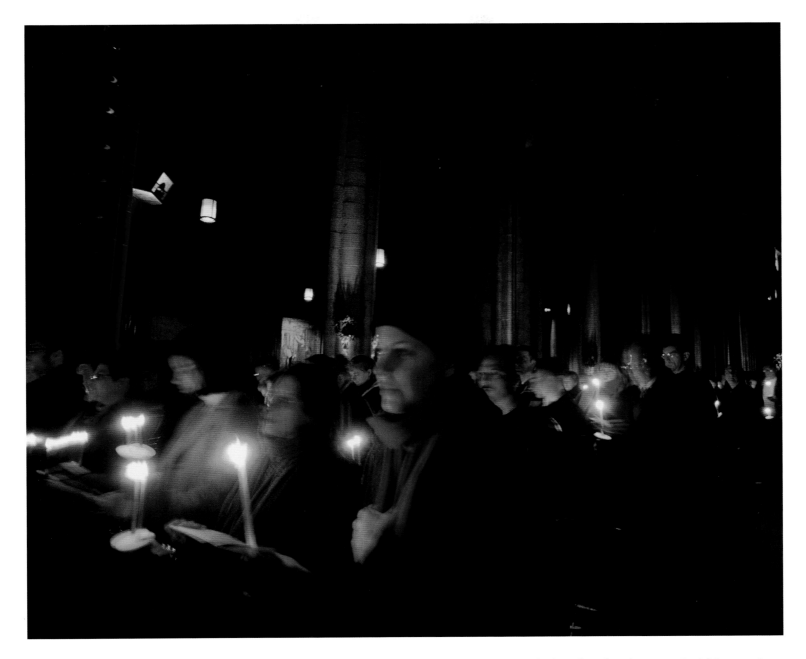

Worshippers are set aglow by the candlelight of midnight mass held beneath the soaring Gothic columns of St. John the Divine. Though its cornerstone was laid in 1892, the largest cathedral in the world, with a nave stretching two football fields and a seating capacity of 5,000, is still a work in progress.

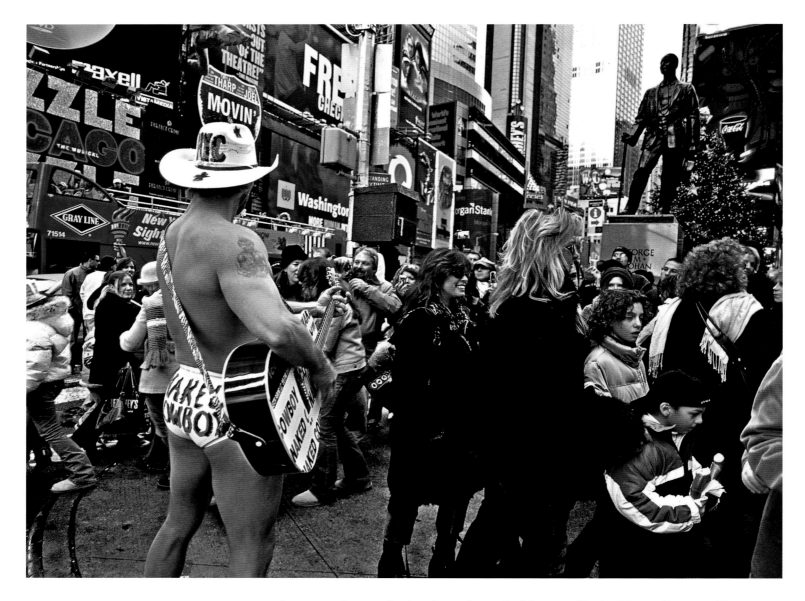

Amongst the razzle dazzle and snarl of foot traffic in Times Square, Christmas shoppers give nary a glance to the Naked Cowboy strumming his stuff. A fixture commonly found revealing his talents to oncoming hordes, he keeps George M. Cohan company as he continues to give his regards to Broadway.

A brilliantly bejeweled constellation of twinkling lights coat the bare winter trees as dusk grows in the garden outside Central Park's Tavern on the Green.

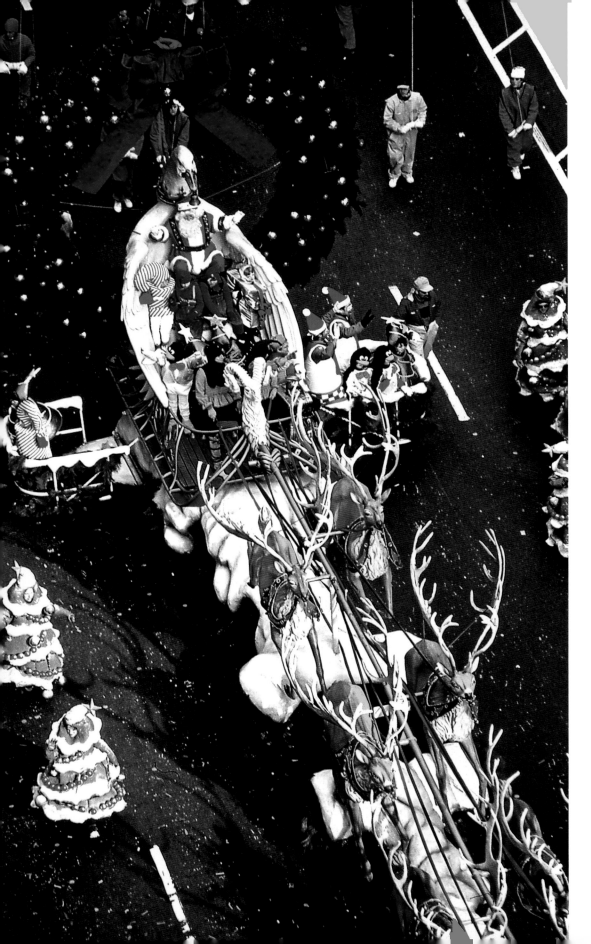

Pulled by a plastic herd of reindeer, a baronial Santa Claus shares the sleigh with his elves as an escort of delighted Christmas trees marshal their path down Broadway during the New York finale of Macy's Thanksgiving Day Parade (left).

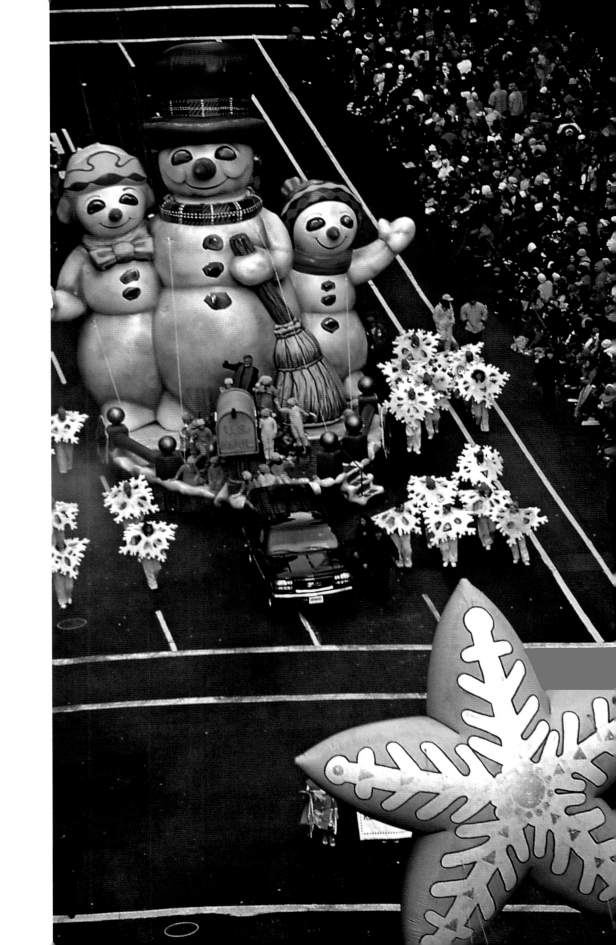

Dancing snowflakes and an inflated family of Brobdingnagian snowmen acknowledge throngs of bundled spectators who have put their turkey on hold to gaze in astonishment at holiday icons (right).

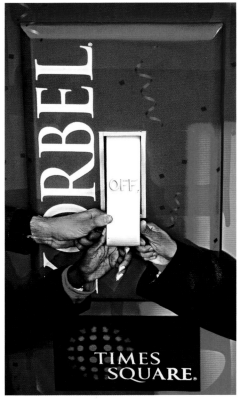

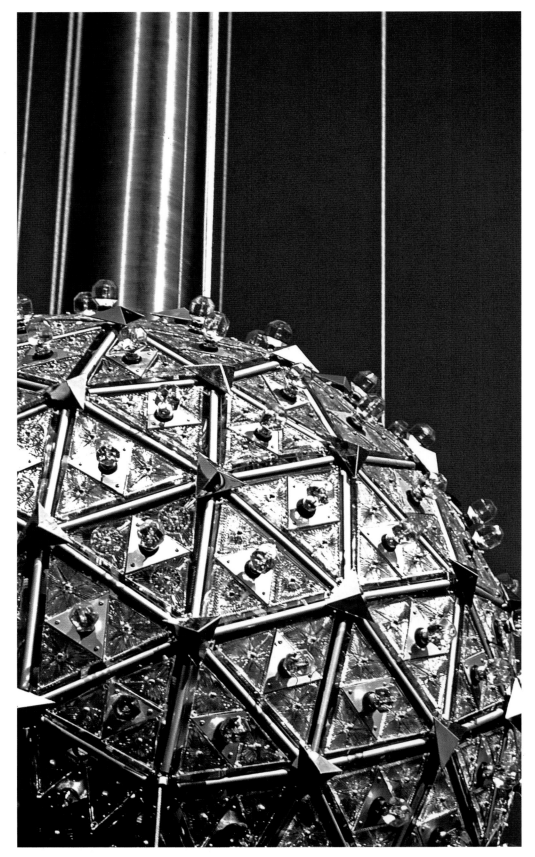

Twenty-five storeys above the jammed streets of Times Square, impatient hands stand ready to flick an oversized switch (above). Its "On" position begins the minute-long descent of the half-ton ball that serves as a high-tech smoke signal to the masses, trumpeting the dramatic encroachment of time. One of the most watched ballgames in the world centers on its 1,070 pound ball (right) as its six-foot diameter slowly slides down a Times Square flagpole to announce yet another year and reveal the dancing strobe lights from within 504 Waterford crystal triangles. The baton passes from one year to the next as a blizzard of confetti and laser beams (far right) sweep the Manhattan sky just below a noted structure's celebrated flagpole and its descending sphere. Once the second tallest building in the world, One Times Square is now dwarfed by a forest of skyscrapers.

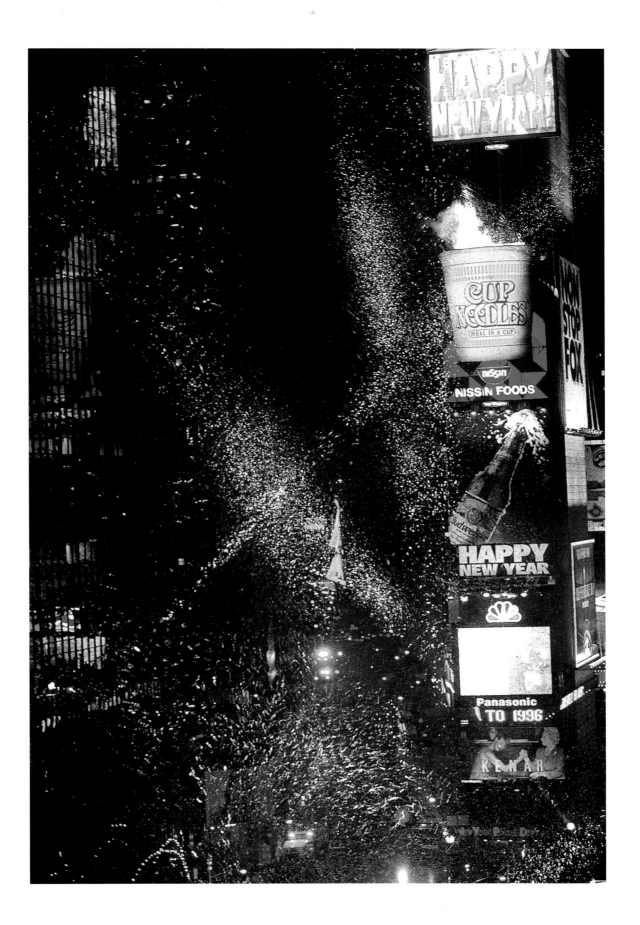

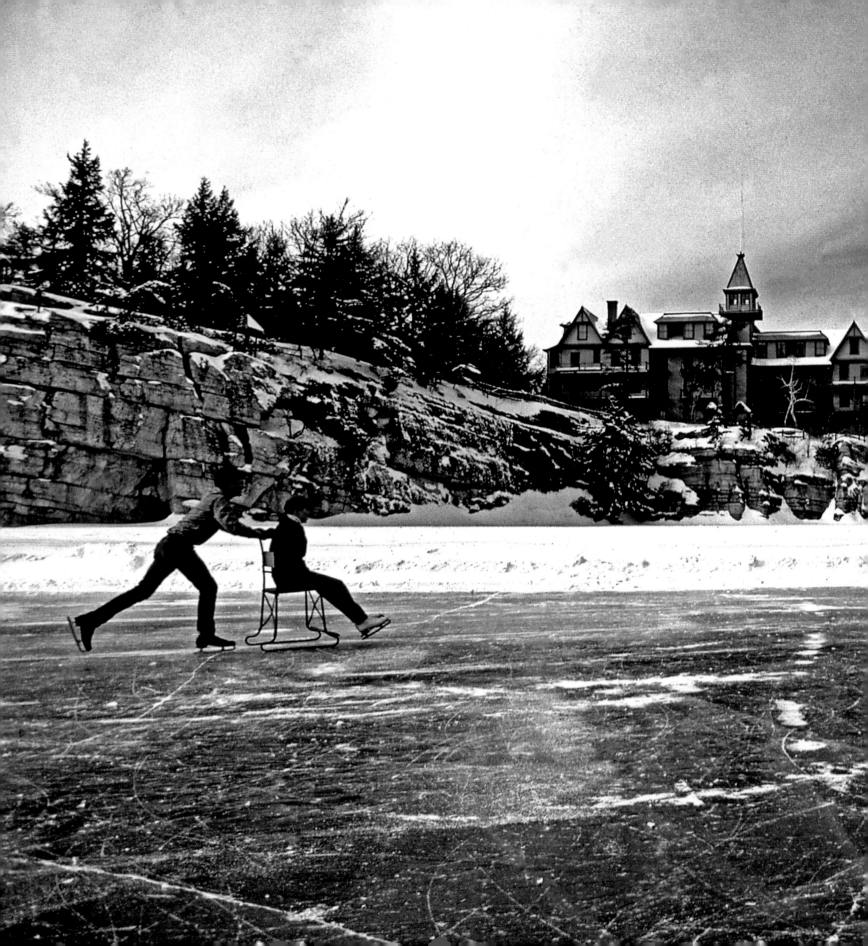

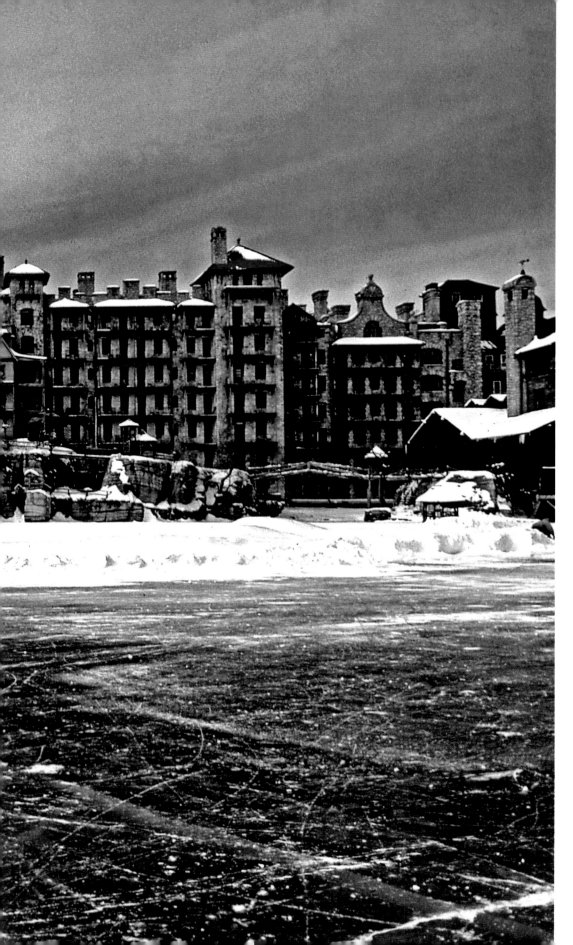

A dreamlike Victorian tableau slides into reality as nineteenth century chair skaters deftly skim across Lake Mohonk in full sight of the imposing Mohonk Mountain House. A Bunyanesque hodgepodge of chalets, turrets and chimneys, the castle hotel straddles the granite escarpment of upstate New York's Shawangunks.

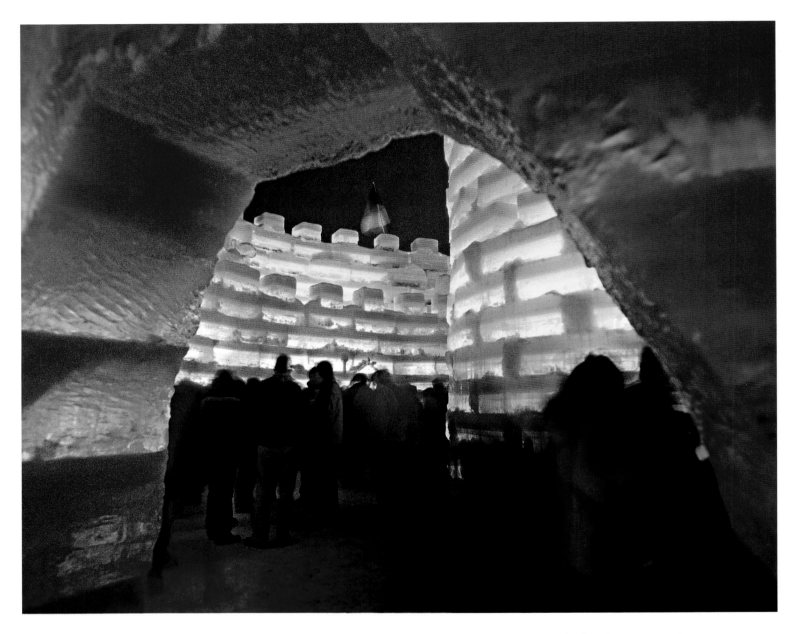

Sizzling nightlife heats up the frigid courtyard of Lake Saranac's massive frozen palace. The carnival centerpiece is a Lego-like construction of 3,000 translucent blocks of ice destined to water plants in the thawing spring.

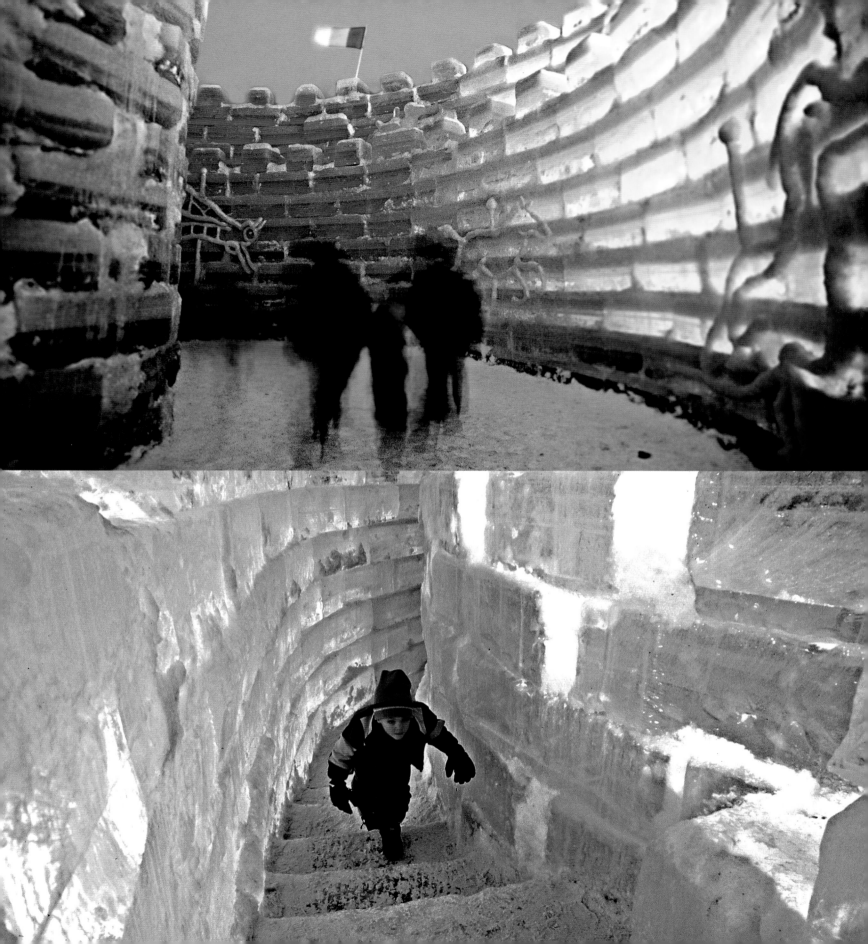

Adrenaline and stocking cap fly furiously in the gust that powers mighty handcrafted iceboats plying the frozen stretches of the Hudson River near Rhinebeck. Shaved ice slaps cheeks with a wind chill that sweeps tears from squinting eyelids.

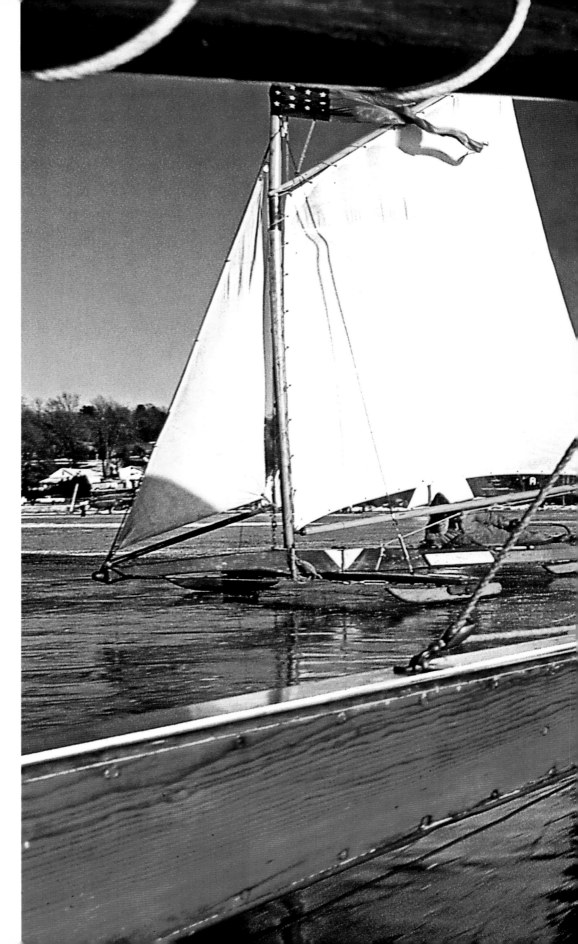

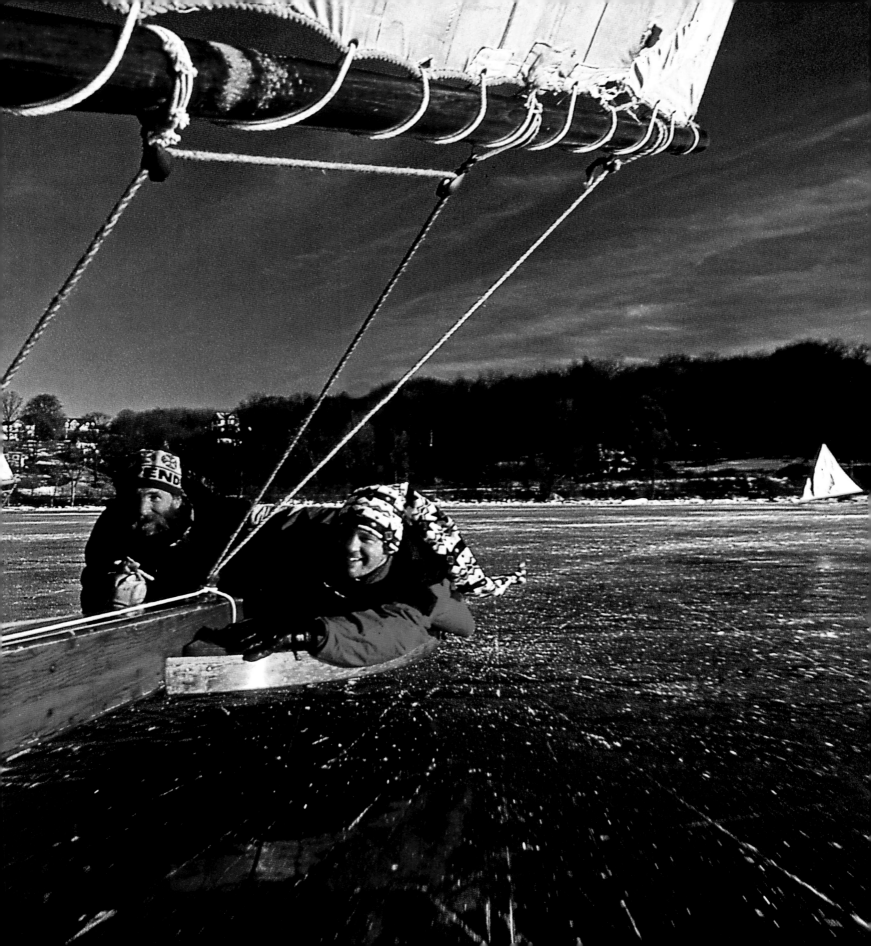

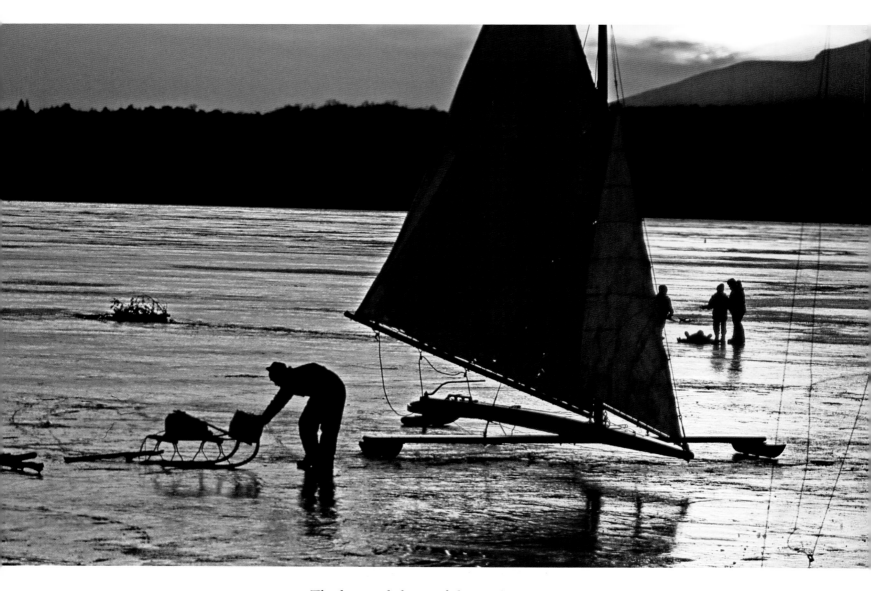

*The bronzed sheen of the mighty Hudson silhouettes a stately iceboat await-
ing service for another exhilarating day screaming with the wind on sharpened
runners.*

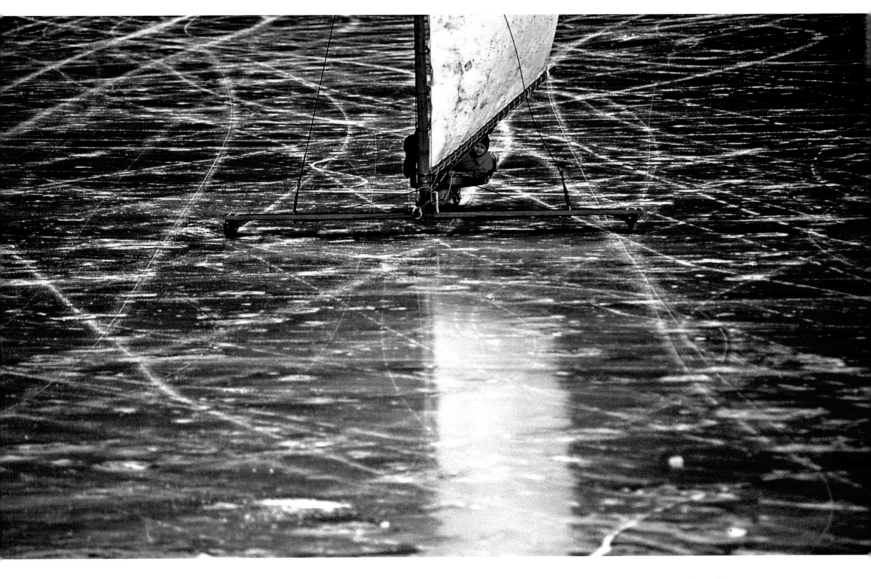

A scribbled message of bladed exhilaration is plainly etched in glassy expanses of the Hudson. Only possible a few weeks a year, ice sailing is a remnant of a nineteenth century winter pastime for the wealthy whose mansions lined the valley.

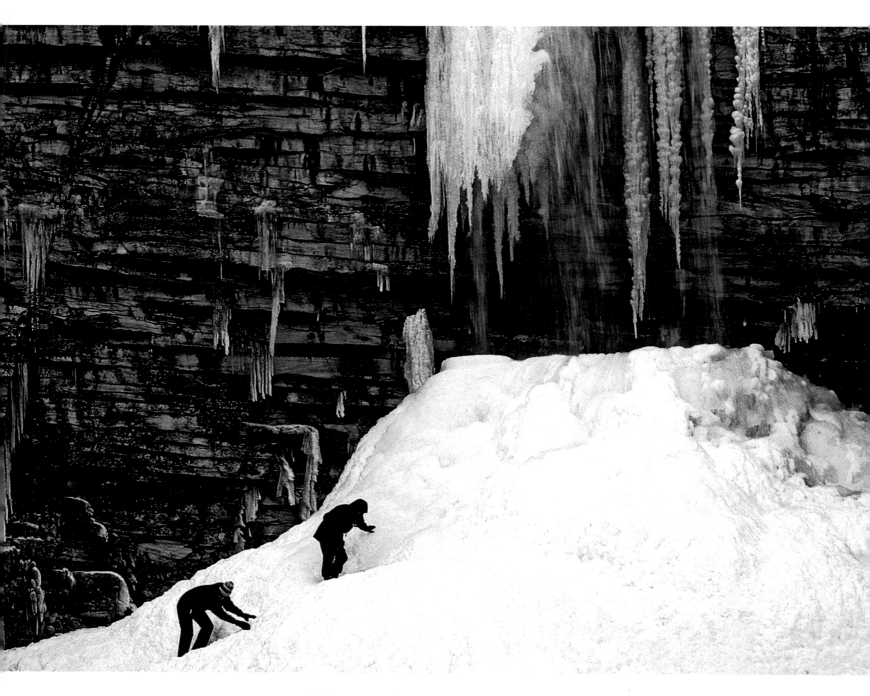

Weeping icicles at Awosting Falls create a sugarloaf in a deep natural cavity within the Shawagunk Mountains. This hill of ice formed by frozen mist provides a magnet for intrepid winter explorers.

A stunning crystallized universe varnishes trees and twigs alike in the wake of an ice storm that passed over Long Island and left this glassy meadow near Locust Valley.

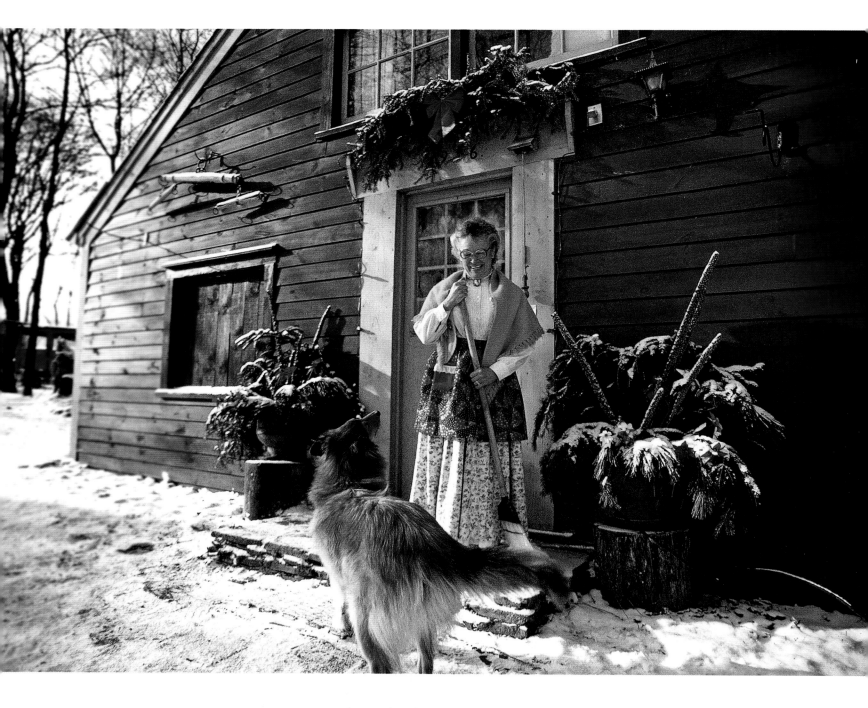

A gingham-clad farm wife sweeps a new dusting of snow from her 1916 farmstead near the sleepy agricultural village of Brookfield in New York's Leatherstocking District.

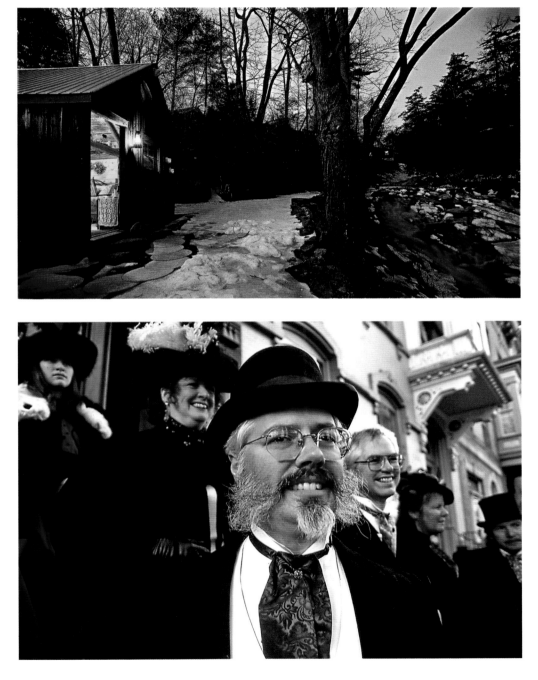

Amber light emanates from the hog house as dark descends over Timmerman Creek and its Adirondack foothills. Built during the blizzard of 1888, the rustic shanty provides comfy lodging for visitors to the Inn by the Mill tucked away in a St. Johnsville gorge.

Victorian in both architecture and the fashion of its strolling carolers, downtown Troy hosts an annual holiday promenade where songs of the season echo amongst ribbon-laced brownstone stoops.

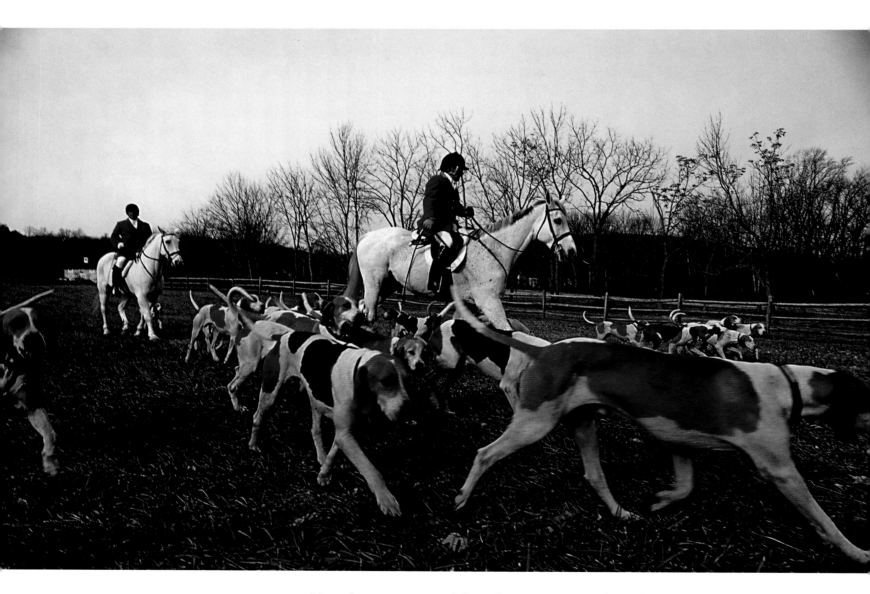

Hounds on a mission follow their scents into the rolling Somerset Hills as scarlet-clad landed gentry pull up the rear. Jacqueline Kennedy Onassis spent a number of holidays on the hunt with the Essex Fox Hounds amongst the lovely estate-rich woodlands of central New Jersey.

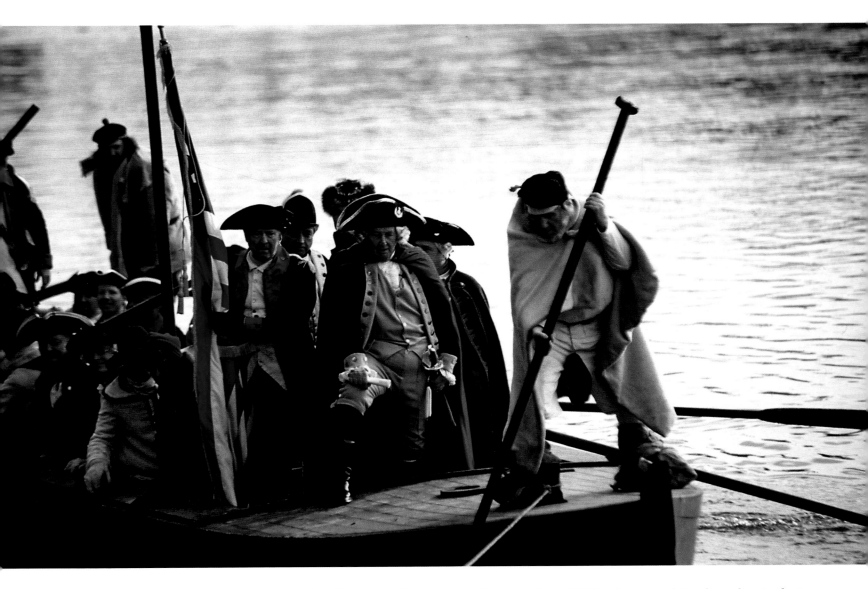

On Christmas Day, a sea of tricorn hats fill flat-bottomed Durham boats that make their way across the tricky currents of the Delaware River. The yearly reenactment of George Washington's decisive movement to surprise groggy post-holiday Hessian troops in Trenton reminds spectators of a heroic turning point in the Revolutionary War.

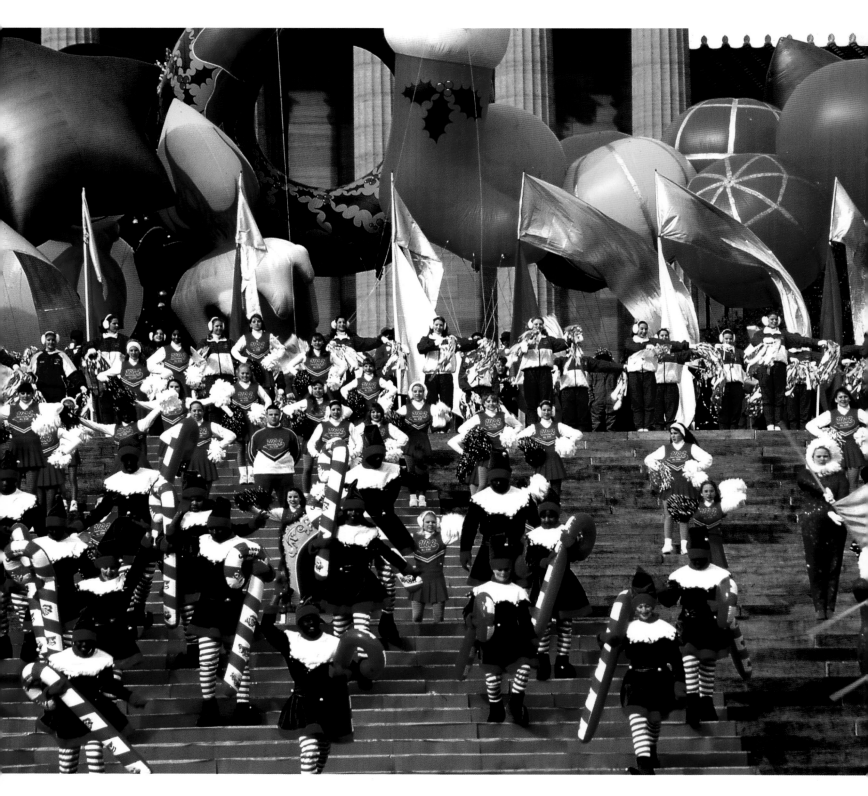

An army of elves and their overinflated candy canes create a fanciful extrava-
ganza as part of Philadelphia's Thanksgiving Day Parade. Started in 1920
by Gimbels, Macy's erstwhile department store competition, the tradition was
initiated a full four years before their better known rival's first celebration.

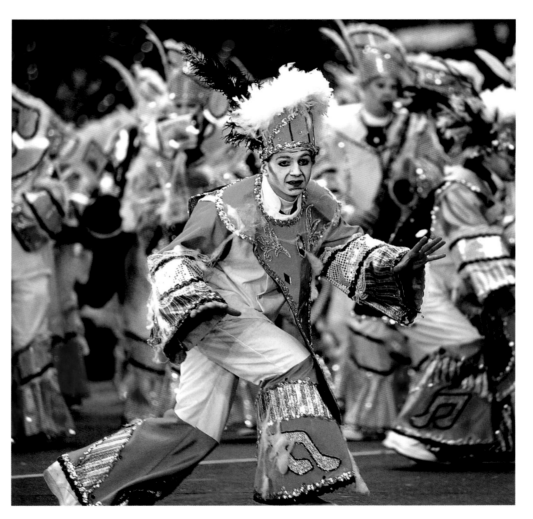

Strutting their pomp and feathers, the Mummers, a banjo- and sax-playing brigade of sequined revelers, have for over a century dazzled downtown Philadelphia on New Year's Day. For up to twelve hours, their contagious enthusiasm ignites the crowds that gather around City Hall.

A half million glistening bulbs dress the rural farmhouse and barn at Koziar's Christmas Village deep in the rolling Penn Dutch country near Bernville.

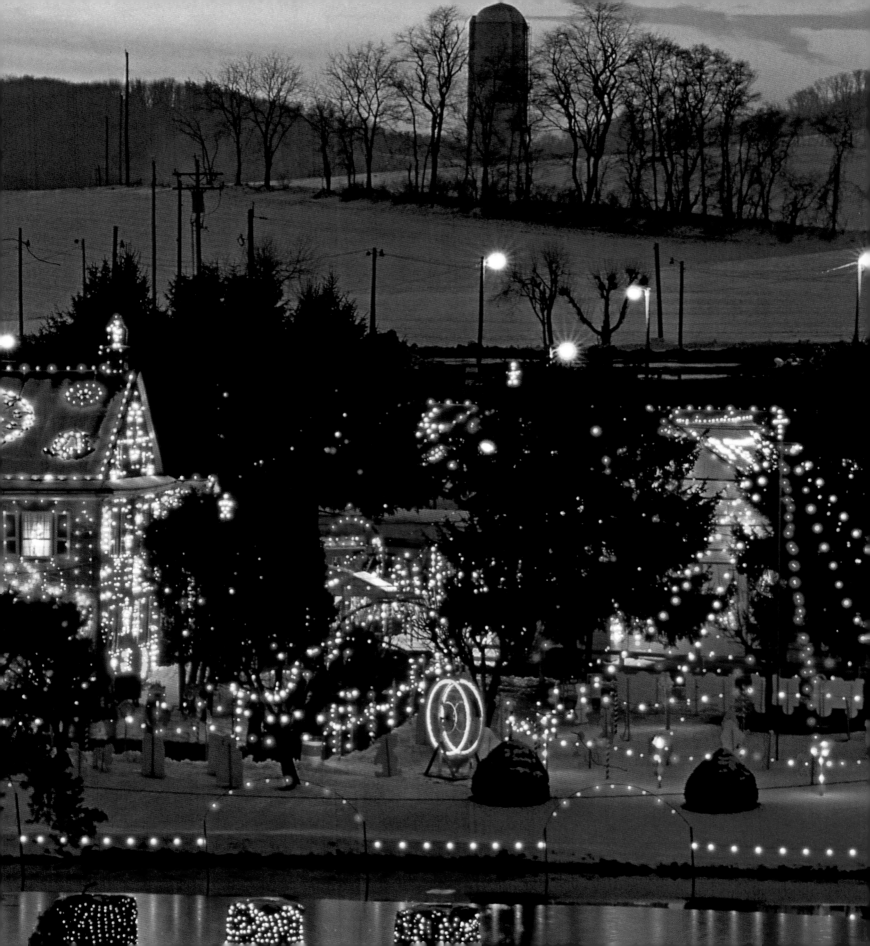

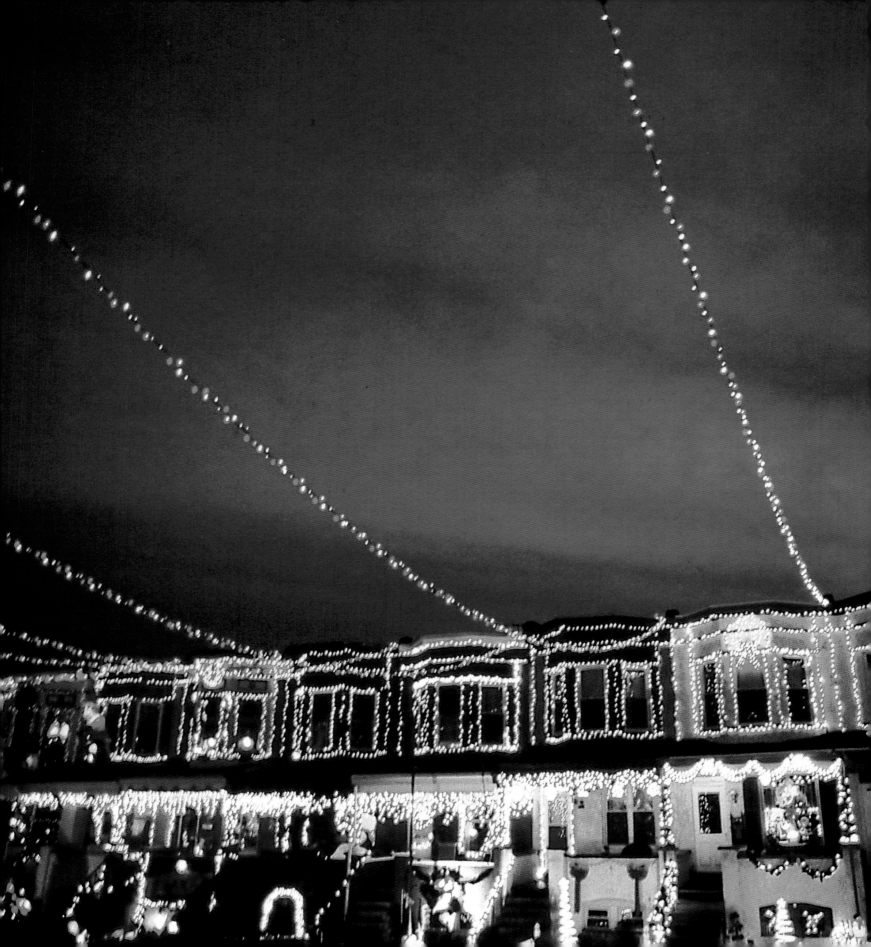

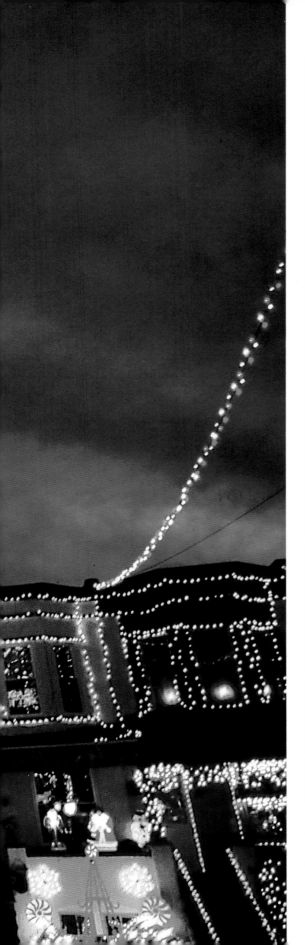

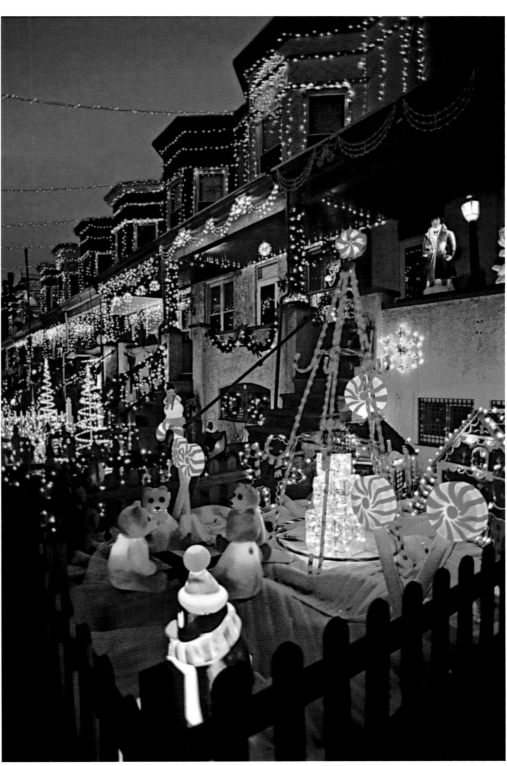

A phalanx of wildly over-decorated row houses guard a renowned stretch of *Christmas Street* in Baltimore's working class Hampden neighborhood. Turrets, eaves, and windowsills are stitched in pointillistic illumination that weaves together both sides of the highly visited street.

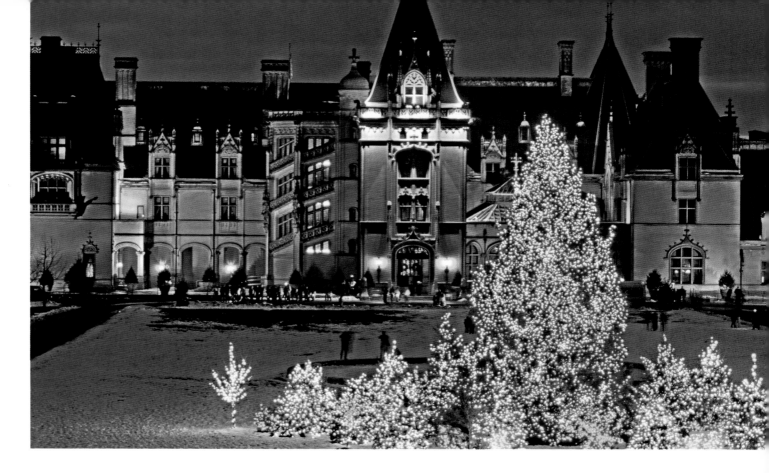

Commanding its 125,000 acre Gilded Age estate, the country's largest private home flaunts its holiday spirit across the front lawn of George Biltmore's French Renaissance chateau where 250 rooms can be kept warm in the Smokies' winter chill by over 65 roaring fireplaces.

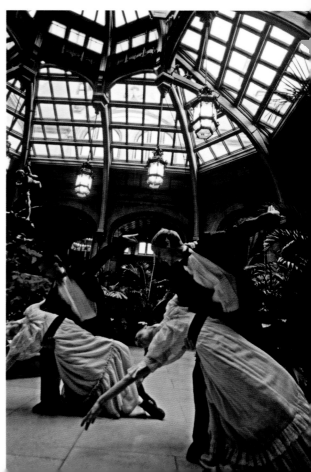

In fading December light, amazing grace is displayed by dipped Edwardian dancers performing amongst palms and holiday poinsettias that decorate the sunken Winter Garden at the lavish Biltmore House near Asheville.

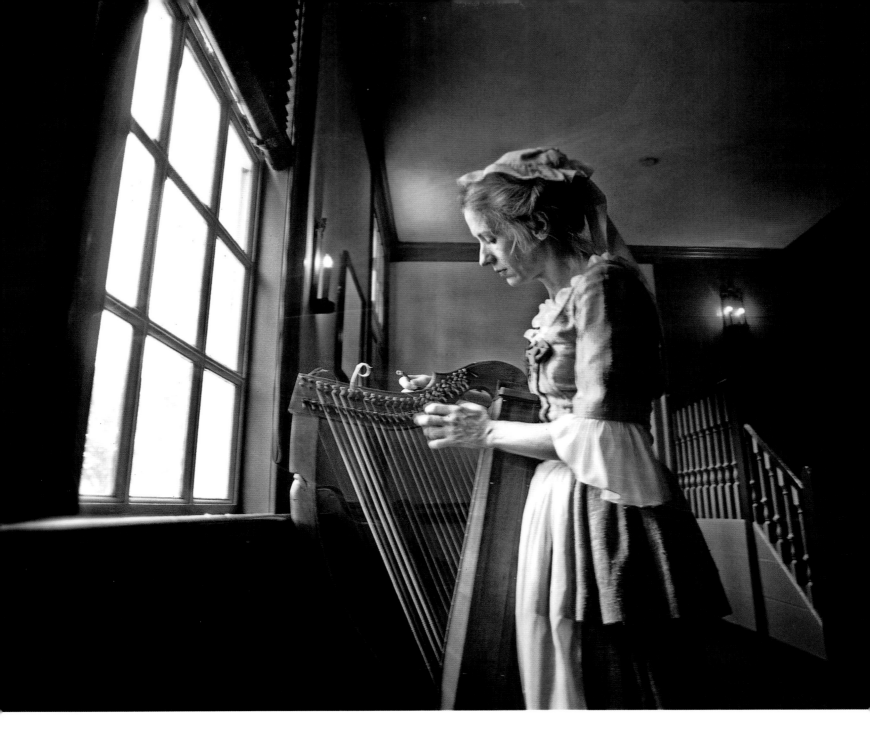

A harpist gently tunes her instrument by the window's dim winter daylight preparing for the evening's nineteenth century tavern entertainment in Colonial Williamsburg.

Echoing down the winding back roads of North Carolina, suppertime fiddles and bass toast the toe-tapping spirits gathered inside the parlor of the cozy Mast Farm Inn, dispensing regional spiced pumpkin dishes and mountain hospitality since the nineteenth century.

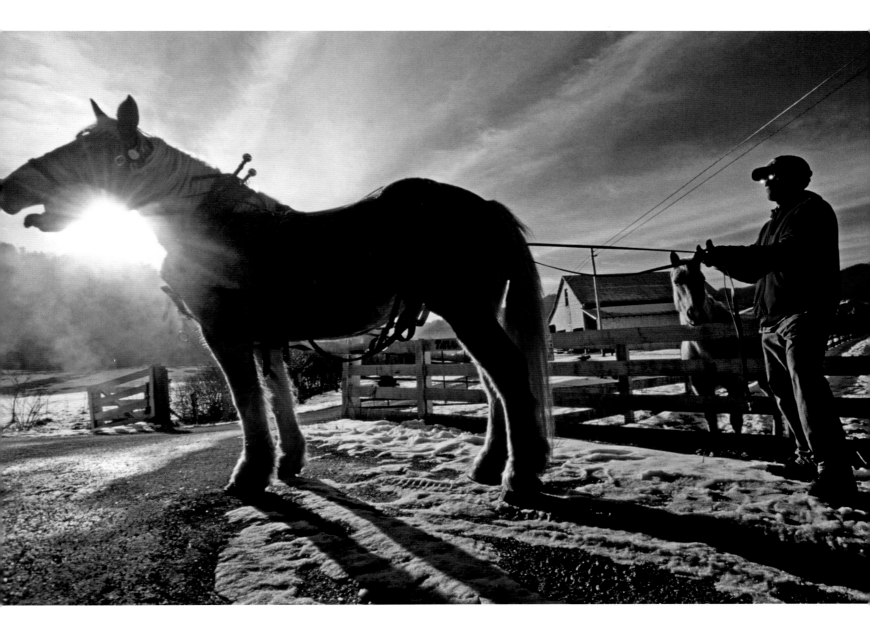

Where mountains yield to meadow, an anxious Percheron sprays a crystal morning sky with the frost of equine breath as his owner readies the horses for another day of rural errands at the Valle Crucis Farm in the western Carolinas.

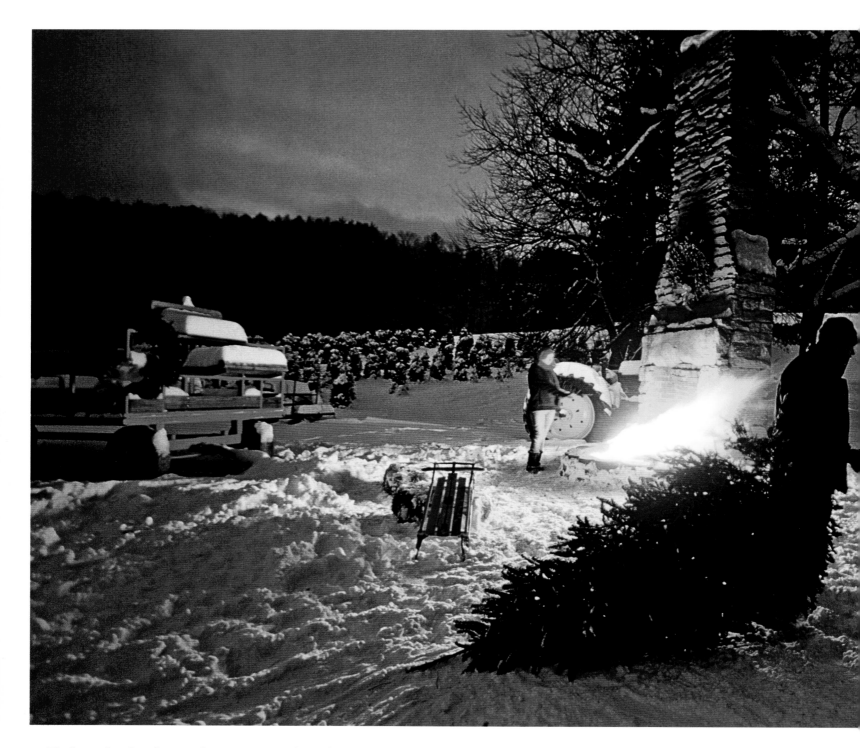

High in the Smokies, a last-minute sale is dragged away at Tom Sawyer's Christmas Tree Farm in Cashiers, North Carolina, where pine-scented sledding and a Christmas Eve bonfire help thaw digits frozen by a passing snowstorm.

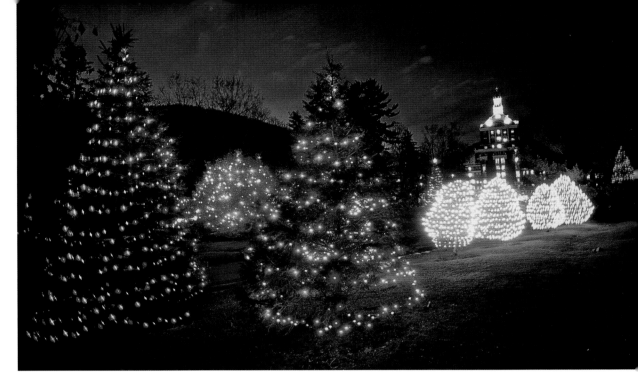

A bewitching landscape of glowing Christmas trees fill a meadow entrance to the stately Homestead Resort, stashed in the hills of Hot Springs, Virginia.

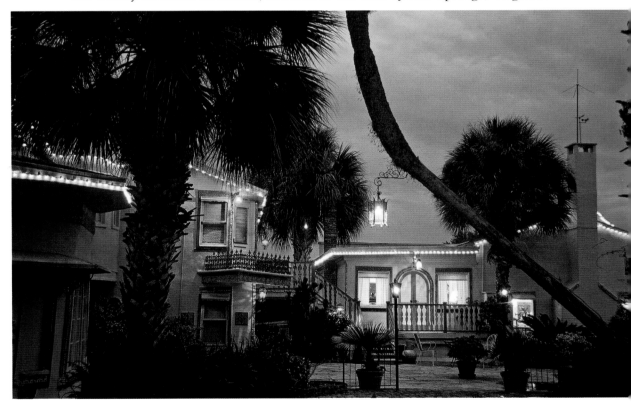

As palms sway and indigo skies deepen, luminous accents infiltrate the enchanting Latin courtyard of Chalet Suzanne in Florida. An eccentric hacienda-style oasis amidst Lake Wales's fragrant orange grove offers gourmet meals in a fairytale setting that echoes a Christmas spirit year-round.

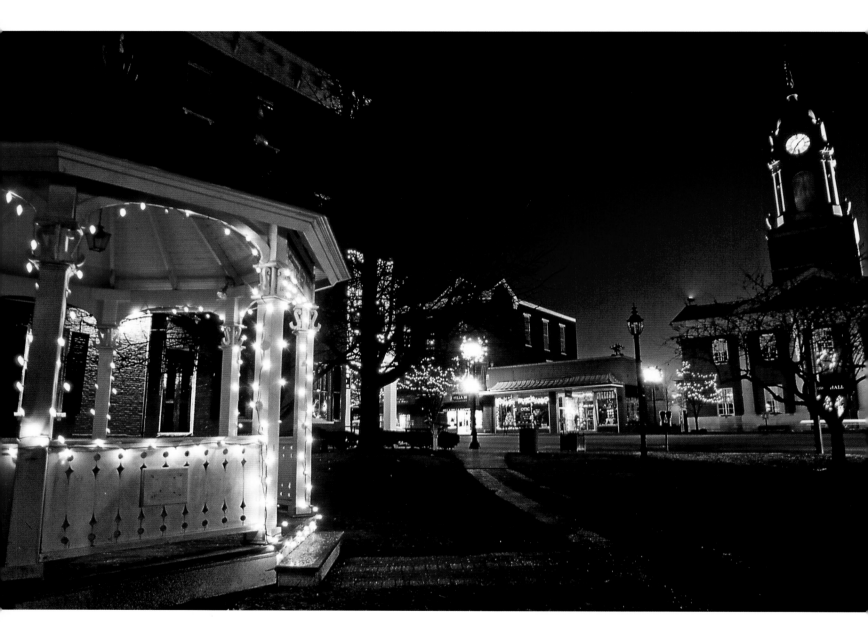

Christmas in the Heartland

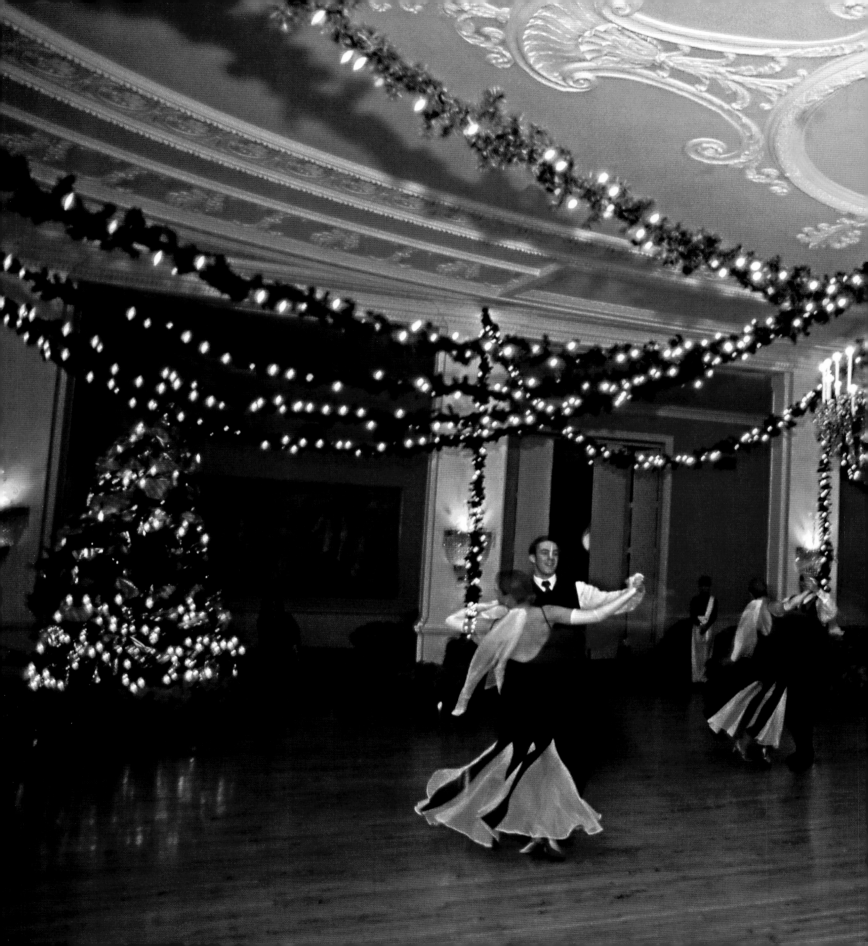

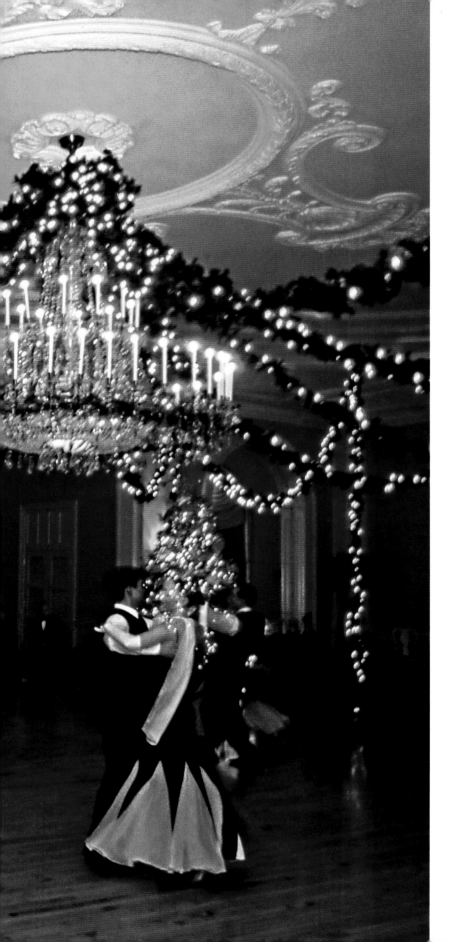

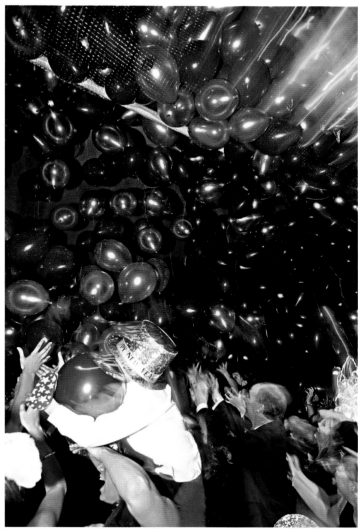

A New Year's Eve waltz graces the exquisitely appointed ballroom of West Virginia's Greenbrier Hotel (left). Since the late eighteenth century, sulphur springs discovered on the resort's property have served as a magnet for legions of travelers hunting for healing, hot spring waters. Reaching into a shiny sea of balloons, merrymakers at the Greenbrier celebrate the first seconds of a new year as a ceiling's cascade offers hope for resolutions yet fulfilled (above).

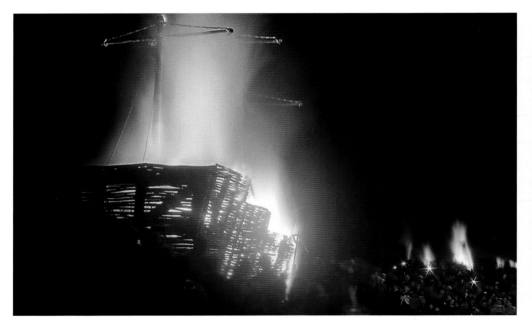

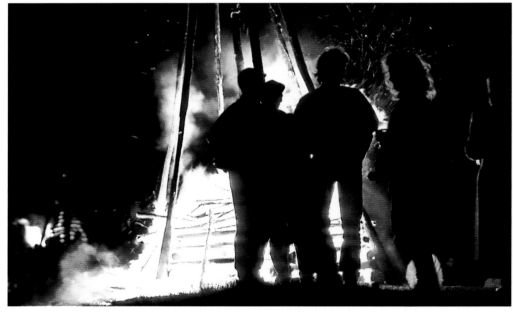

Blazing Christmas Eve infernos on both sides of the Mississippi form a
bonfired alley meant as pyrotechnic runway lights to guide Papa Noel to
Lousiana's Cajun swamps. Thirty-foot-high wooden pyramids laced with
bamboo and firecrackers line the levee where celebrants feast on pots of
simmering gumbo. Over a hundred bonfires rage from lovingly prepared
swamp willow structures that stretch for miles along the Mississippi River in
St. James Parish.

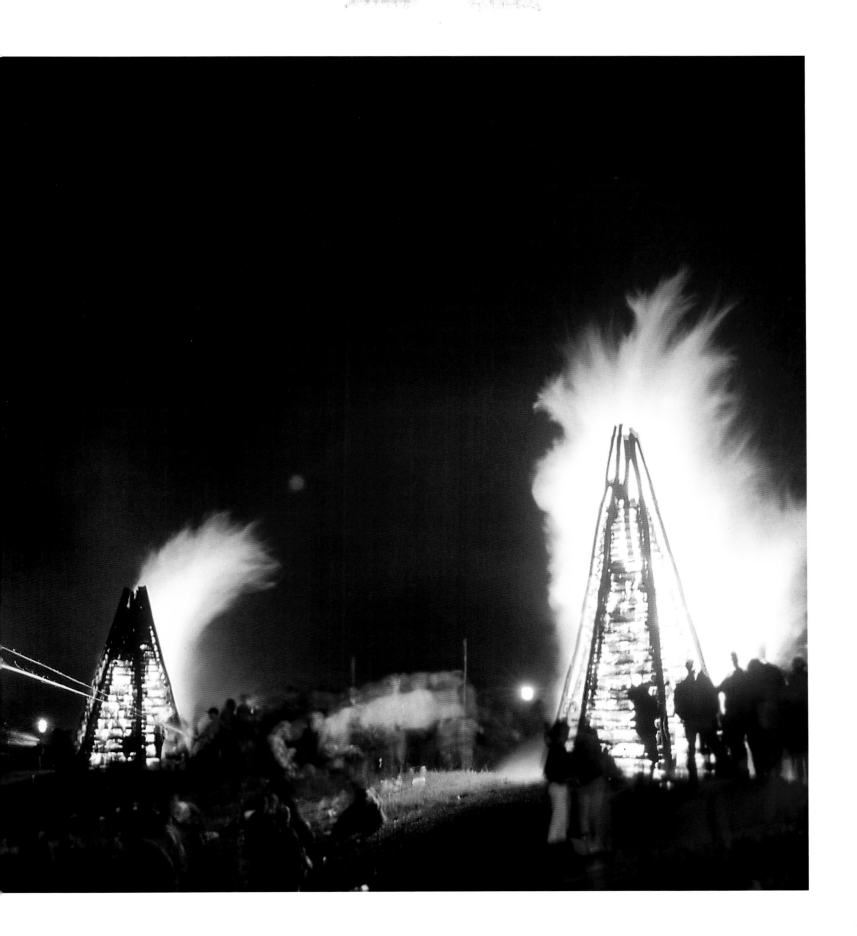

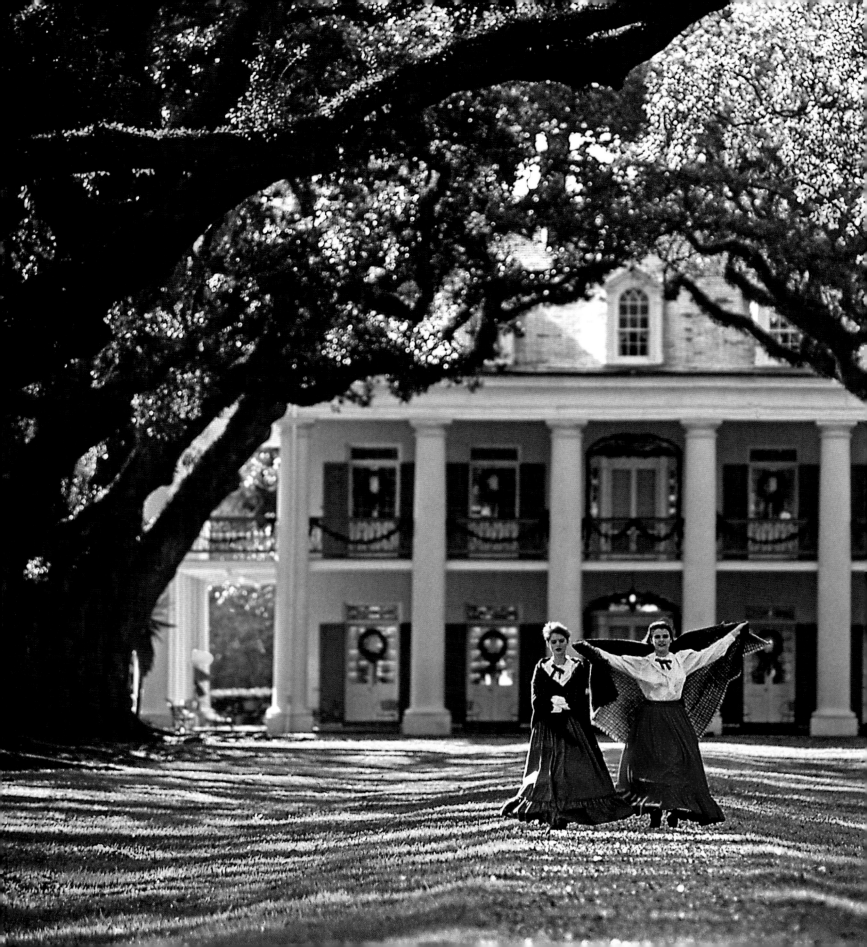

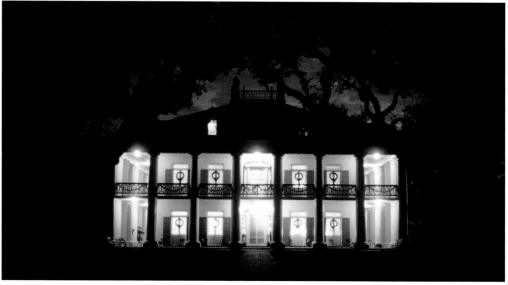

Period shawls warm a brisk Louisiana morning during a promenade beneath a stately natural pergola of three-centuries-old live oak trees. Adorned in wreaths, Oak Alley is an antebellum Greek Revival sugar plantation whose colonnaded wedding cake exterior faces the levees of Old Man River.

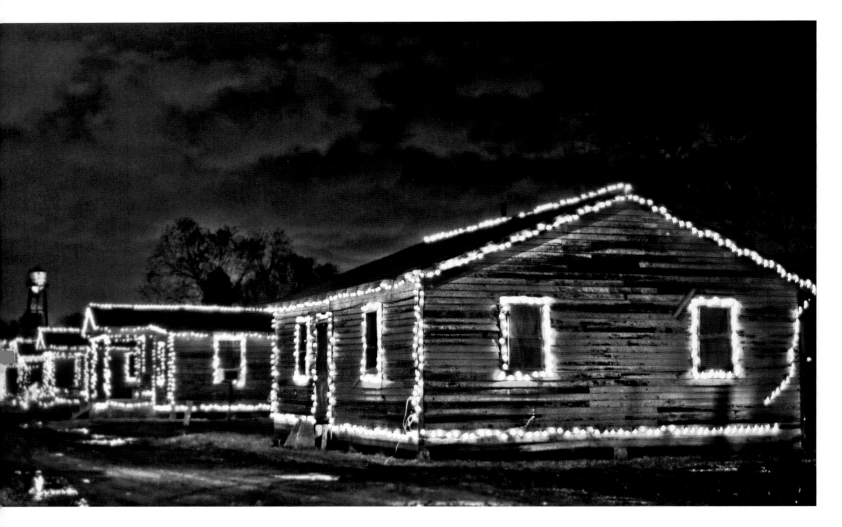

A once sad history is now gilded in lights down this lane of restored slave cabins at the Poplar Grove Plantation near Baton Rouge, Louisiana.

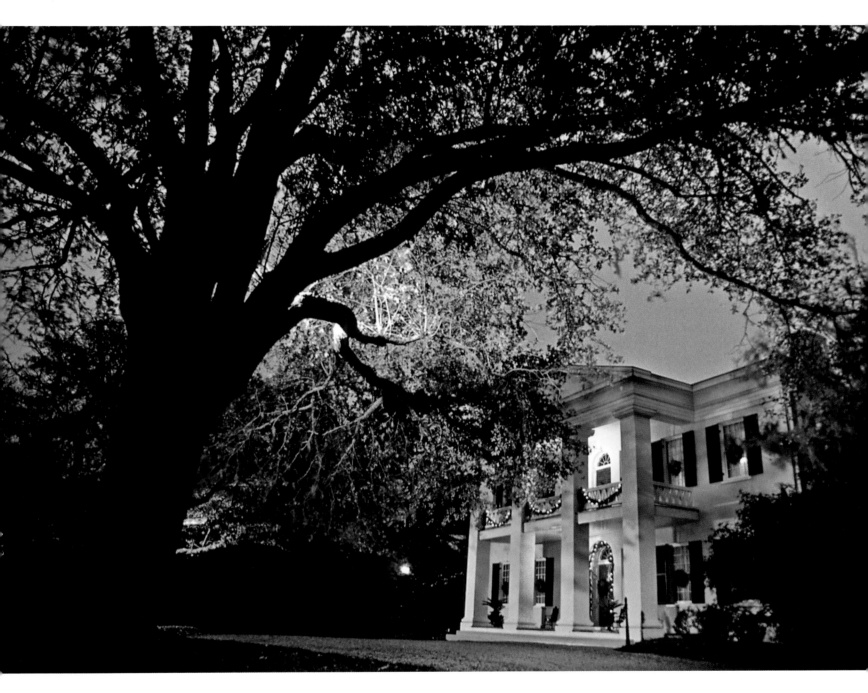

A jasmine-scented dusk descends softly on romantic Monmouth Plantation, strung in subtle Christmas finery. Mint juleps are sipped within the Federal-style 1818 mansion that graces twenty-six acres of Natchez, Mississippi's decidedly antebellum character.

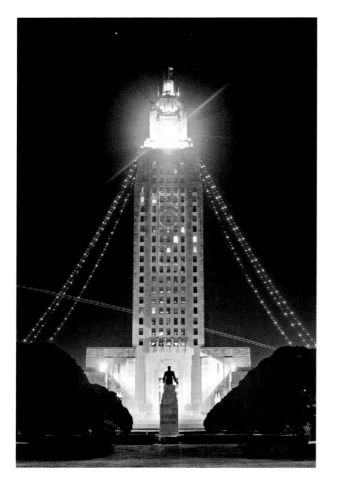

Glowing like a birthday candle, the tallest state capitol in the country delivers wishes of Noel to Baton Rouge visitors (above). The Louisiana edifice was finished under its governor, the "Kingfish" Huey Long, whose life unfortunately was also finished in the building after a successful strike by an assassin's bullet.

The fireplace in elegant Nottaway Plantation is kept company by an imposing Christmas tree, barely straining to reach the traditionally high ceilings of Southern architecture (right).

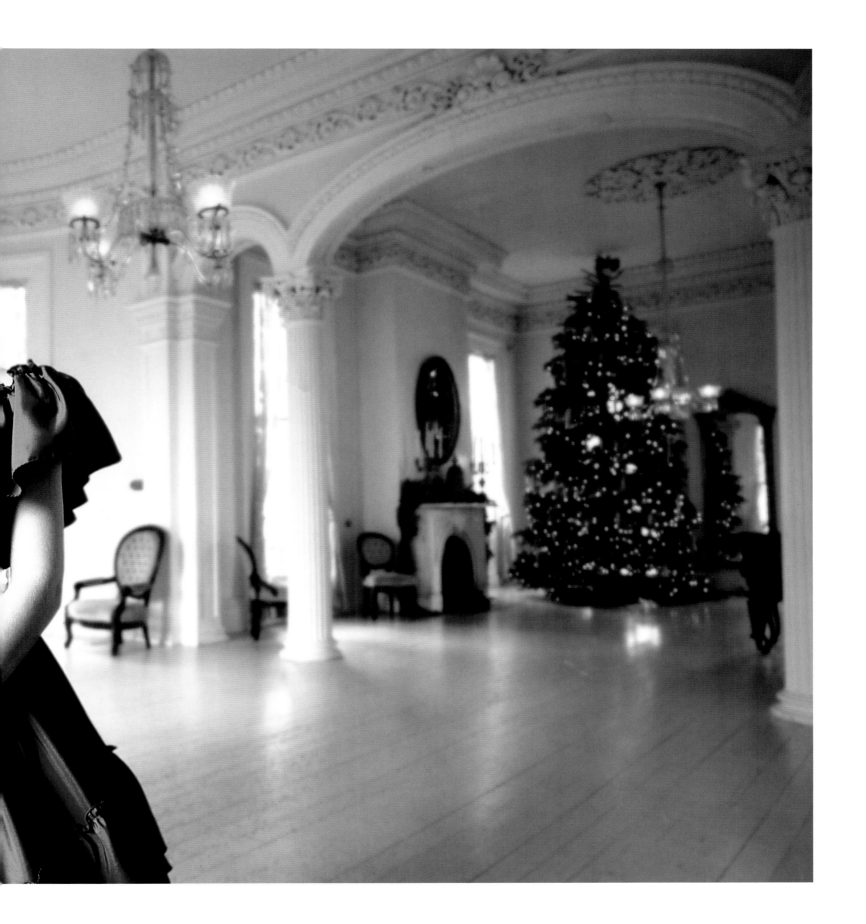

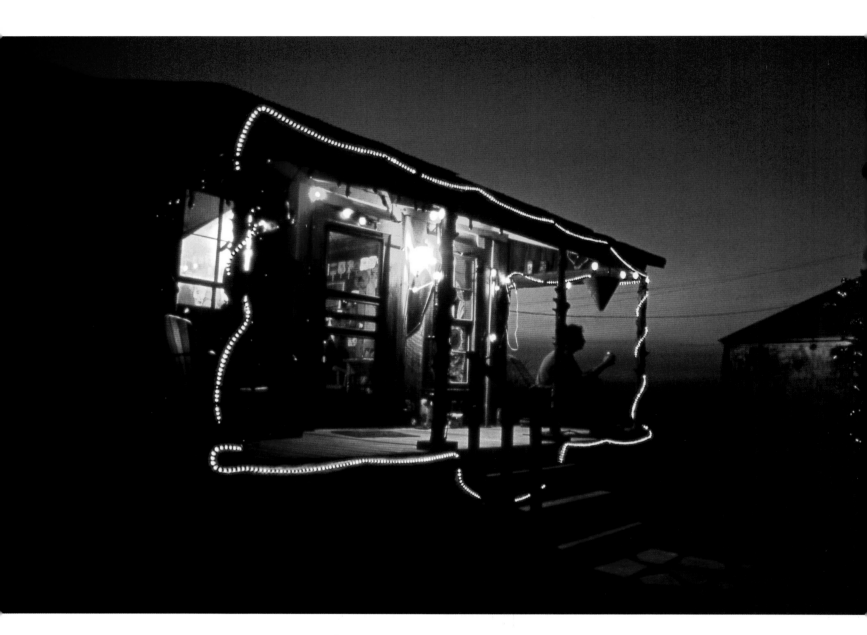

In the sleepy Mississippi Delta, a blue dusk cloisters a former sharecropper's shack. A creaky porch wears a necklace of lights and provides a ramshackle haven for the exhausted holiday traveler at the Shack Up Inn near Clarksdale.

A blazingly delineated neighborhood awaits the season's first snow in the nineteenth century village of Clifton, Ohio.

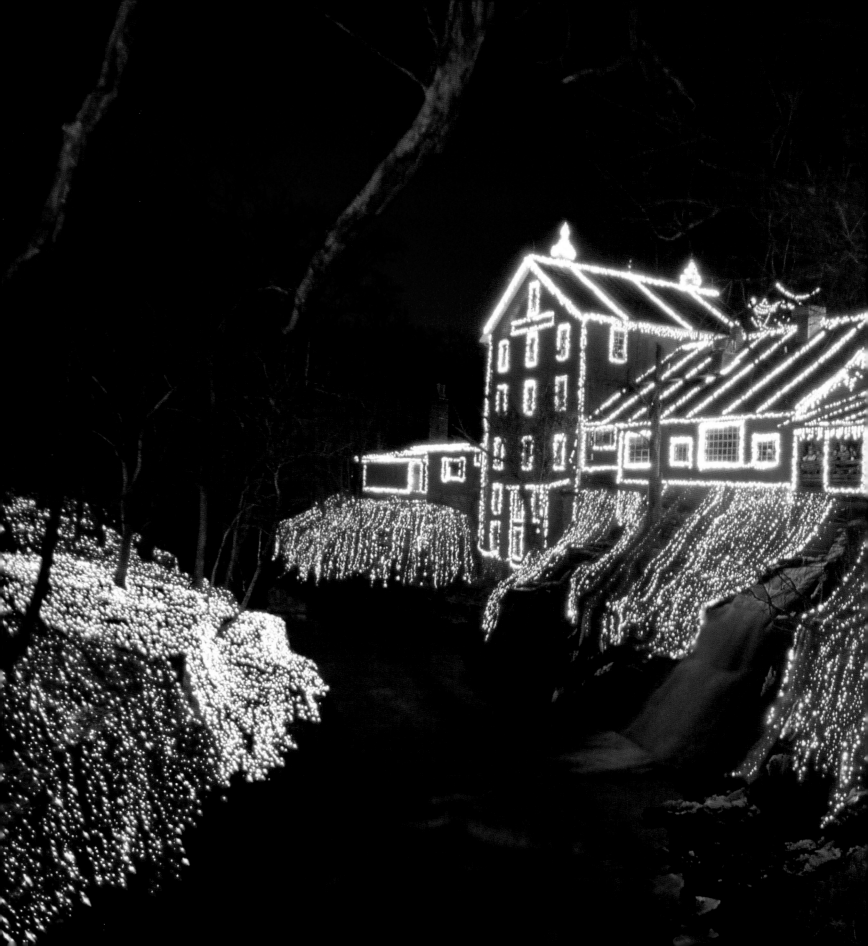

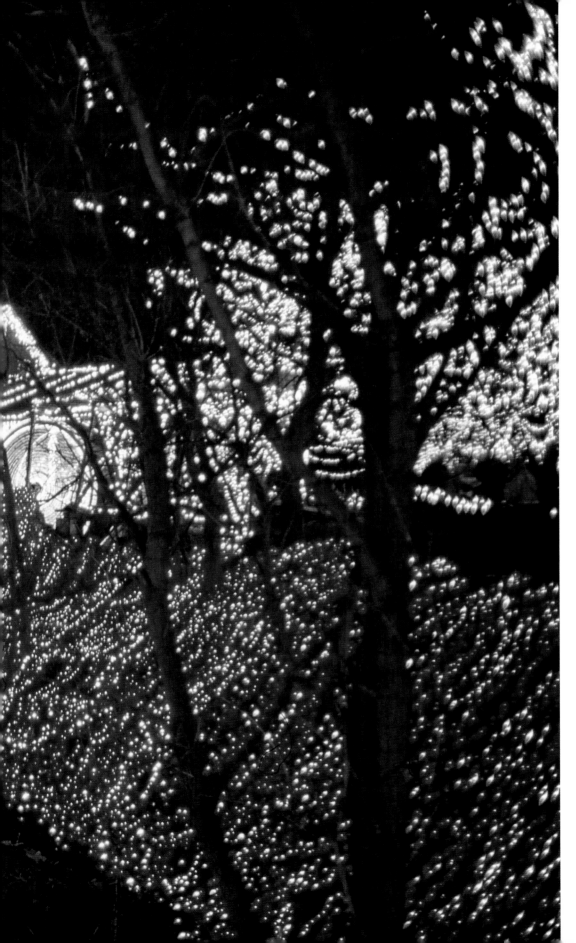

The Clifton Mill's gorge is carved by the Little Miami River, spanned by a covered bridge and, in season, pixelated with 3.2 million bulbs. Its jewel-like setting creates an astonishing sight for Midwesterners who undertake a yearly pilgrimage to fill their eyeballs with color.

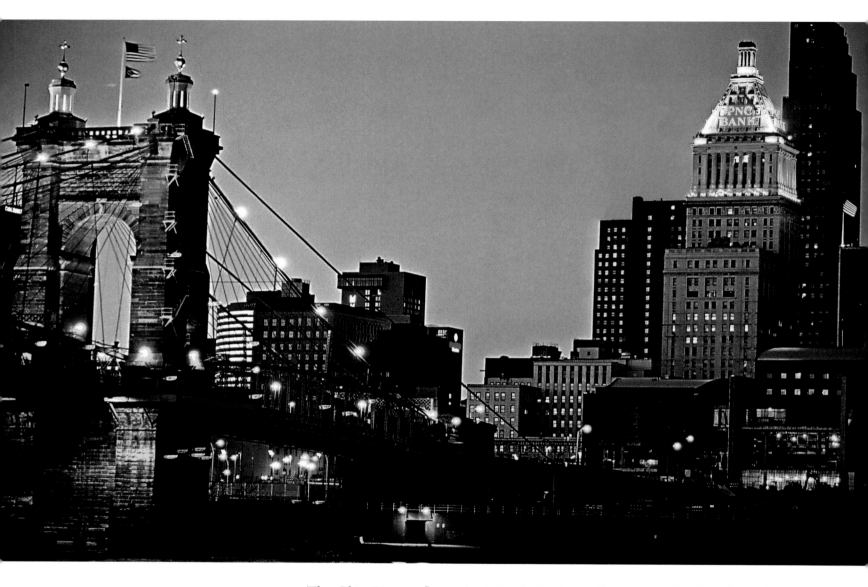

The Ohio River reflects the John A. Roebling Suspension Bridge, the architect's practice session for its famous Brooklyn sister, connecting Cincinnati with the Kentucky riverbank. The PNC Tower, lit in Christmas colors, was once the tallest building in the world outside New York City.

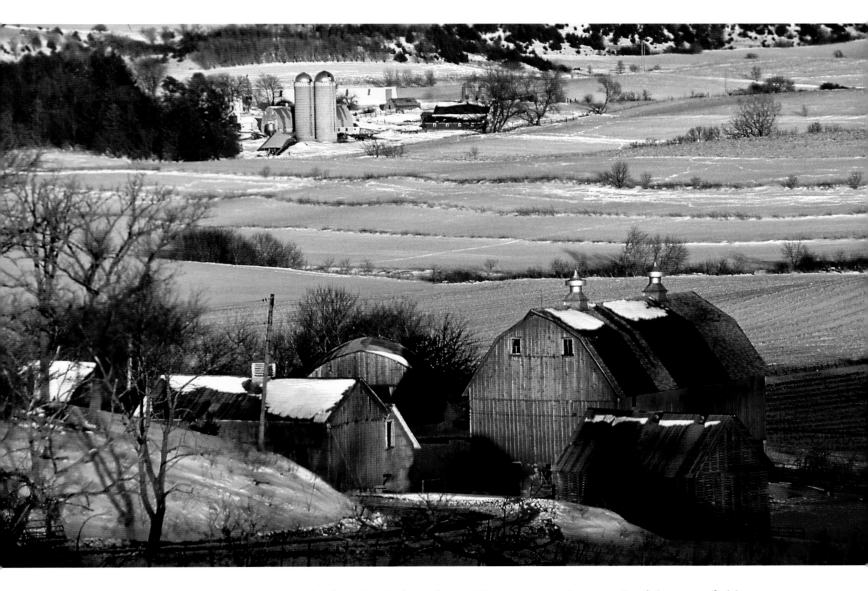

In the farmland of southern Minnesota, a winter quilt of dormant fields covers the vast distances between agricultural neighbors and their conspicuously noble barns.

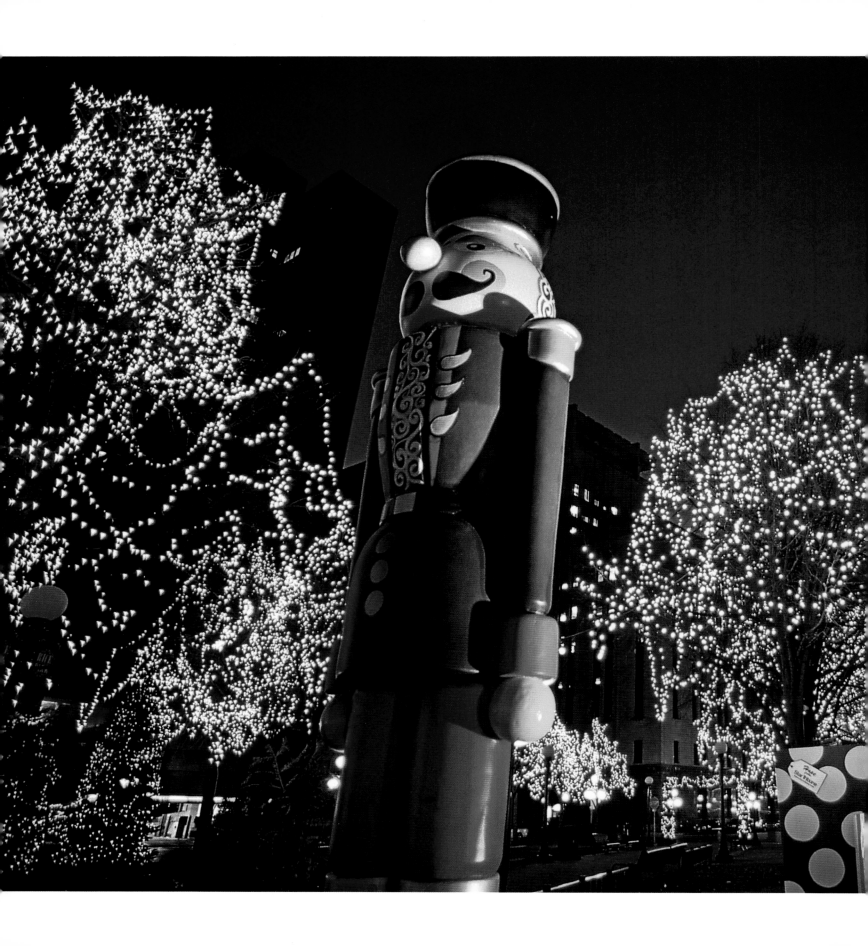

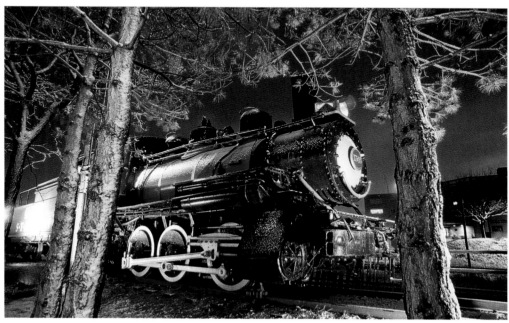

Dusted with snow, a steam locomotive idles out back behind the Inn at Quaker Square, a unique hostelry converted from a series of grain silos in Akron, Ohio (above).

Silent and erect, this vigilant nutcracker guards the festive forest of Rice Park's twinkling lights in downtown St. Paul, Minnesota (left).

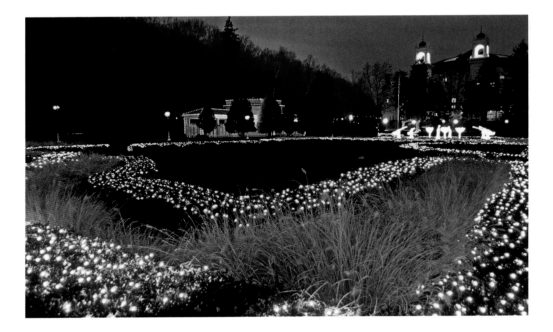

Sprawling gardens and holiday statuary gleam with festive luminescence beneath the Victorian grandiosity of the West Baden Springs Hotel. Once known as the Eighth Wonder of the World, its notoriety and wealth sprung from the unique properties of its mineral waters, America's laxative of choice. The majestic glow of an immense Christmas tree is completely dwarfed by the jaw-dropping circular 1901 lobby of the resort which was the world's largest self-supporting dome over 60 years before the Houston Astrodome was constructed.

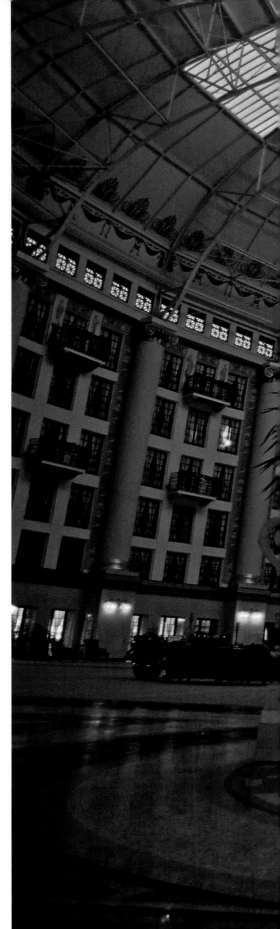

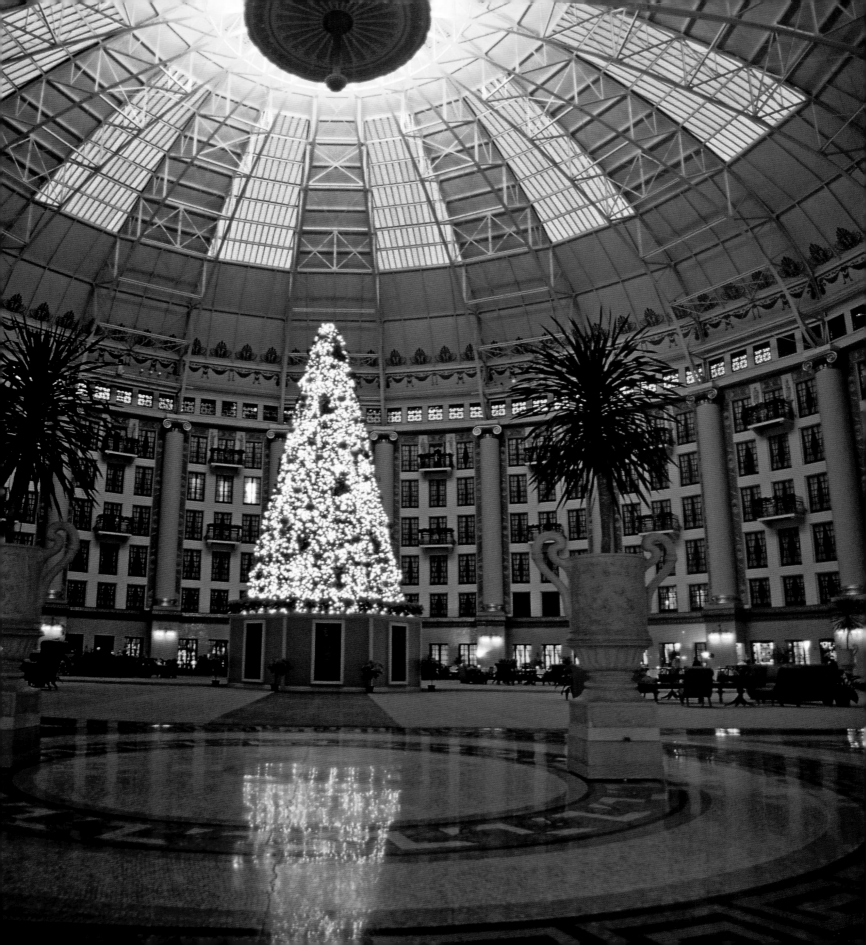

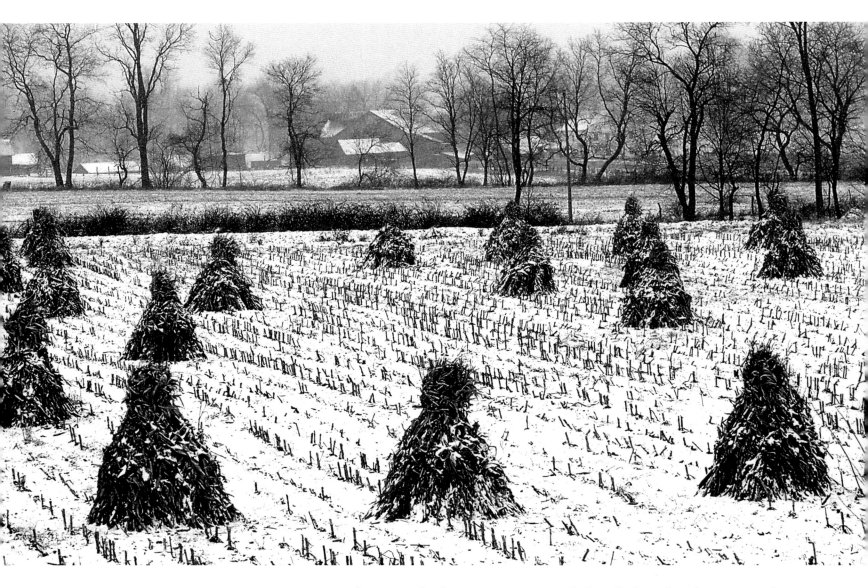

Beneath a central Ohio snowstorm, neatly bundled stacks of straw rise from last year's cornfields and provide comfortable bedding for weary livestock.

Near Dodgeville, Wisconsin, the world's largest carousel inspires wonders as it spins inside the House on the Rock, a meandering residential oddity.

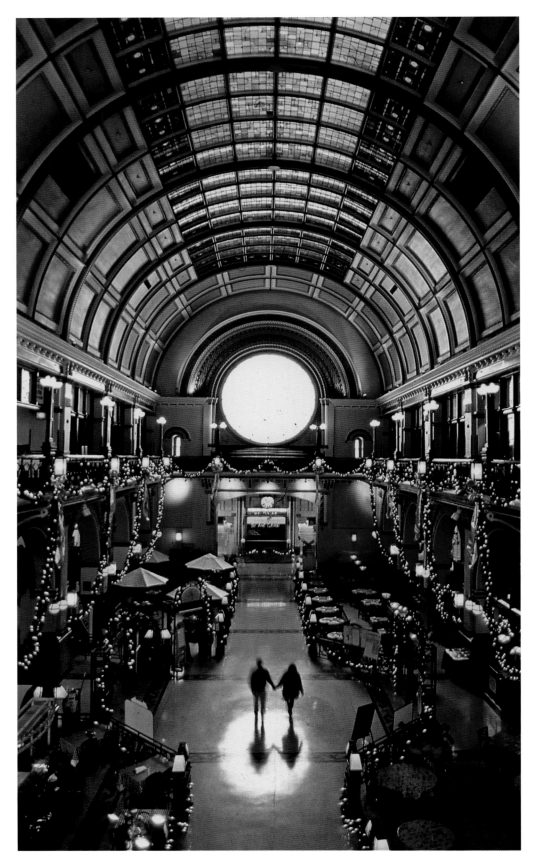

Below acres of stained glass and the barrel vaulted ceiling of a Romanesque Revival train terminal, a couple strolls through an after-hours restaurant and shopping complex decked out for the holidays. Union Station, in Indianapolis, has been a vibrant fixture downtown since 1888.

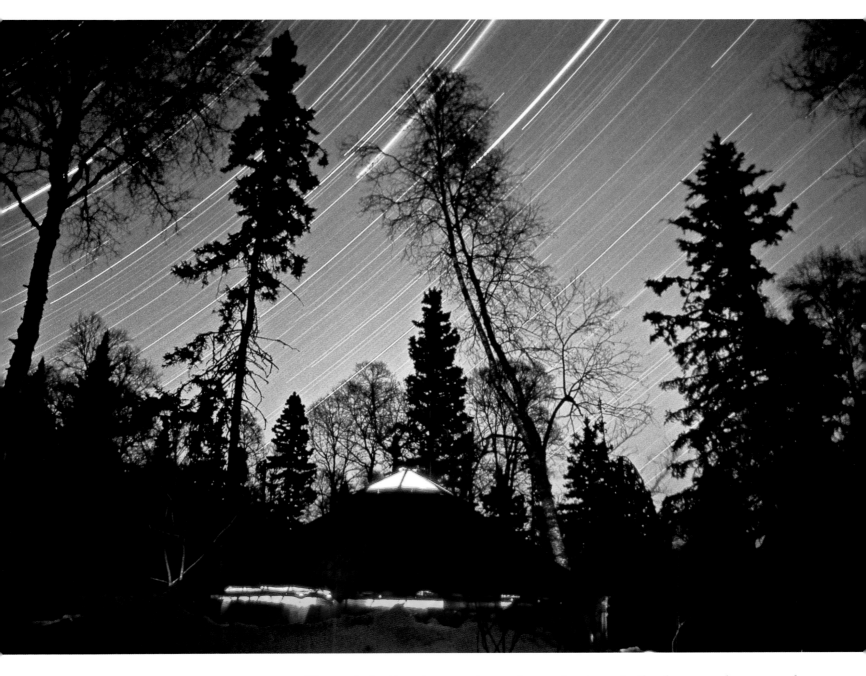

Heavenly bodies pirouette beyond towering trees in the deep woods surrounding the Lake Bedew Yurt, just off the Gunflint Trail.

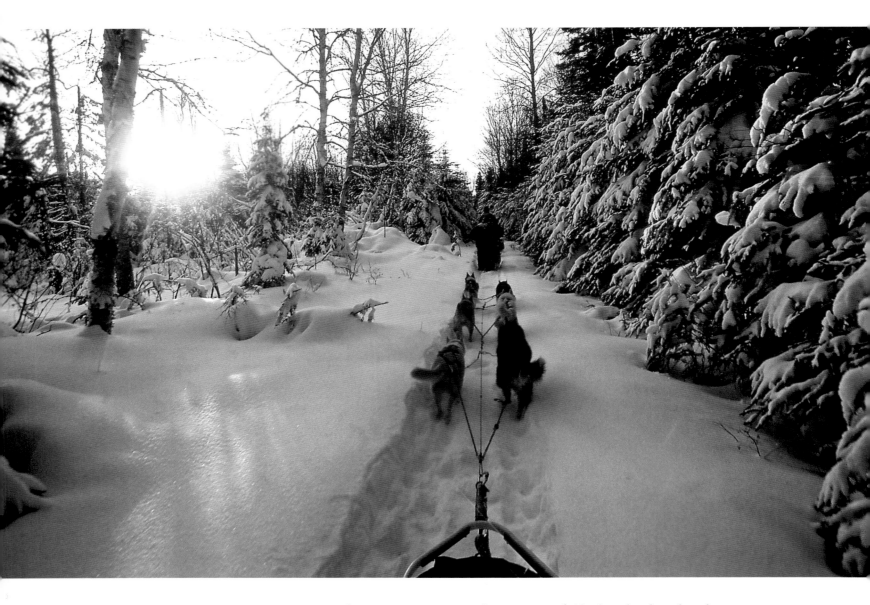

Bursting with canine energy, a yelping team of Alaskan huskies hurtles at breakneck speed trying to outrun their gangline's harness. These endurance-bred marathon mutts test braking skills through the forested avenue of Minnesota's Boundary Waters wilderness.

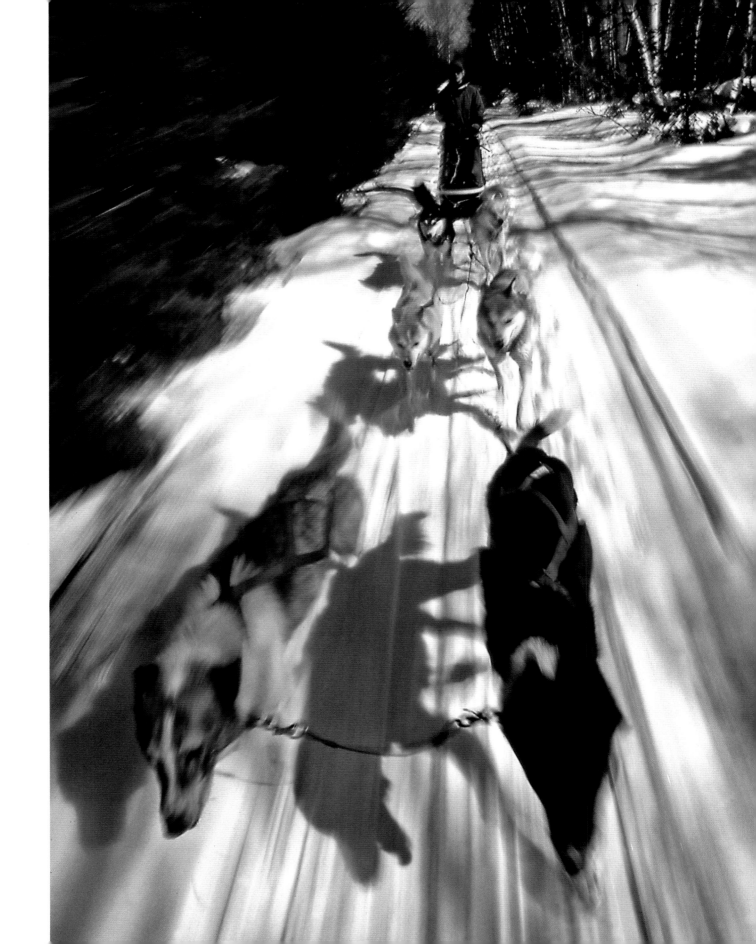

While fun to fool with on a nice day, snow caves may serve as emergency shelters from howling wind chills during unexpected arctic conditions.

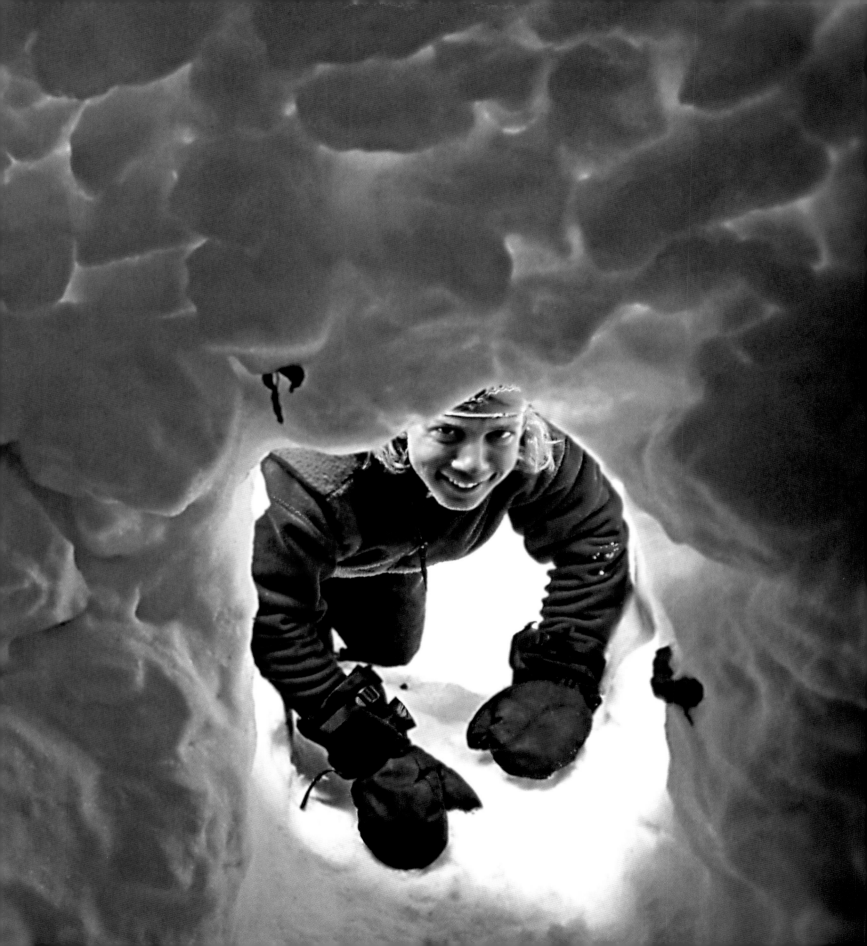

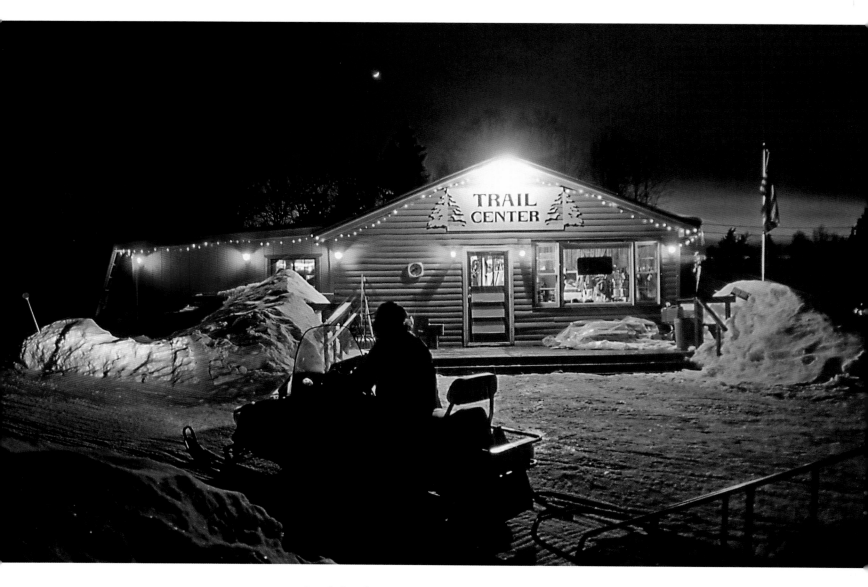

Luckily, the Trail Center's welcoming outpost stays open late for snowmobilers stocking up on winter supplies. Located just off the Gunflint Trail near Minnesota's Poplar Lake, the complex is a popular beacon along a historic trail lacing through more than sixty miles of wilderness with spurs that amble into Canada.

A cantaloupe sky and electrified trees envelop the downtown shopping district of Madison, Wisconsin, the state's capital city.

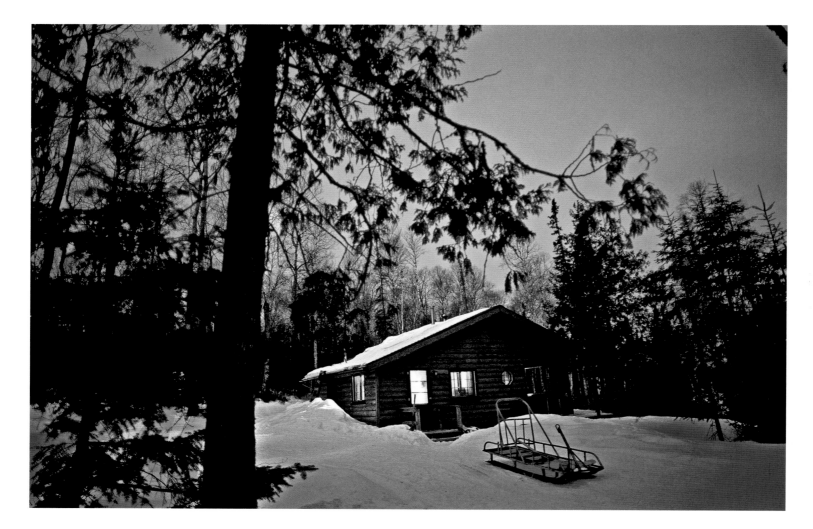

The alluring isolation of Little Ollie Lake Cabin becomes increasingly clear as evening approaches, and the crackling fireplace is the noisiest distraction heard along Minnesota's Gunflint Trail.

Gravity quickens both the journey and the sound of hooves as an Amish buggy races the disappearing sun home near Harmony, Minnesota.

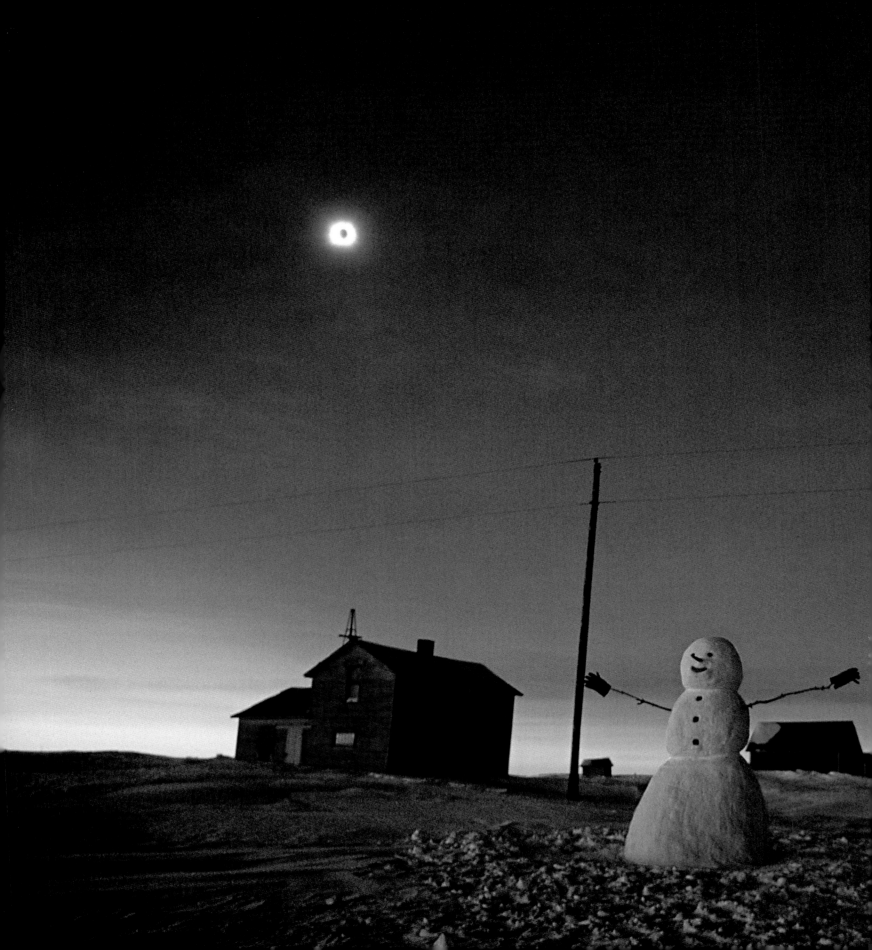

Unthreatened by the diminished rays of a total solar eclipse, a solitary snowman with a corncob grin and outstretched arms celebrates the haunting, twilit vastness of Ray, North Dakota, and its isolated farmstead.

Christmas in the West

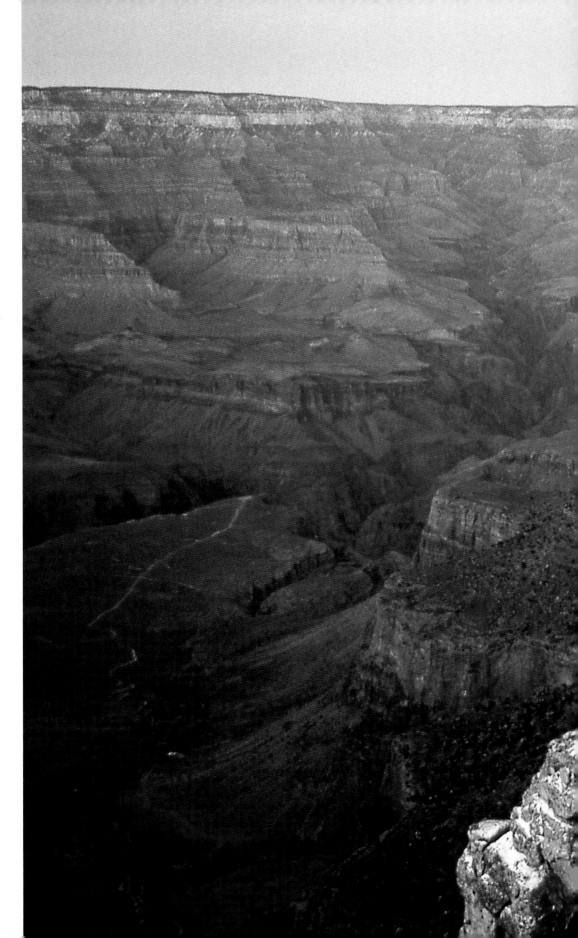

Frosted on top, the geologic layer cake at this bend of the Grand Canyon whispers its age in eons of erosion beneath a strawberry sky. Thousands of feet in altitude differentiate temperature and snow conditions across a vertical slice of this spectacular rift in the Colorado Plateau.

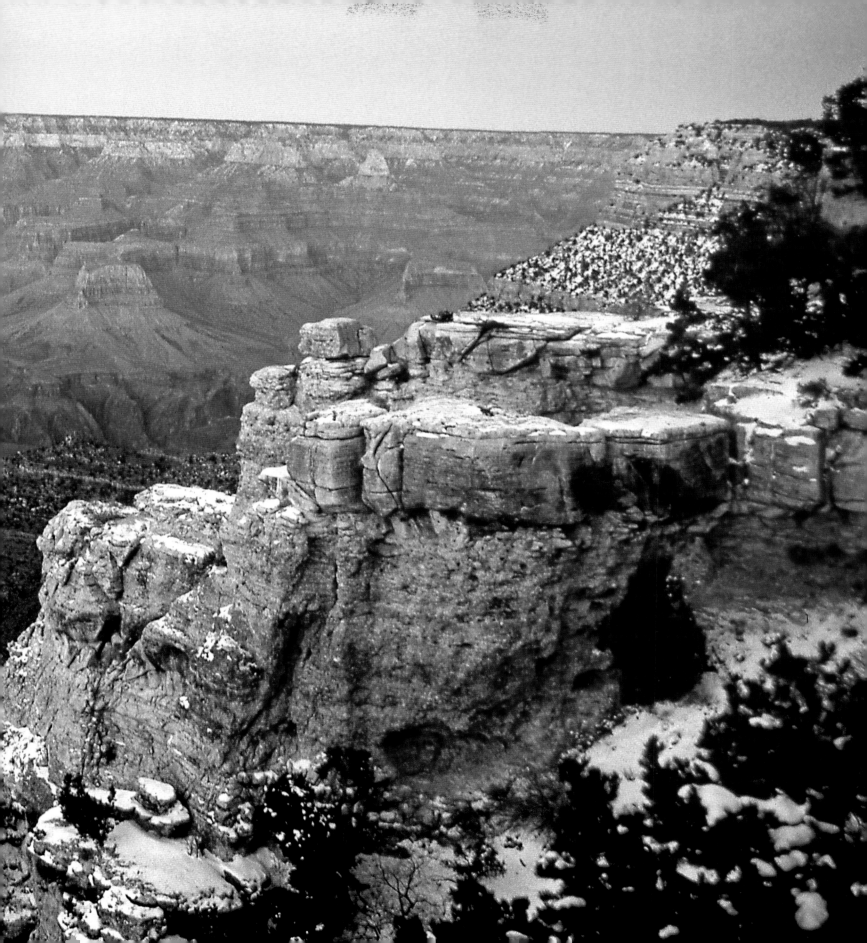

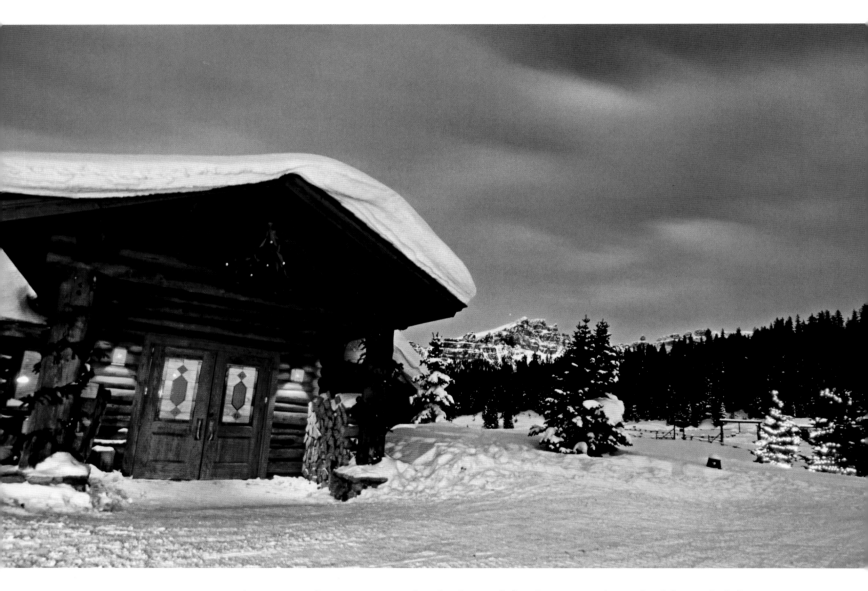

A snowcoach journey into the shadows of the Continental Divide delivers holiday visitors to the historic Brooks Lake Lodge, blushing at dusk with candlelit dinners and fiery embers of a massive river rock fireplace. In the thin air of its 9,200 foot altititude, the snug wilderness retreat proves a luxurious base for hardy snowmobilers and ice fishermen.

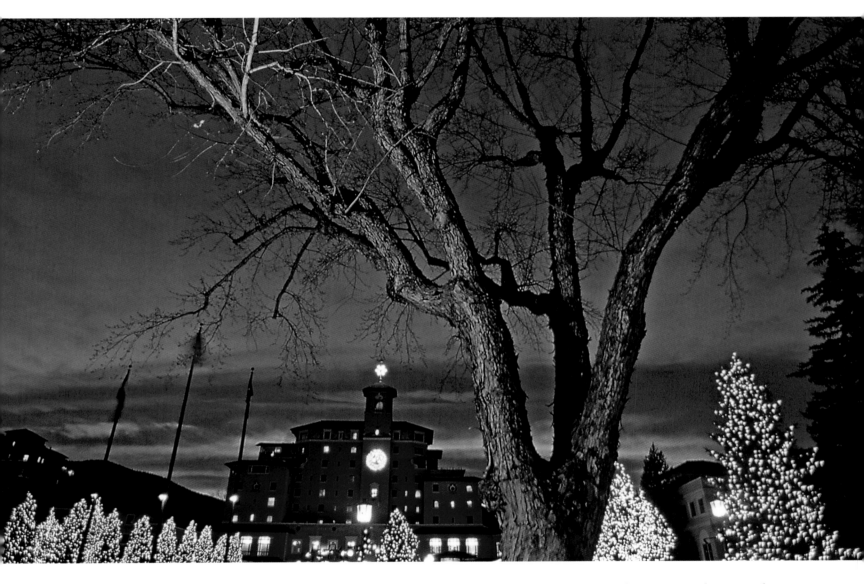

Colorado Springs' grand star-topped Christmas beacon is the spectacular Broadmoor Hotel. Its original incarnation during the 1890s as a casino was facilitated by the newfound wealth of local gold prospectors.

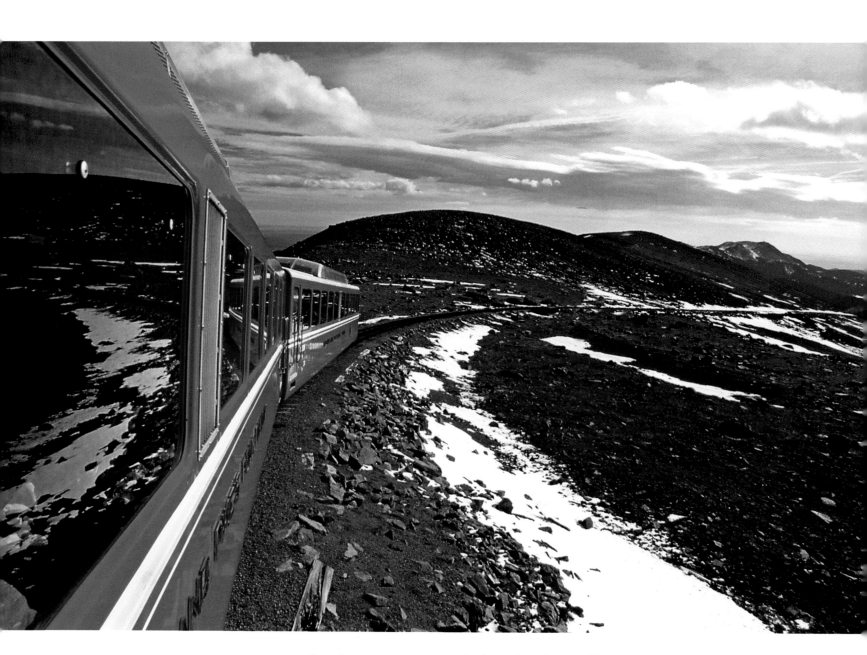

Cranking its way up toothed tracks, the world's highest cog railroad strains for the 14,110 foot summit of Pikes Peak. Soaring high above midwestern prairie, the summit, visible from 130 miles away, inspired Katherine Lee Bates to write of its "purple mountain's majesty above the fruited plain."

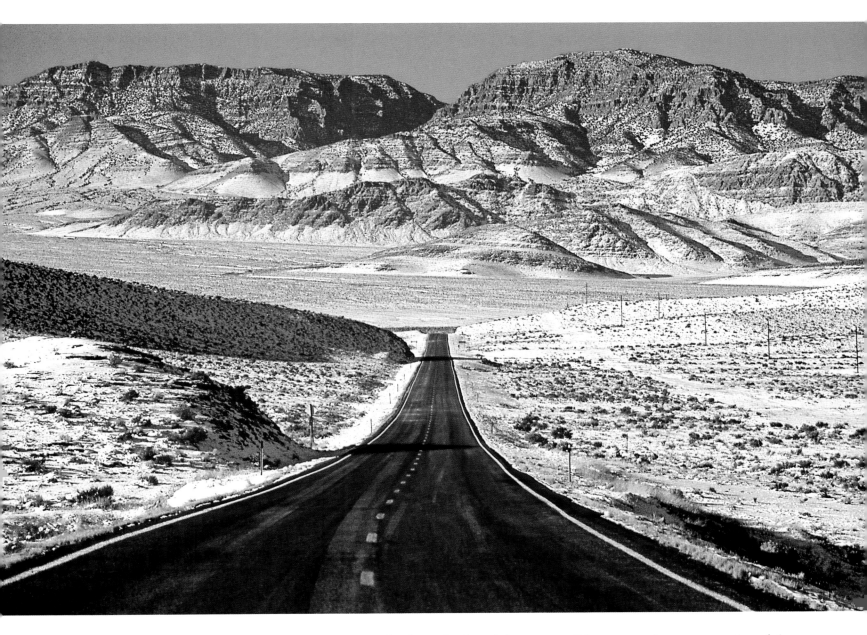

U.S. 50 winds through Nevada's empty wilderness and across a series of desolate mountain passes. The self-proclaimed "loneliest road in America" displays its usual traffic patterns, providing great comfort for impatient travelers trying to make it home for Christmas.

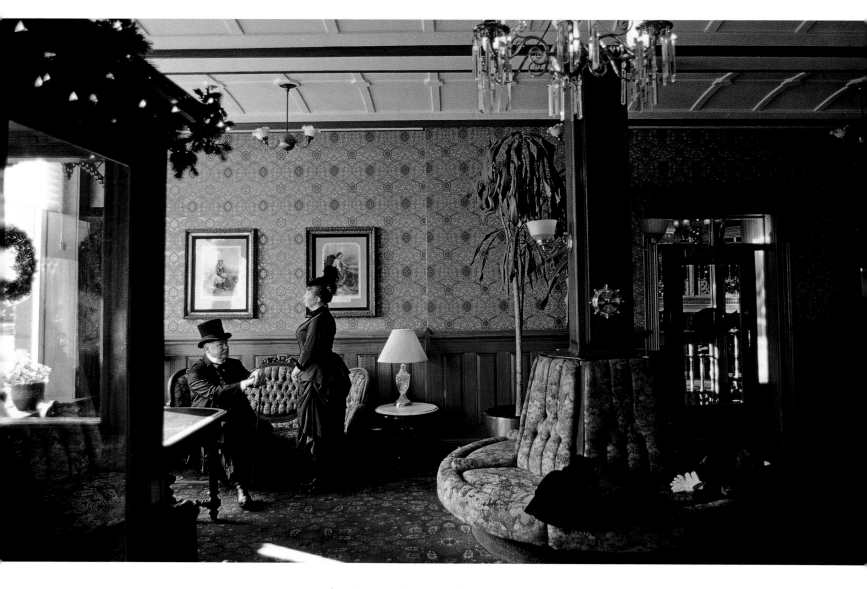

At the Strater Hotel in Durango, the lobby throbs with the ghosts of nineteenth century Victorian life when Christmas strollers take a break.

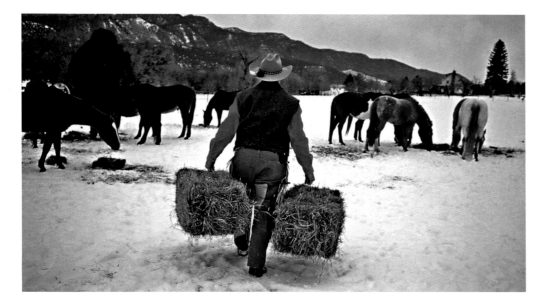

Out in the pasture, fast food delivery is on its way at a ranch just outside of Durango. Grasslands covered by snow make winter grazing a more labor-intensive activity for hard-working cowboys.

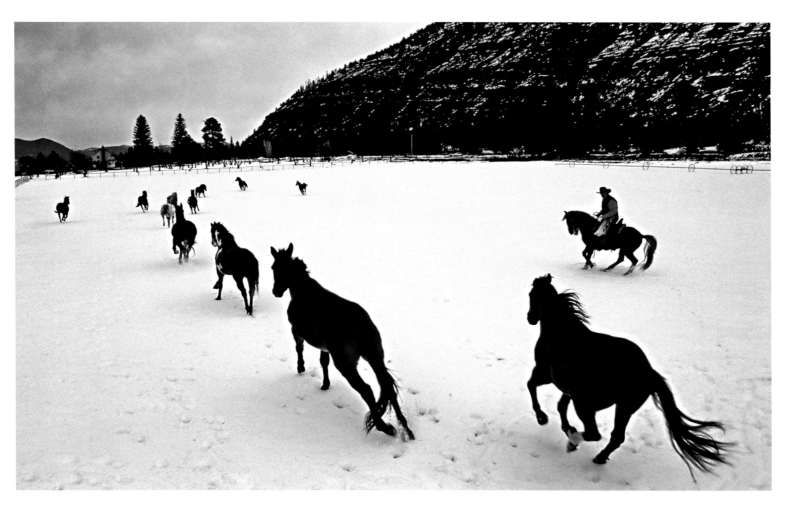

Tails fly and hooves pound as unfenced horses discover a new pasture. A cowboy supervises the stampede at a valley ranch outside Durango, Colorado.

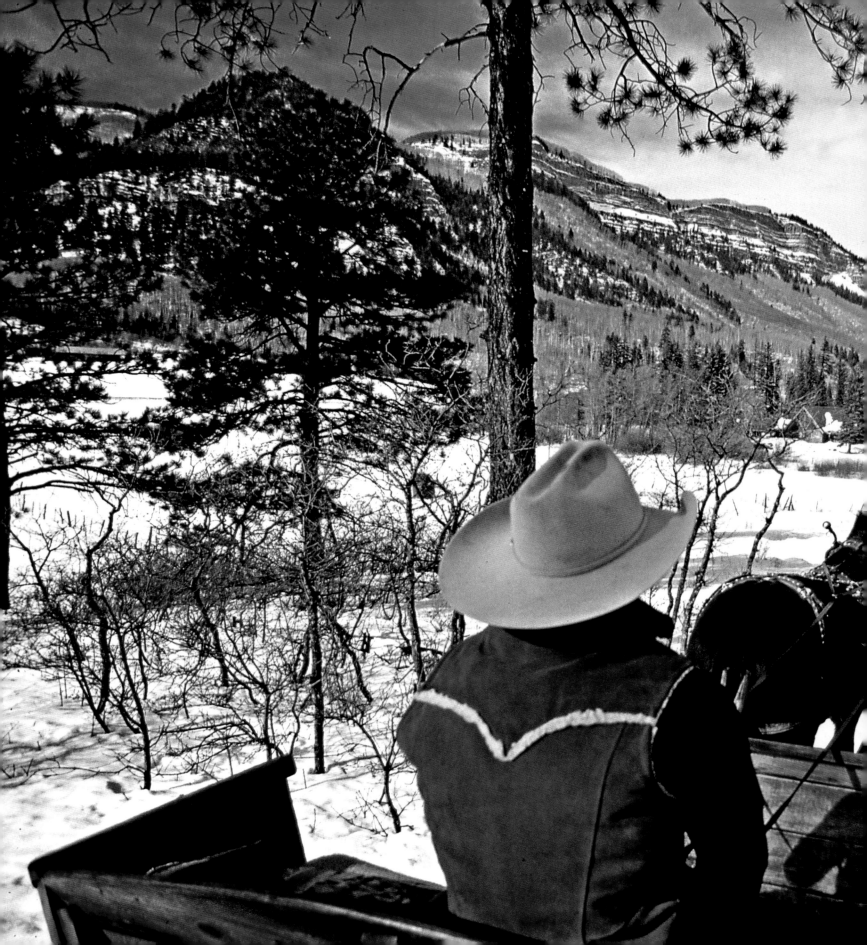

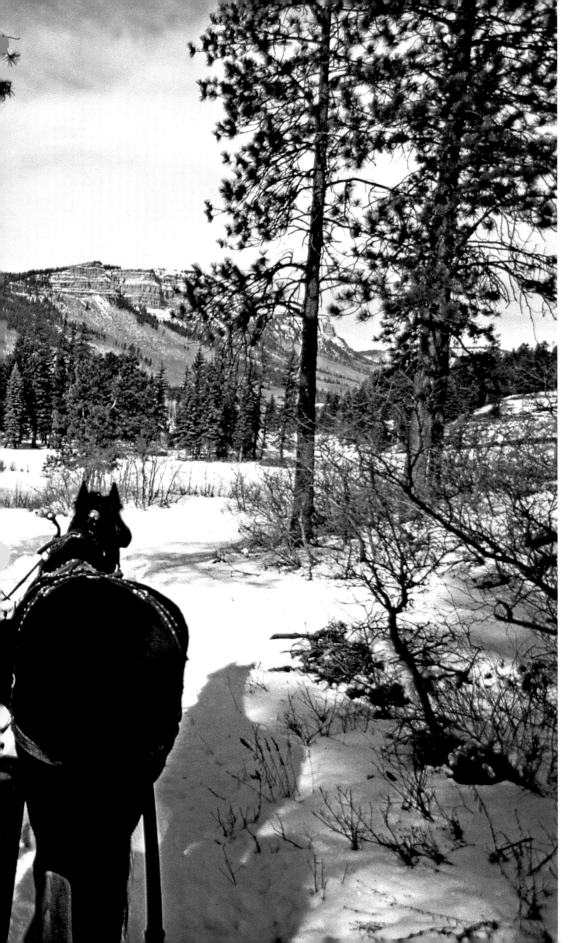

Jingling all the way back to the Rapp Corral in Durango, a cowboy-hatted driver maneuvers his team back to his humble ranch, hemmed in by the San Juan's lofty palisades.

Blasting plumes of charcoal steam into a leaden Colorado sky, the Durango and Silverton Narrow Gauge Railroad has been chugging continuously for over 125 years. Originally hauling gold and silver from the rich veins of San Juan, the steam-powered locomotive engine is fed up to six tons of coal a day.

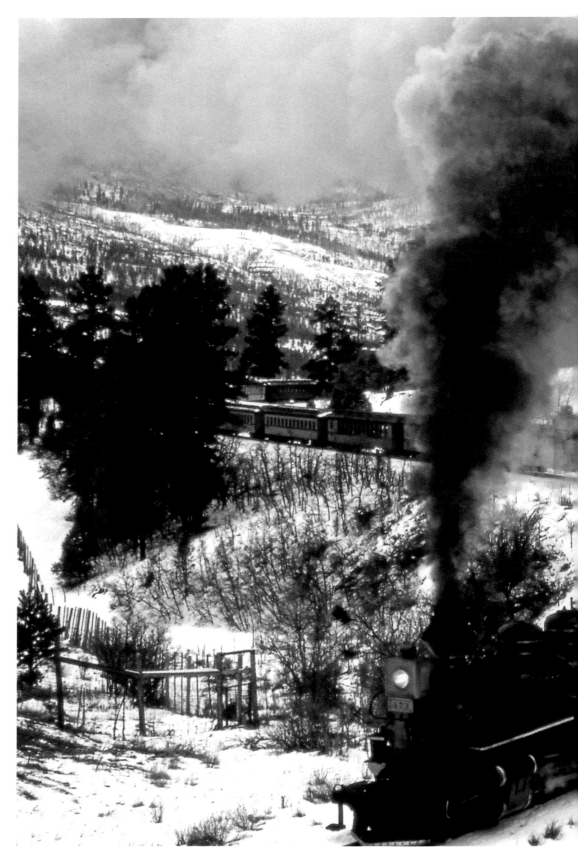

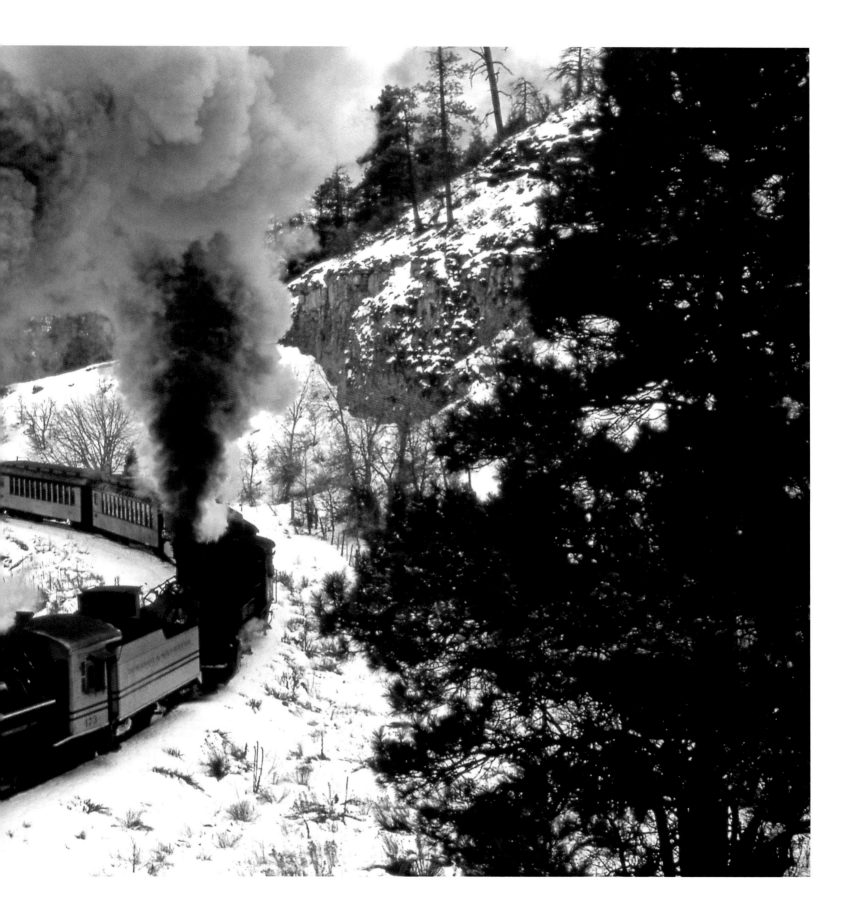

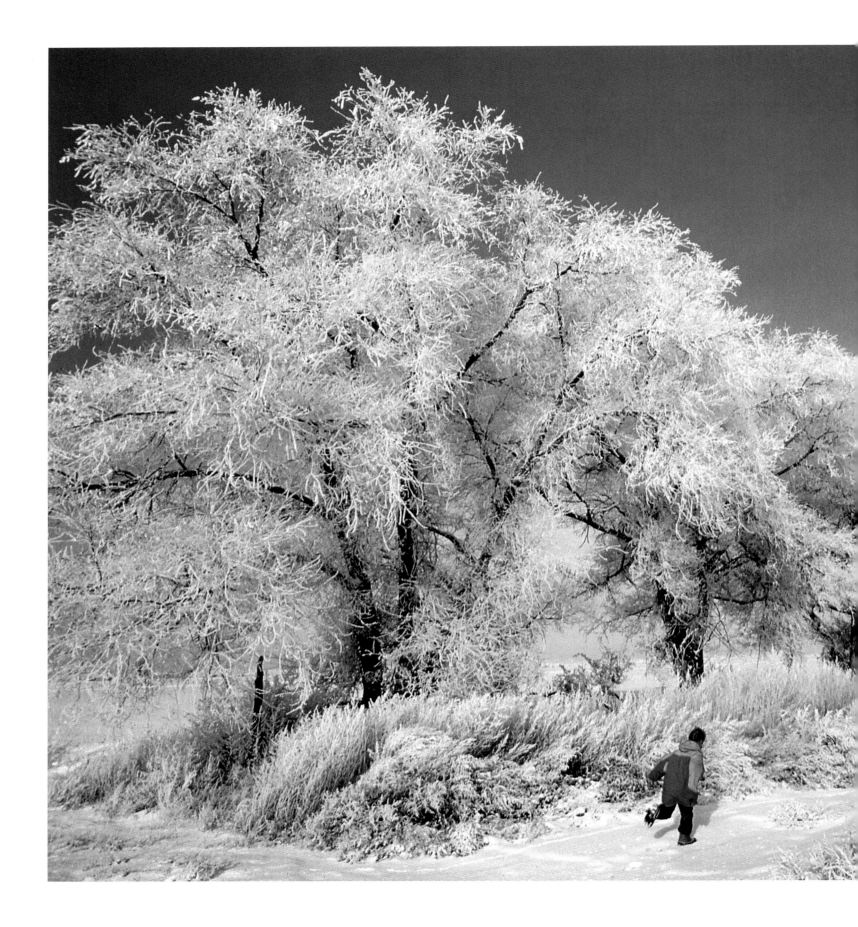

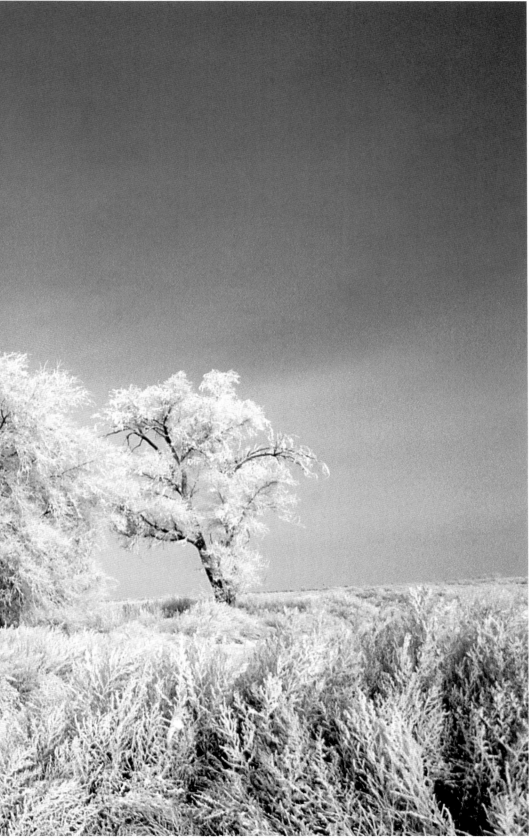

A boy's excitement with winter runs wild amongst this sugar-spun dreamland of southern Utah near the ranching community of Delta.

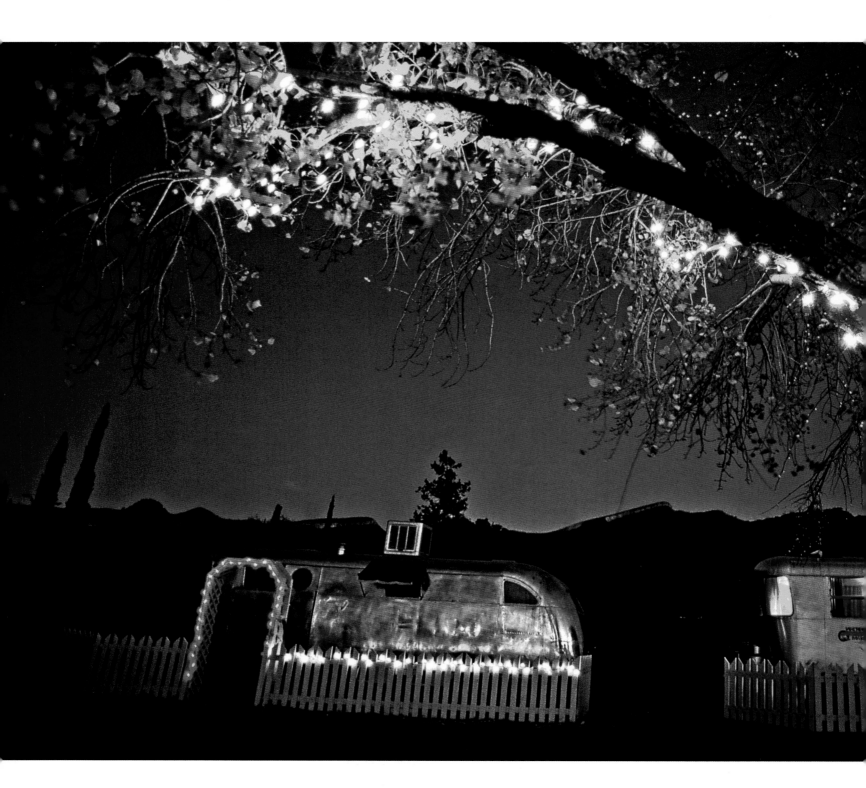

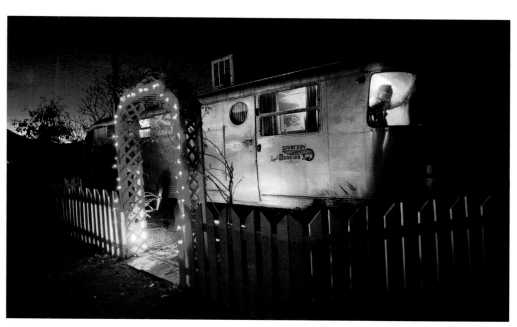

The burnished chrome of sleek Airstream trailers glows eerily at the Shady Dell RV Park, a vintage collection of streamlined gypsies. In the copper mining town of Bisbee, Arizona, the passion for other metals is evident here where aluminum overcoats of these wheeled nomads provide holiday pleasure for nostalgia buffs.

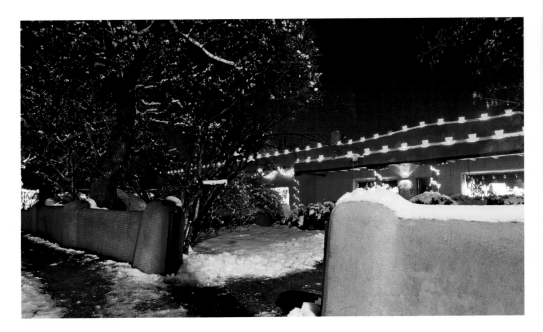

Crowned with tiara-like farolitas, the traditional adobe architecture of Taos, New Mexico, is lined with the Southwest's regional affirmation of the holiday season. The custom of displaying these sand-filled paper luminaria first infiltrated pueblo communities via cultural roots in Mexico (above).

Snow-choked farolitas punctuate the adobe lines of a nineteenth century trading post with a message of peace at Arroyo Seco, a small Hispanic village in the high altitudes of New Mexico's sage-scented mountains (right).

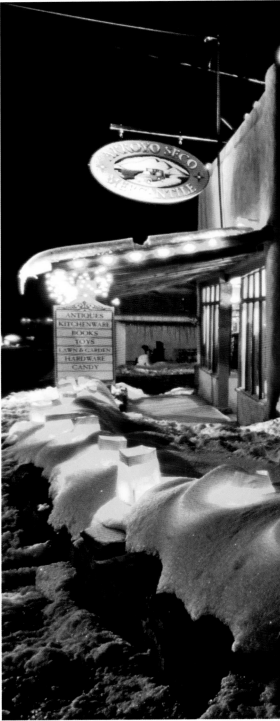

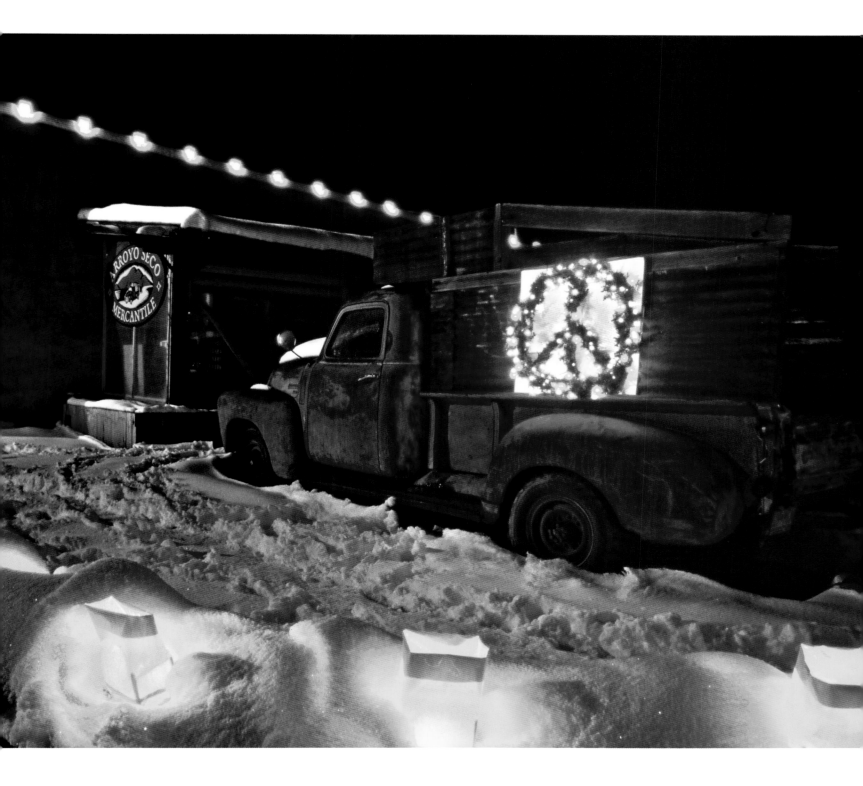

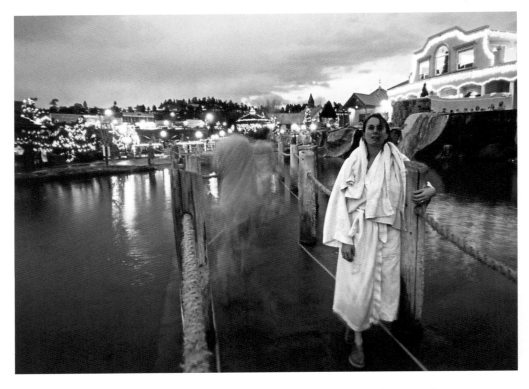

A floating boardwalk provides steamy access to a series of riverside grottoes in Pagosa Springs, Colorado. At the Springs Resort, said to be the world's deepest hot springs, you may select your desired cooking temperature and bask in the misty glow of the town's Christmas decorations.

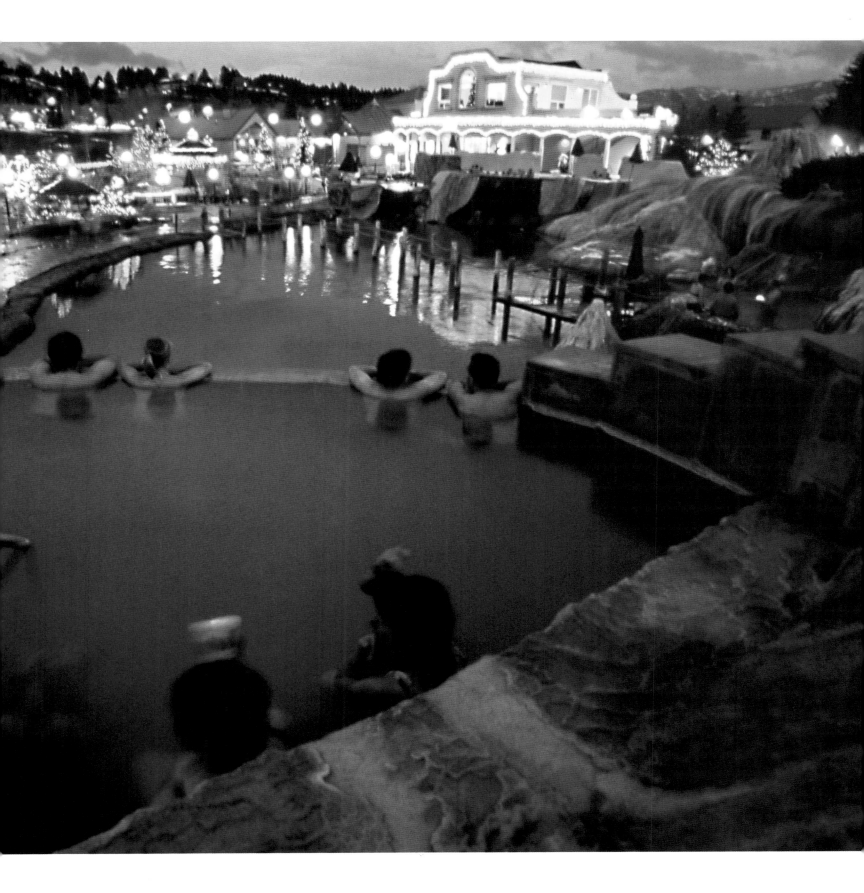

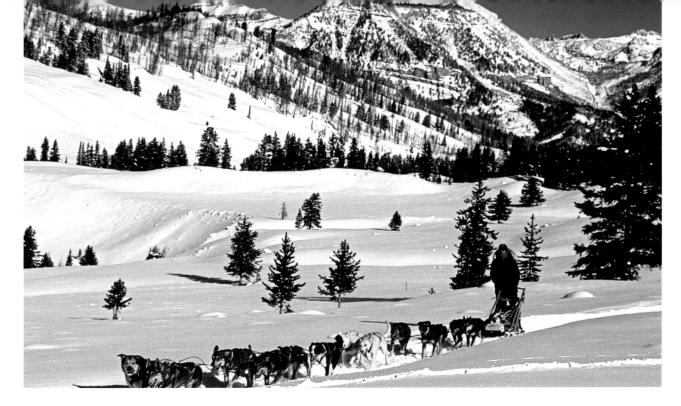

Faster by the dozen, a runaway train of canine exuberance roars through snowbound valleys in the Gros Ventre wilderness, preparing for yet another championship Iditarod marathon.

Blasting through the 12-foot blanket of superb powder snow that annually decorates the slopes, this snowmobiler has a field day beneath Two Ocean Mountain, a divide that splits raindrops into their eventual Atlantic and Pacific destinations.

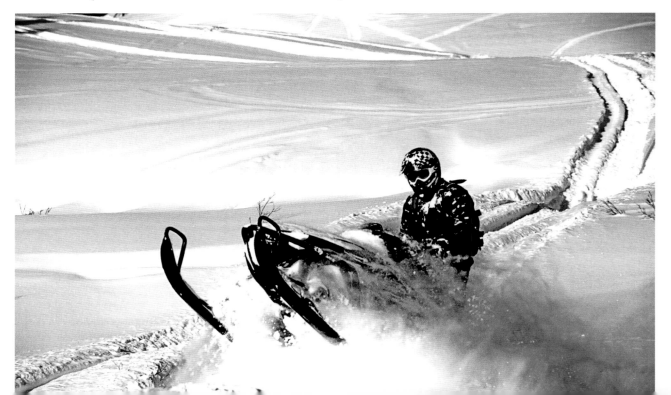

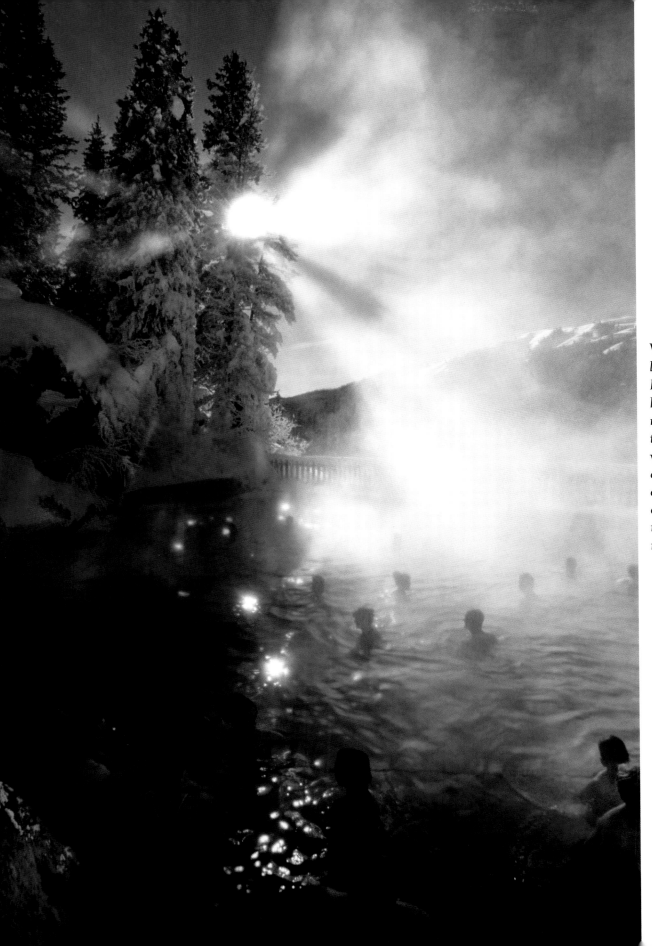

Vaporized by mineral-laden warmth, Granite Hot Springs is a luxuriant haven for bone-weary mushers attracted to this pristine 112 degree wilderness oasis. Cross country skiing and dogsledding provide the only wintertime access to this remote region of the Gros Ventre ranges.

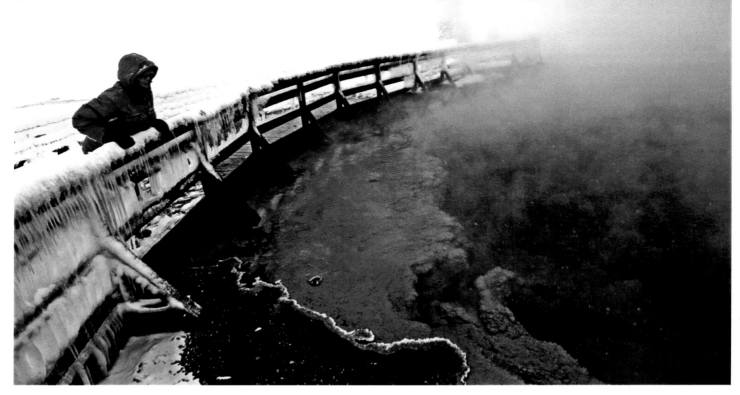

Near the Continental Divide, ice-coated boardwalks recede into the veiling mists of boiling heat at the West Thumb Geyser Basin, paradoxically situated near the coldest spot in the continental United States.

A wide range of temperatures coexist in Yellowstone's thermal valleys where humbled evergreens are burdened by the frozen residue of misty steam vents and fumaroles at Beryl Spring.

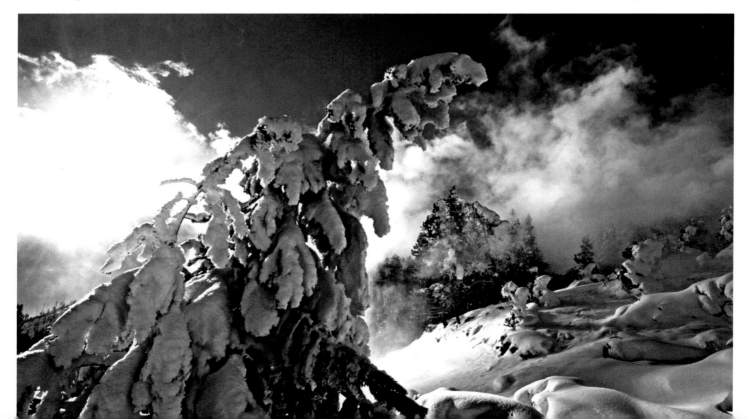

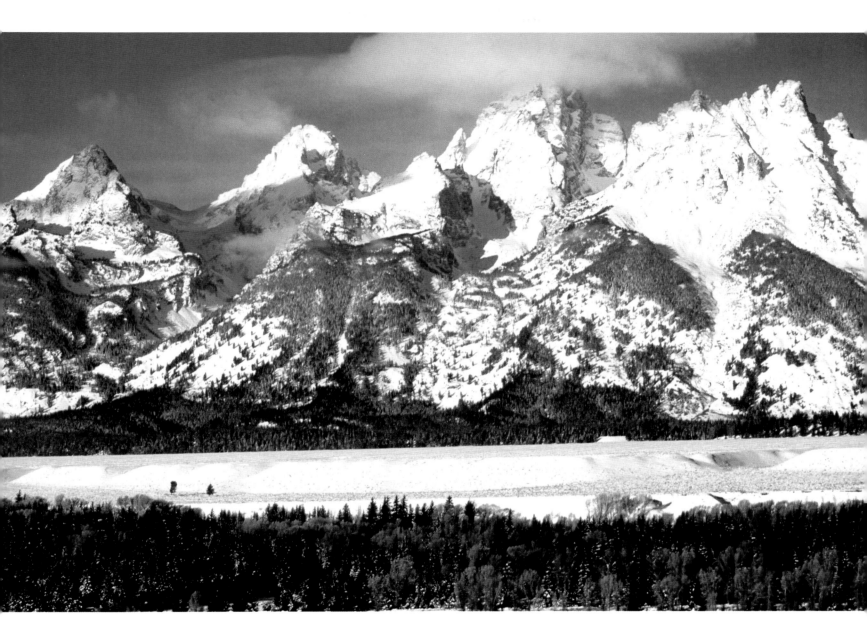

Thrusting an imposing granite skyline as much as 7,000 feet above the valley floor, the Grand Tetons are amongst the youngest geological mountain formations on earth. Their snowcapped silhouttes may be seen from over a hundred miles away out on the Great Plains.

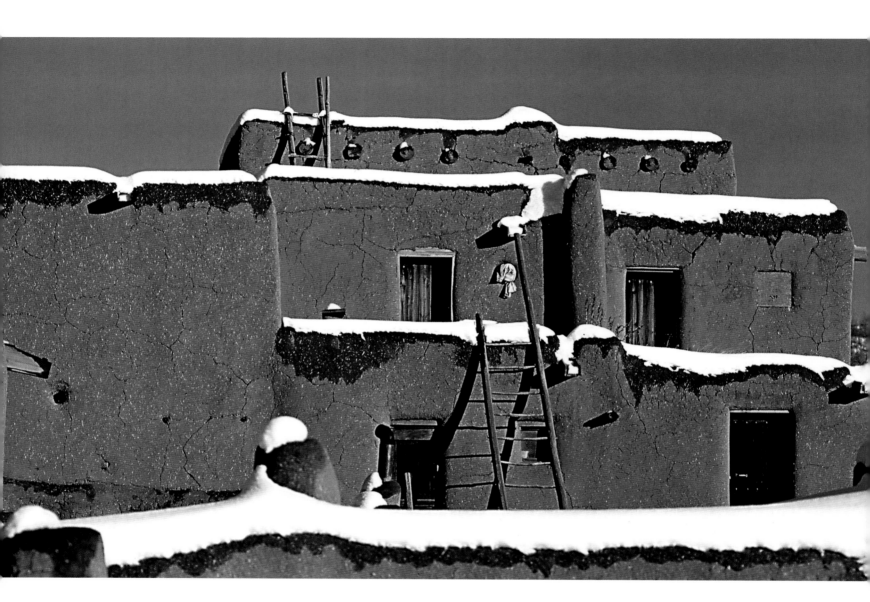

Like icing on a frosted cake, the snow lining Taos Pueblo awaits a clearing. Continuously inhabited for over 1,000 years, its apartments are made accessible by ladders in a complex of Tewa-speaking Native Americans. On New Year's Day, spirits of renewal are expressed here through the Turtle Dance.

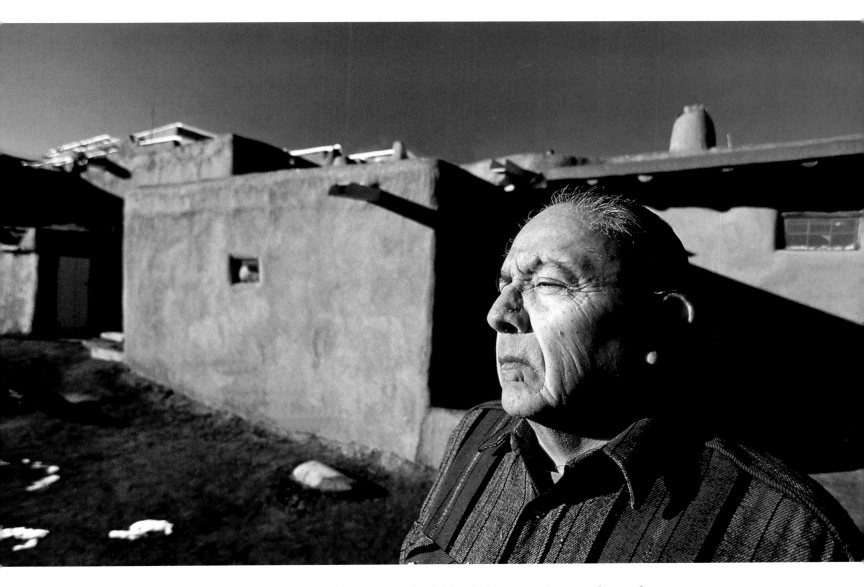

A tribal elder prepares for the next day's Turtle Dance, when rattles and pine boughs are gyrated by waves of shirtless men in the New Year's Day cold. The adobe structures at Taos Pueblo in New Mexico have been continuously inhabited for over 1,000 years.

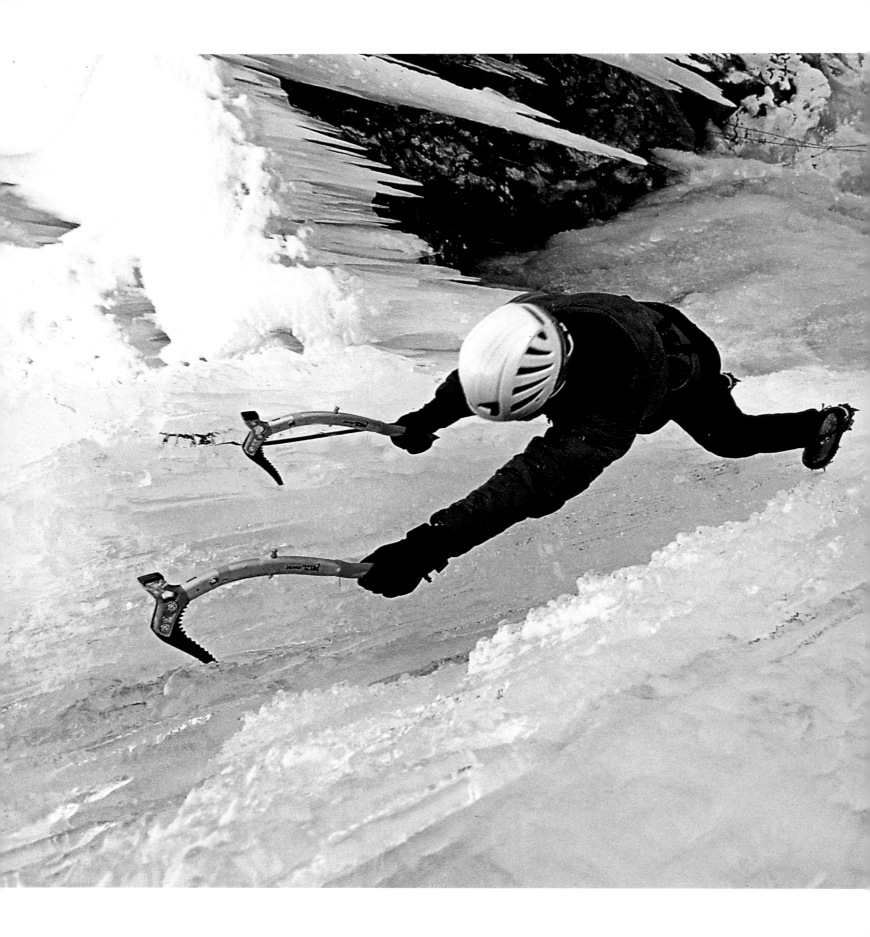

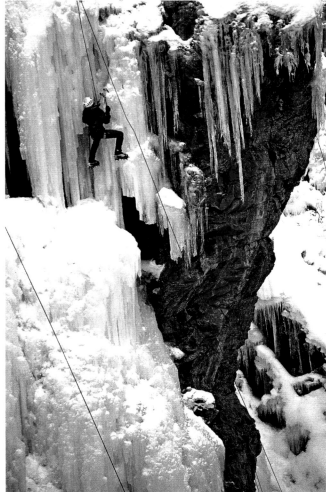

The Ice Park in Ouray, Colorado, is a magnet for thrill seekers who get their kicks on treacherous threads of frozen water.

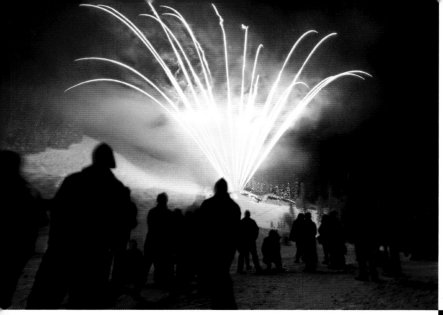

The heavily rouged landscape of Taos Mountain Ski Resort is flushed with the glow of torchlight skiers and fireworks whose staccato blasts signal New Year's Eve to the gathering crowd.

A home-made fireworks display brightens both the New Mexico night and the first moments of another year on a cliff edge at Kokopelli's Cave near Farmington.

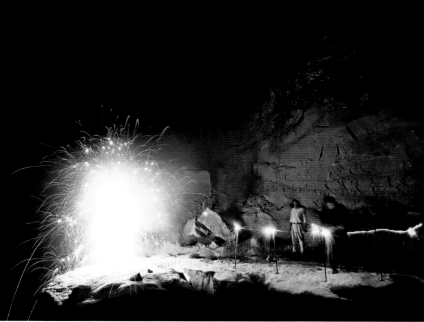

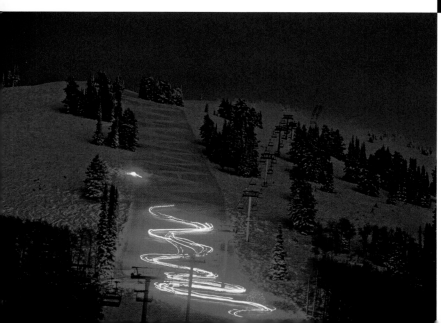

Gravity tugs on a spaghetti strand of ruby illumination as torchlight skiers announce Christmas and spill down the ski slopes of the Grand Targhee Resort, cradled on the western slope of the Teton Mountains.

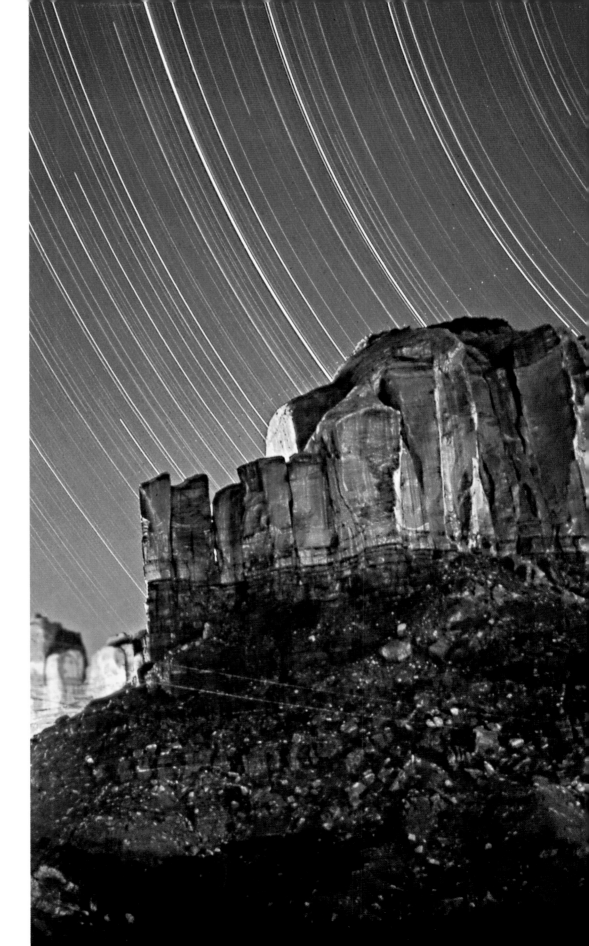

Recalling biblical reference points, heavenly bodies swirl around the North Star and over the jagged buttes of Monument Valley on the southern fringes of Utah.

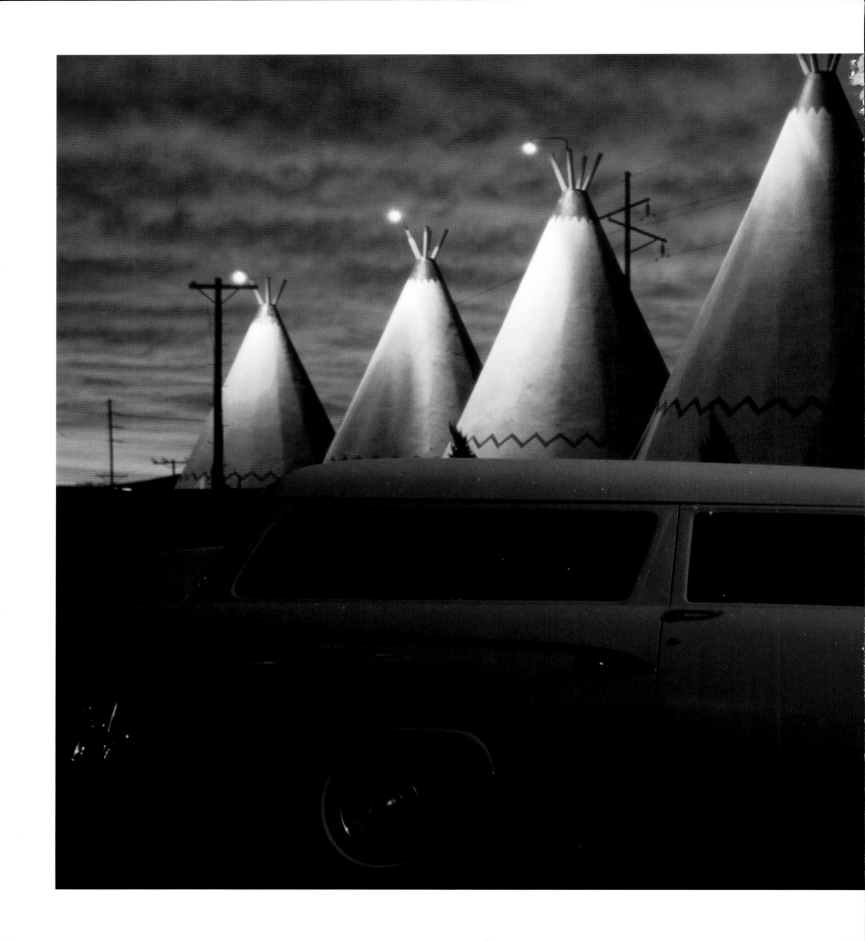

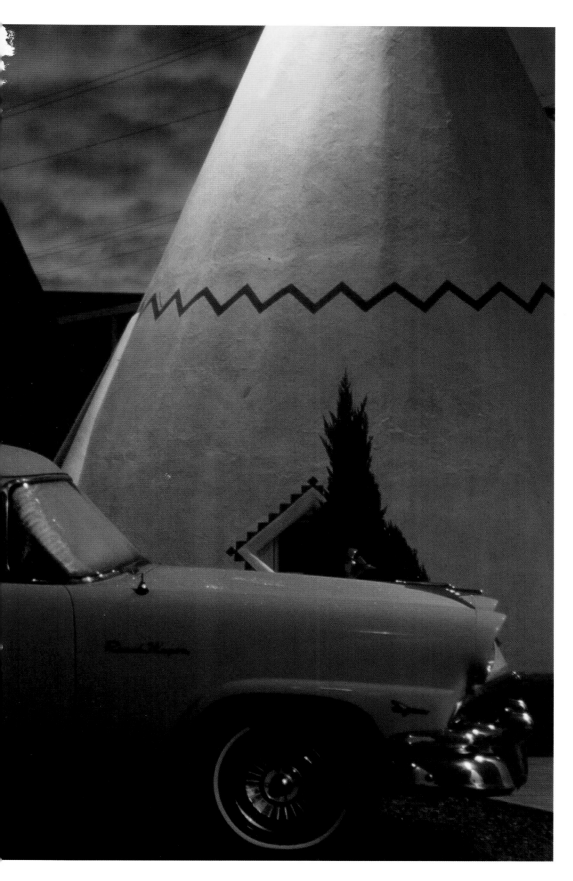

Beneath bloodshot skies, the frosted windows of a classic Ranch Wagon signal a rare Arizona chill by the Wigwam Motel on Route 66.

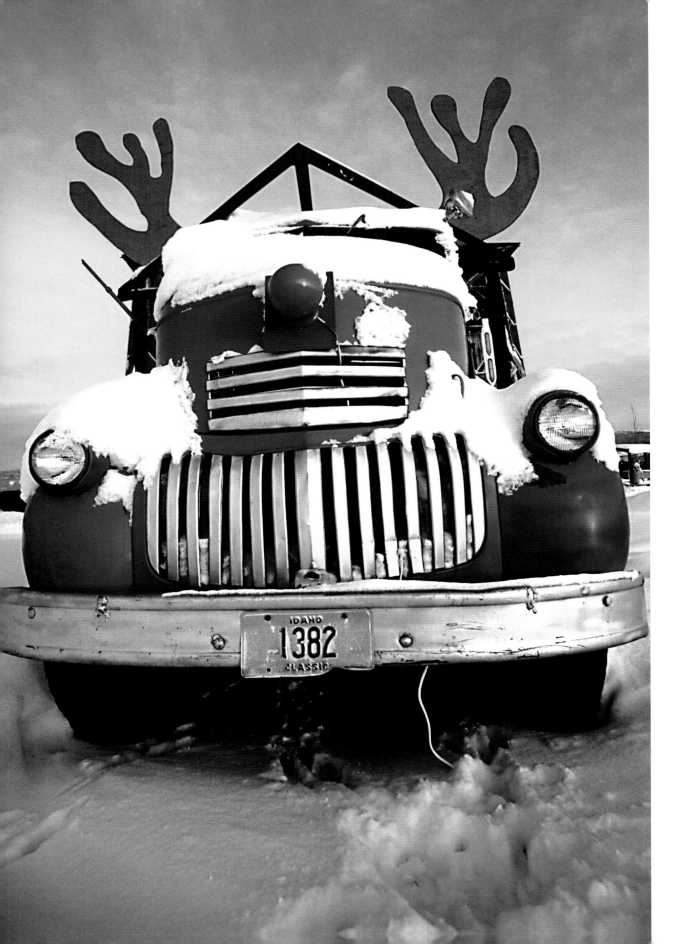

Awaiting some serious defroster action, a classic farm vehicle sports a seasonal Rudolph motif and decorates the vast, windswept plains of southern Idaho.

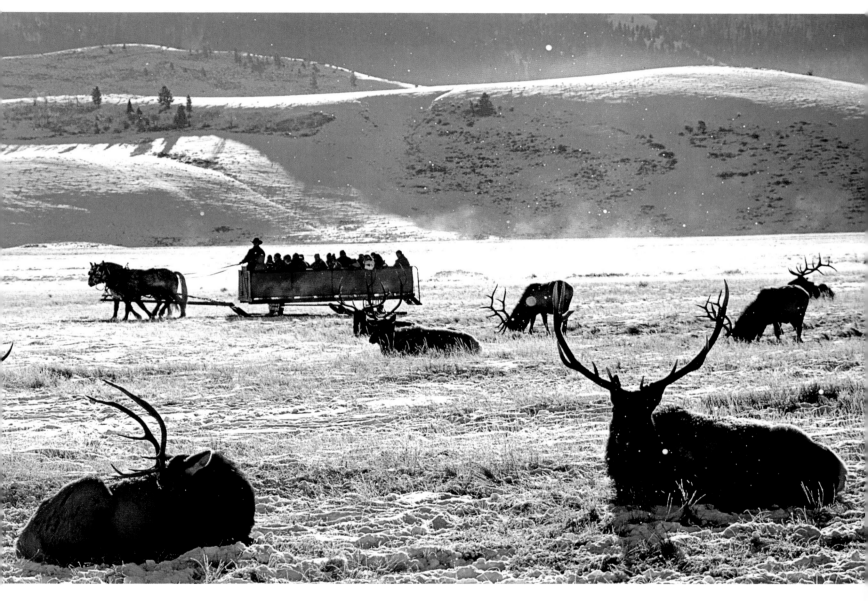

Diamond dust peppers the wilderness bedroom of the world's largest concentration of elk, where these 700-pound ungulates prepare for another round of testosterone-fueled antler wrestling.

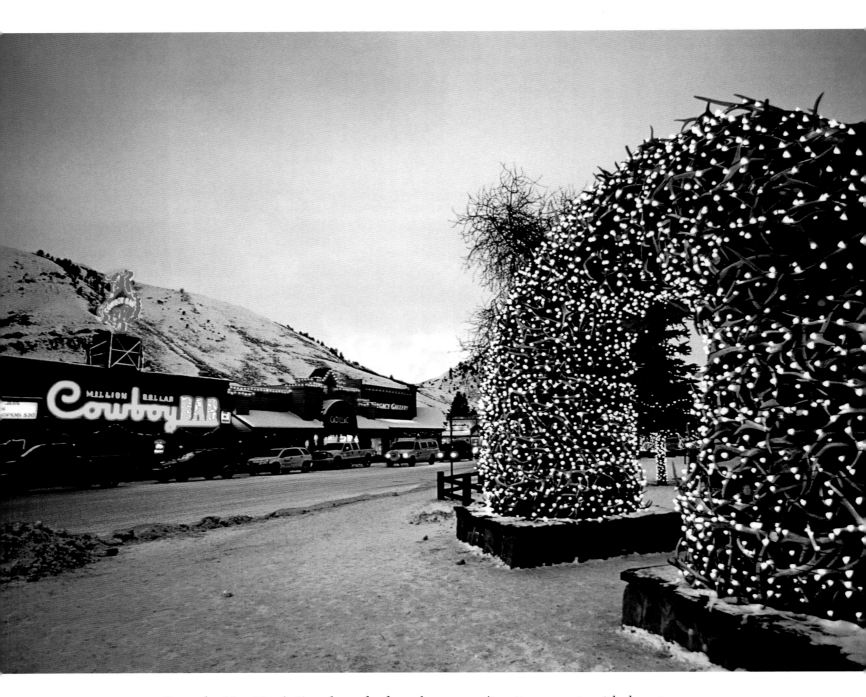

Even the New Year's Eve glow of a famed neon can't quite compete with downtown Jackson's pioneer-inspired arches, a jigsaw jumble of over two thousand elk antlers.

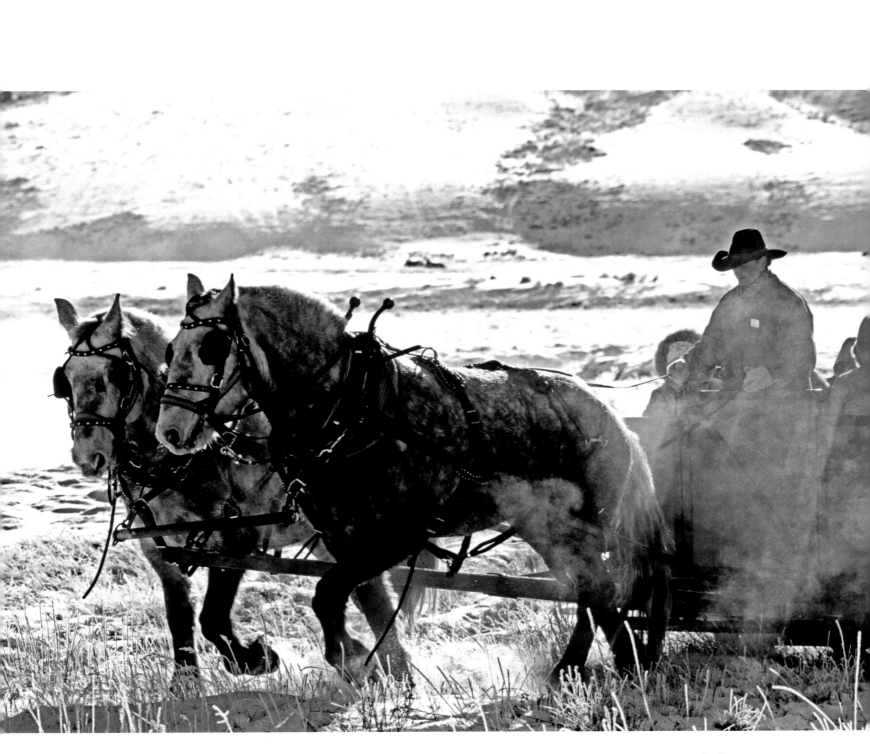

On the outskirts of the Teton wilderness, an equestrian taxi penetrates primeval elk grounds, trampling brush lacquered in sub-zero glaze.

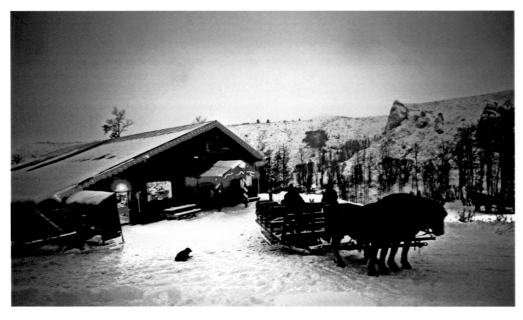

A snowbound Mill Iron Ranch glows with festivities as patient cowboys await the crowds finishing their Christmas dinner of Coors-marinated steaks.

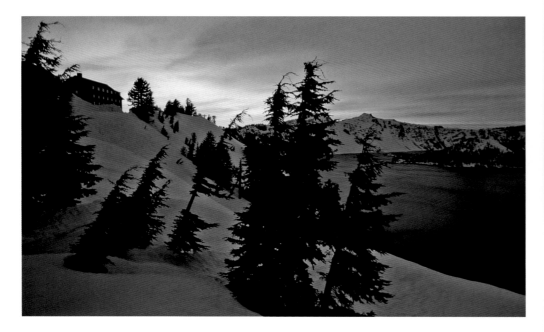

With winter bringing some of the heaviest snowfalls in the country, the Crater Lake Lodge sits out the holiday season as a roseate glow seeps into America's deepest lake. Around the volcanic caldera of Oregon's Mt. Mazama, persistent evergreens are smothered by more than five hundred inches of snowfall each year (above).

The golden warmth of the historic Awahnee Hotel is dwarfed in stark relief against the majestic ramparts of Yosemite's famed El Capitan (right).

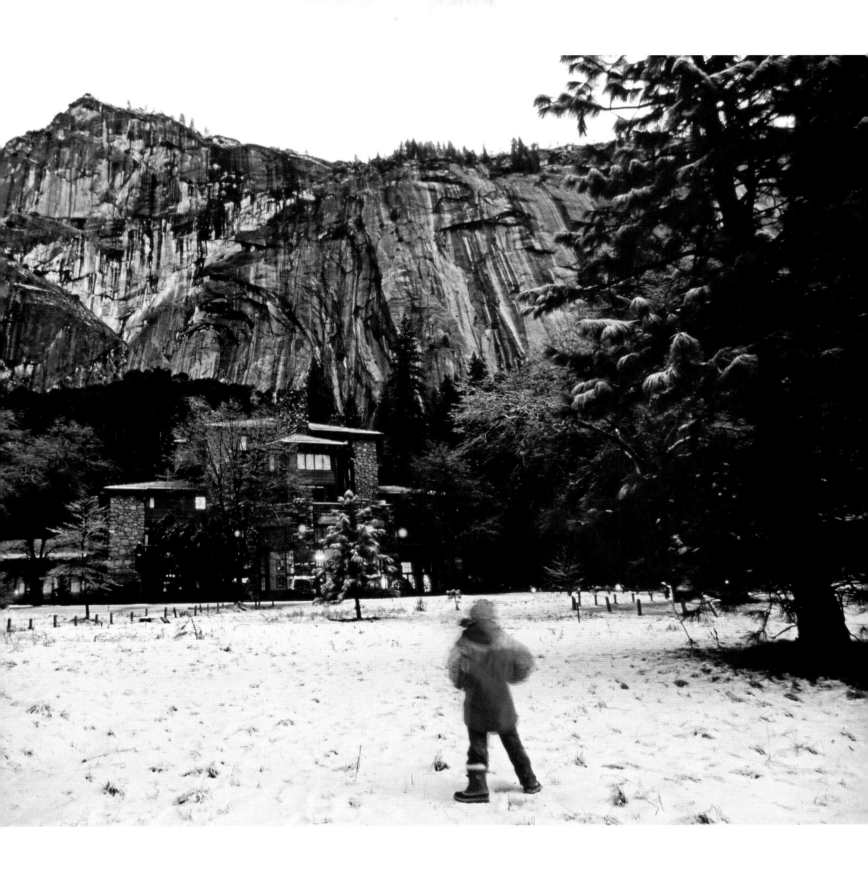

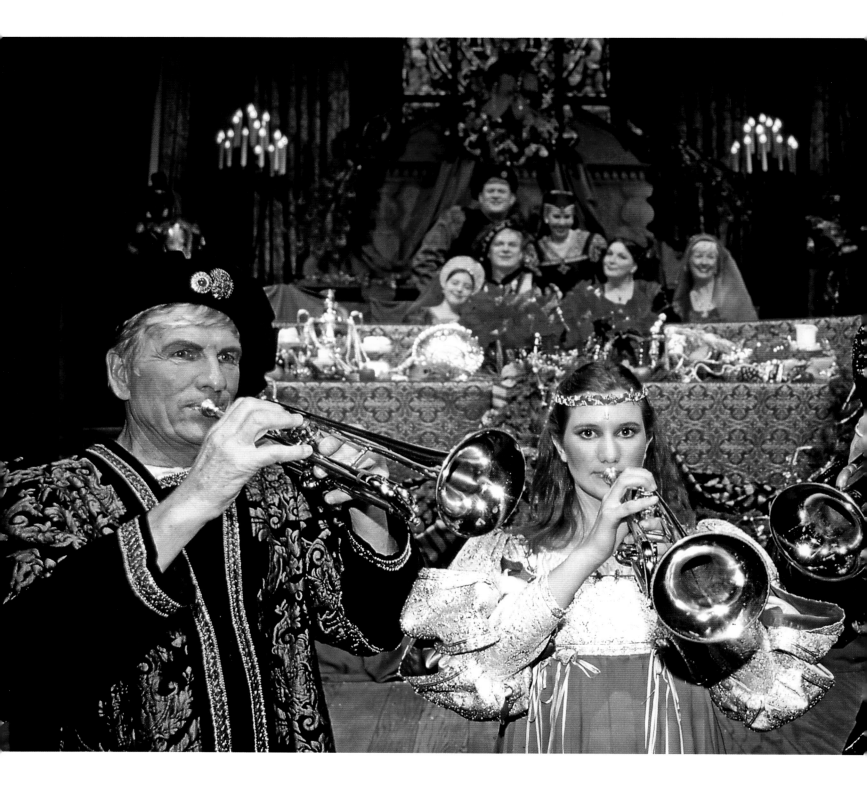

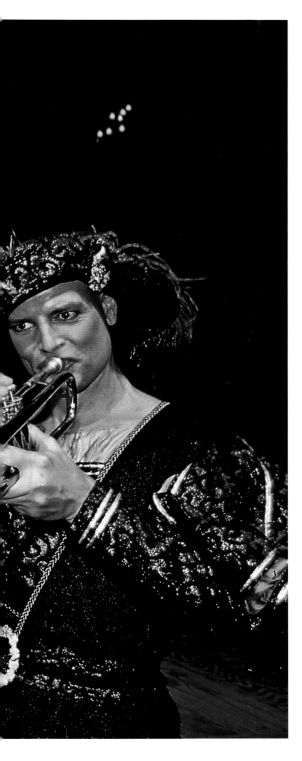

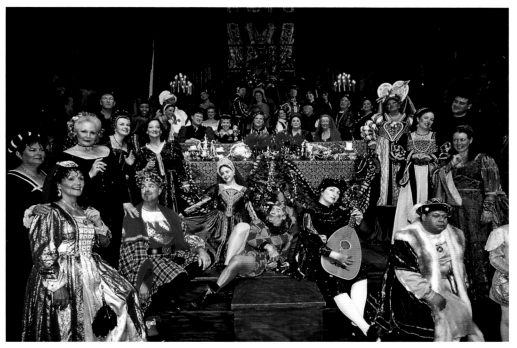

A Renaissance painting come to life, the eighty-year old Bracebridge Dinner at the Awahnee Hotel is probably the most lavish Christmas feast in the world. Surrounded by snowy Yosemite wilderness, the eye-popping four-hour extravaganza features a luscious cornucopia of rich food and astonishing pageantry first scripted by Ansel Adams.

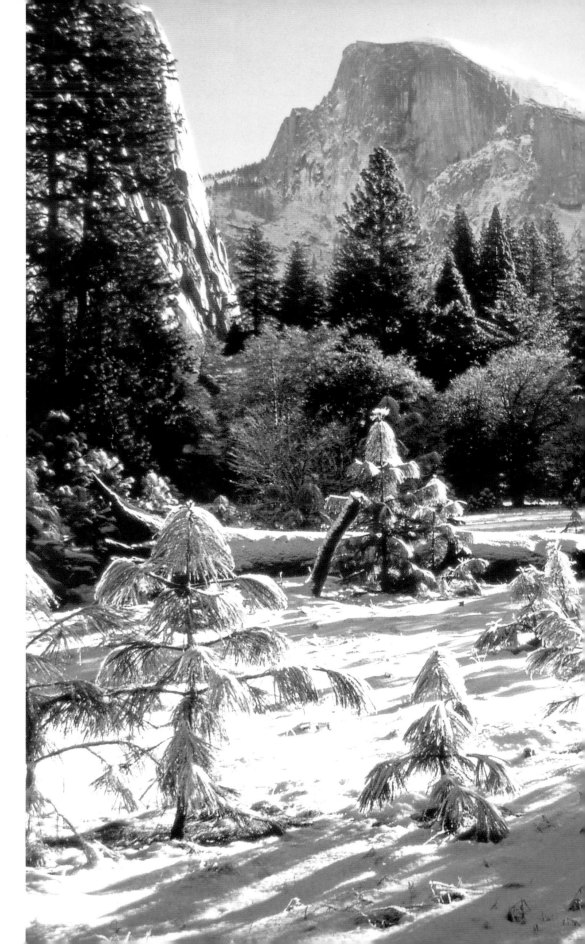

A crystal wilderness of frosted pines and soaring rock screams its fairytale setting below a glinting sun in California's astonishing Yosemite Valley.

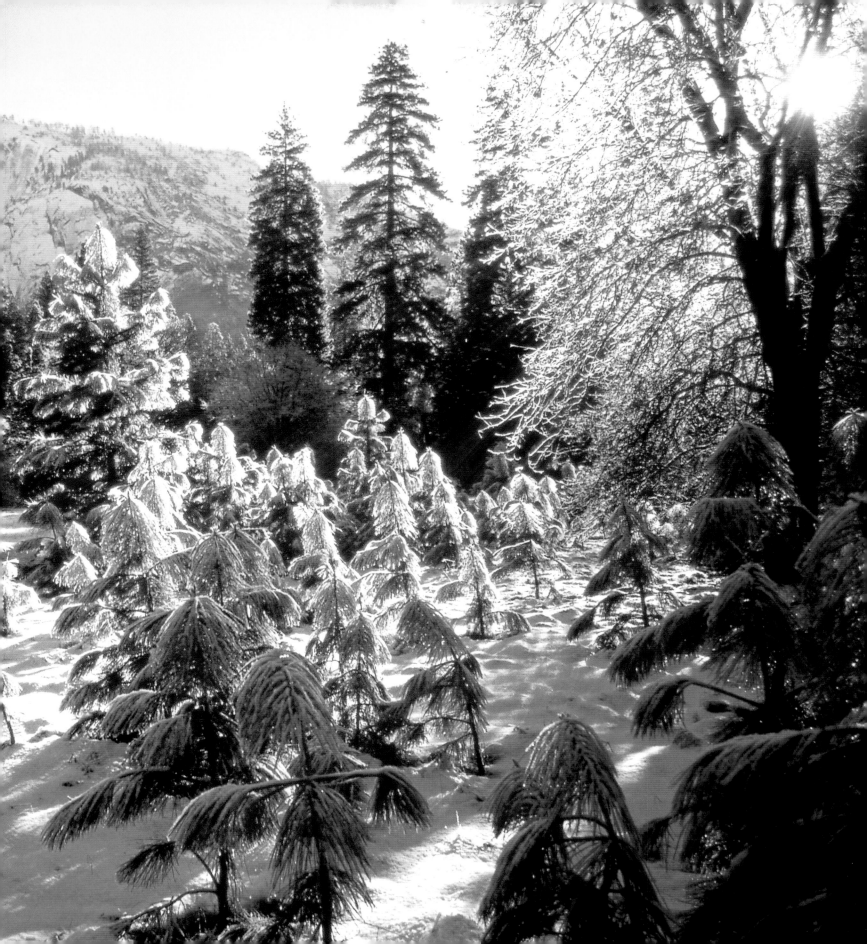

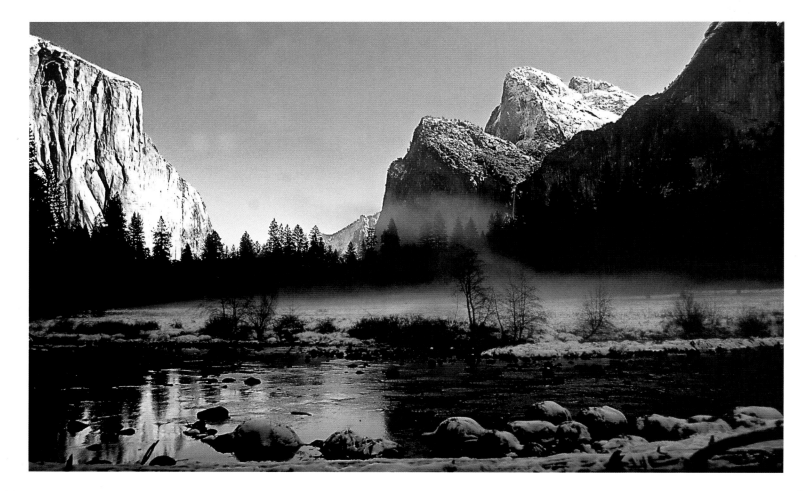

Morning fog kisses the valley floor and its gentle Merced River in the gorgeous Yosemite wilderness of California's Sierra Nevada Range.

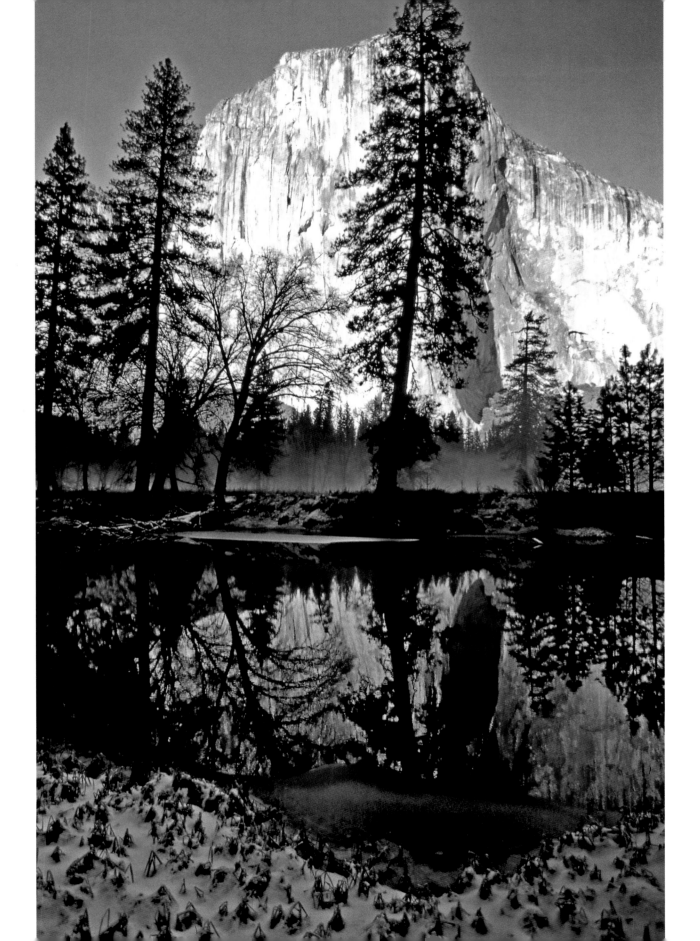

The tallest living creatures on earth stretch their redwood bark over three hundred feet toward the heavens and serve as terrestrial reminders of a higher source beyond human comprehension.

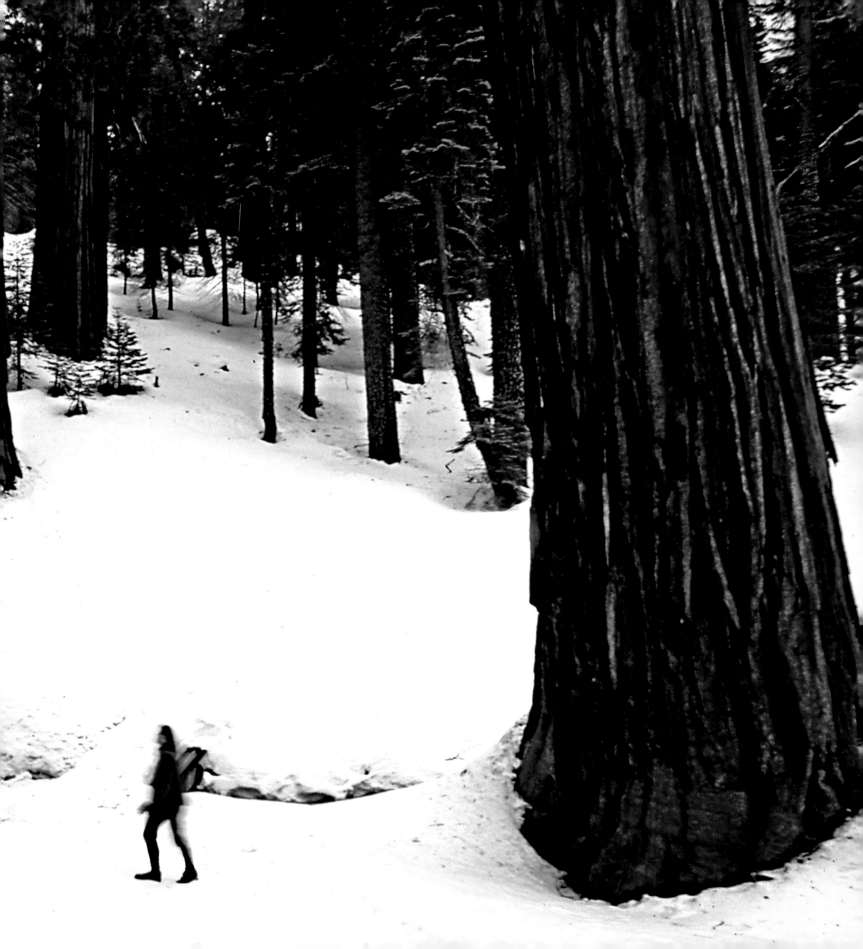